BACKROADS

of

ARIZONA

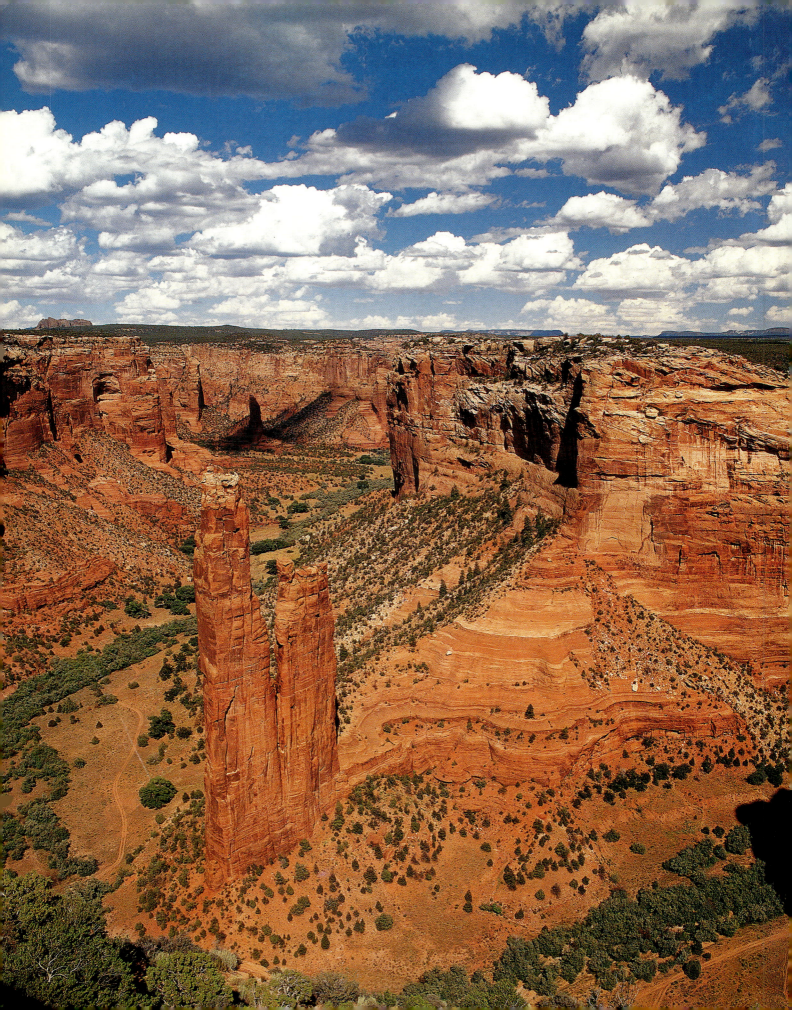

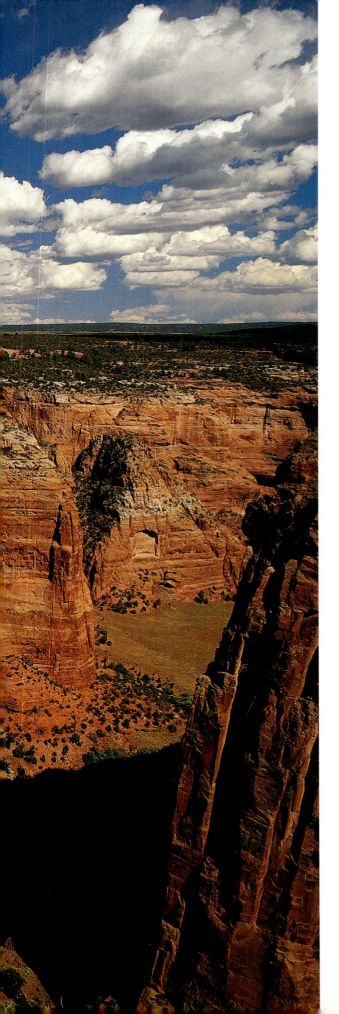

BACKROADS

of

ARIZONA

Your Guide to Arizona's Most Scenic Backroad Adventures

TEXT BY JIM HINCKLEY

PHOTOGRAPHY BY KERRICK JAMES

Voyageur Press

DEDICATION

The list of those whose contributions made this book a reality would be a lengthy one and to those fine folks I say thank you. However, special thanks are in order to the greatest contributor—my dear, loving wife, my best friend. Without her patient support and encouragement, and without her ability to keep the home fires burning in my absence, none of this would have been possible.

— *Jim Hinckley*

To my parents, Jesse and Mary Lou, who instilled me with a love of learning, roaming, and seeing—and the freedom to grow up doing all three.

— *Kerrick James*

First published in 2006 by Voyageur Press, an imprint of MBI Publishing Company, 400 First Avenue North, Suite 300, Minneapolis, MN 55401 USA

The information in this book is true and complete to the best of our knowledge. All recommendations are made without any guarantee on the part of the author or Publisher, who also disclaim any liability incurred in connection with the use of this data or specific details.

We recognize, further, that some words, model names, and designations mentioned herein are the property of the trademark holder. We use them for identification purposes only. This is not an official publication.

Voyageur Press titles are also available at discounts in bulk quantity for industrial or sales-promotional use. For details write to Special Sales Manager at MBI Publishing Company, 400 First Avenue North, Suite 300, Minneapolis, MN 55401 USA.

To find out more about our books, join us online at www.voyageurpress.com.

Editors: Amy Rost and Leah Noel
Designer: Sara Grindle
Cartographer: Mary Firth

Printed in China

ON THE COVER:

TOP LEFT: *Petroglyphs on Newspaper Rock in Petrified Forest National Park.*

MIDDLE: *The Mission San Xavier Del Bac near Tucson.*

TOP RIGHT: *A lone Arizona cowboy framed against a sunset.*

MAIN: *Cathedral Rocks looms over Oak Creek at Red Rock Crossing State Park near Sedona.*

ON THE TITLE PAGES:
The 800-foot-tall sandstone spire known as Spider Rock in northeastern Arizona is an important feature in Navajo legend.

INSET ON THE TITLE PAGES:
In Arizona's Organ Pipe Cactus National Monument, the upraised arms of saguaros reach toward the heavens.

Library of Congress Cataloging-in-Publication Data

Hinckley, James,
 Backroads of Arizona : your guide to Arizona's most scenic backroad adventures / text by Jim Hinckley ; photography by Kerrick James.
 p. cm.
 Includes bibliographical references and index.
 ISBN-13: 978-0-7603-2689-3 (softbound)
 ISBN-10: 0-7603-2689-4 (softbound)
 1. Arizona—Tours. 2. Scenic byways—Arizona—Guidebooks. 3. Automobile travel—Arizona—Guidebooks. 4. Arizona—Pictorial works.
 I. James, Kerrick. II. Title.
 F809.3.H56 2006
 917.9104'54—dc22
 2006019838

CONTENTS

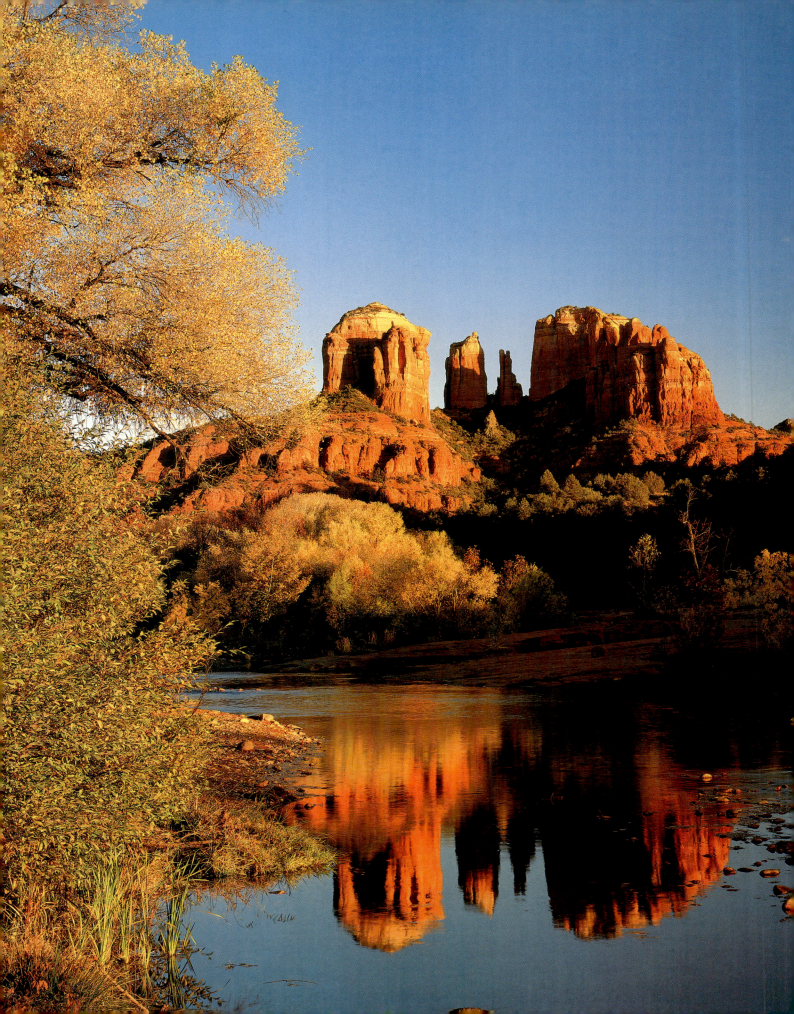

INTRODUCTION

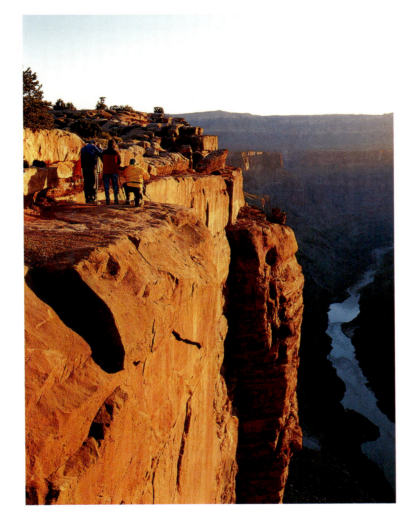

FACING PAGE:
The towering spires of Cathedral Rocks reflect in the waters of Oak Creek at Red Rock Crossing State Park near Sedona.

ABOVE:
Sunrise at Toroweap on the north rim of the Grand Canyon is a breathtakingly stunning sight.

Arizona. The very name conjures images of a rugged, sun-scorched land shadowed by towering saguaros, scarred by deep, colorful canyons, and dominated by towering buttes, blazing multicolored sunsets, and mesas. Though these natural wonders are all found here, Hollywood and countless cinematic epics have created this image of the Grand Canyon State in many people's minds.

The real Arizona is a land of truly stunning natural beauty and indescribable diversity. It is an ancient land where the history of the earth is written on deep canyon walls in chapters of stone. Here and there, crevices in these multihued chasms frame ghostly ruins, remnants of the communities of the mysterious Anasazi, the ancient ones.

Near Flagstaff, towering snow-capped peaks serve as a backdrop for deep forests of majestic ponderosa pines, and Alpine meadows carpeted with a dazzling array of wildflowers are islands in a sea of desert. Elsewhere in Arizona, there are vast moonscapes where stark rock walls stretch heavenward, contrasting with thundering deep-blue waterfalls and seemingly endless plains of sterile black volcanic rock that are broken by splashes of color when the cacti are in bloom. Buttes and mesas change color with the shadows of season or with the time of day, rolling grasslands are home to pronghorn antelope that run free, and cowboys still ride the range.

Natural beauty is what you expect to find in Arizona, a beautiful treasure chest of God's finest handiwork. Scattered here and there are also gems of another kind: remnants from when conquistadors sought the legendary golden cities of Cibola, from when legends such as Wyatt Earp rode tall in the saddle, and from when the United States Army tested the viability of camel caravans for supplying remote outposts. The time capsules hidden here include the charming mission church of San Xavier del Bac, which has served its parishioners for more than two centuries; the dusty streets of Tombstone; the quaint ghost city of Jerome, with its majestic views of the Verde Valley; and the Palace Station on the old Senator Highway. Not to be forgotten are the botanical gardens, the excellent zoos, and the Route 66 icons and vintage neon signs that flash under star-studded desert skies. These, too, are Arizona.

Traveling the backroads of Arizona is a rare opportunity to experience a rich tapestry of sights, sounds, flavors, colors, and cultures. With common sense, a little sunscreen, and some advance planning (which should include evaluating dramatic variances in climate and road conditions because of changes in elevation), it is possible to enjoy Arizona in any season or to experience every season in a weekend.

It is my sincere hope that the drives outlined in this book will serve as an introduction to the many wonders that make Arizona truly unique. Moreover, I hope they show you Arizona's many charms so that you will return time after time.

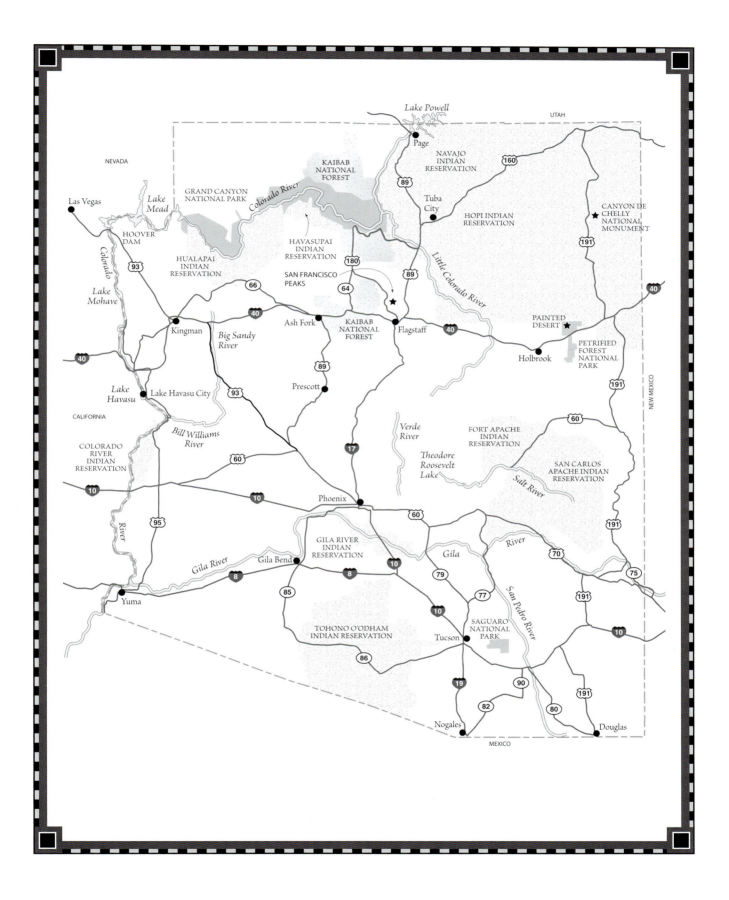

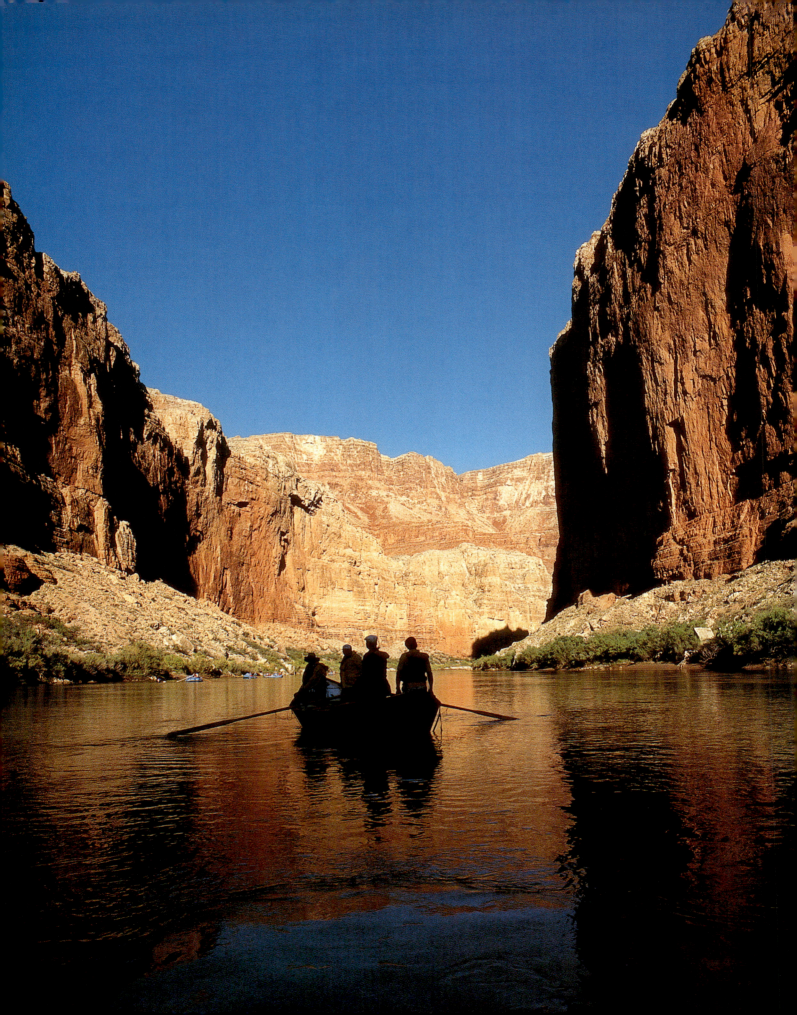

THE NORTHWEST

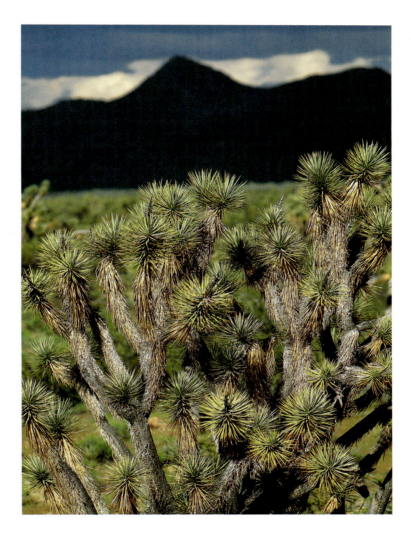

The canyons of the Colorado River present an ever-changing kaleidoscope of color for rafters traveling this ancient passageway.

A strange forest of twisted, spike-topped "trees" unlike anything on earth gives the Joshua Tree Parkway in northwest Arizona its name.

Even though the northwest portion of the state has often been on the forefront of development, it still is a mix between the modern and the frontier era. In spite of explosive growth during the past decade, there are large portions of this area that remain as wilderness, little changed from when the conquistadors first came through this area more than four centuries ago.

Mohave County may be geographically larger than several states, but the population in the northern third of the county is numbered in the thousands. Separating the northern part of the county from the southern part is a raw, rugged land with deep, colorful gorges, including the world-famous Grand Canyon.

With the exception of Kingman, Lake Havasu City, and Bullhead City, the communities in the northwest are, to a large degree, time capsules. In many towns, it feels as if time stopped in the 1950s, while in others, the trappings of that period are but a thin façade covering relics from when this area was a territory and not a state. In the village of Supai, for example, mule trains still bring the mail and most supplies into town.

The longest remaining uninterrupted portion of historic Route 66 crosses northwestern Arizona. As you motor west along this legendary stretch of asphalt, little imagination is required to believe that it is the year 1955, or even 1950, for there is almost nothing to break the illusion, except the passing of a Honda.

Finding adequate words to describe this amazing land is difficult indeed. If, however, I were limited to just two words to describe northwestern Arizona, they would be *time capsule*.

THE MAIN STREET OF AMERICA
ROUTE 66 FROM ASH FORK TO TOPOCK

ROUTE 1

From Interstate 40 west of Ash Fork, take the Crookton Road exit. Follow Route 66 (Arizona Highway 66) west to Kingman, where it becomes Andy Devine Avenue. The route southwest through Kingman, as well as to Goldroad, Oatman, and through the Topock marshes, is well posted as historic Route 66.

This drive is just shy of 160 scenic miles and serves as an excellent introduction to the changing landscapes of Arizona. It is also a one-of-a-kind opportunity to experience the most famous highway in America: Route 66. The numerous attractions, awe-inspiring scenery that encourages frequent stops, unique opportunities for dining and lodging, and the friendly folks found at each stop ensure a memory-making journey.

Each season lends its own charm to this drive. But during summer months, the temperatures are extreme, especially in the Colorado River valley, where nighttime readings of more than 110 degrees are common. In addition, services from the Interstate 40 junction west of Kingman through to Oatman consist of little more than cafés and gift shops.

From the bridge at the Crookton Road exit on Interstate 40, west of Ash Fork, the asphalt ribbon of Route 66 flows across the grassy plain to the far western horizon. Once the drive begins, the solitude of the old highway—bordered by intermittent stands of aromatic juniper trees and

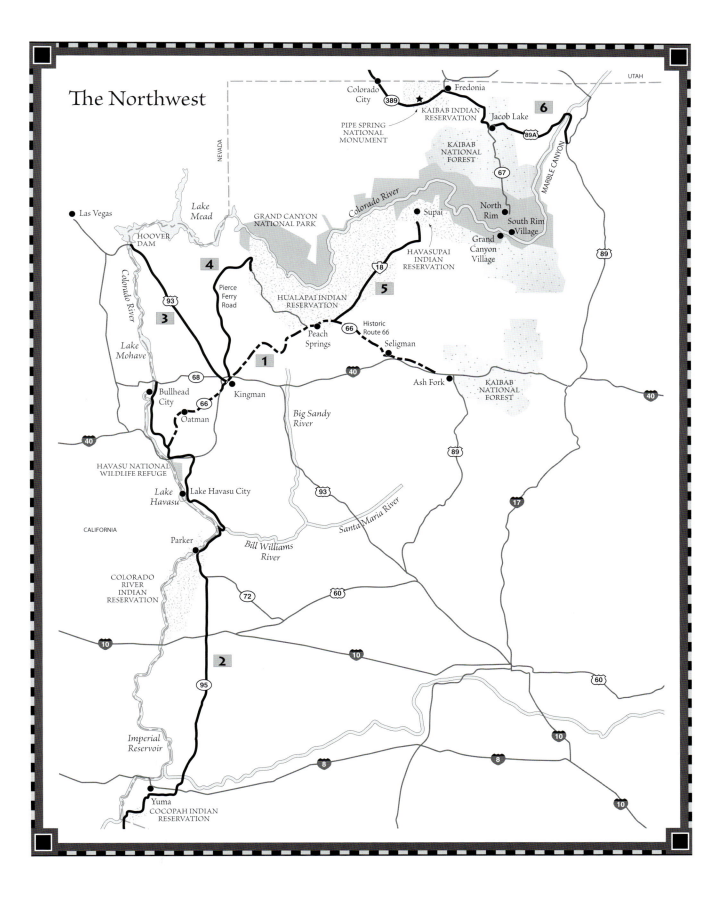

The Northwest

UTAH

Colorado City

Fredonia

NEVADA

389

KAIBAB INDIAN RESERVATION

PIPE SPRING NATIONAL MONUMENT

Jacob Lake

89A

6

Lake Mead

GRAND CANYON NATIONAL PARK

Colorado River

KAIBAB NATIONAL FOREST

67

MARBLE CANYON

Las Vegas

HOOVER DAM

Supai

North Rim

South Rim Village

Grand Canyon Village

89

Colorado River

4

Pierce Ferry Road

HAVASUPAI INDIAN RESERVATION

18

5

Lake Mohave

93

3

HUALAPAI INDIAN RESERVATION

66

Historic Route 66

Peach Springs

Seligman

68

40

1

Bullhead City

66

Oatman

Kingman

Big Sandy River

Ash Fork

KAIBAB NATIONAL FOREST

40

40

HAVASU NATIONAL WILDLIFE REFUGE

Lake Havasu

Lake Havasu City

89

Santa Maria River

17

CALIFORNIA

93

Parker

Bill Williams River

COLORADO RIVER INDIAN RESERVATION

72

60

10

10

60

2

95

Imperial Reservoir

10

8

8

Yuma

COCOPAH INDIAN RESERVATION

10

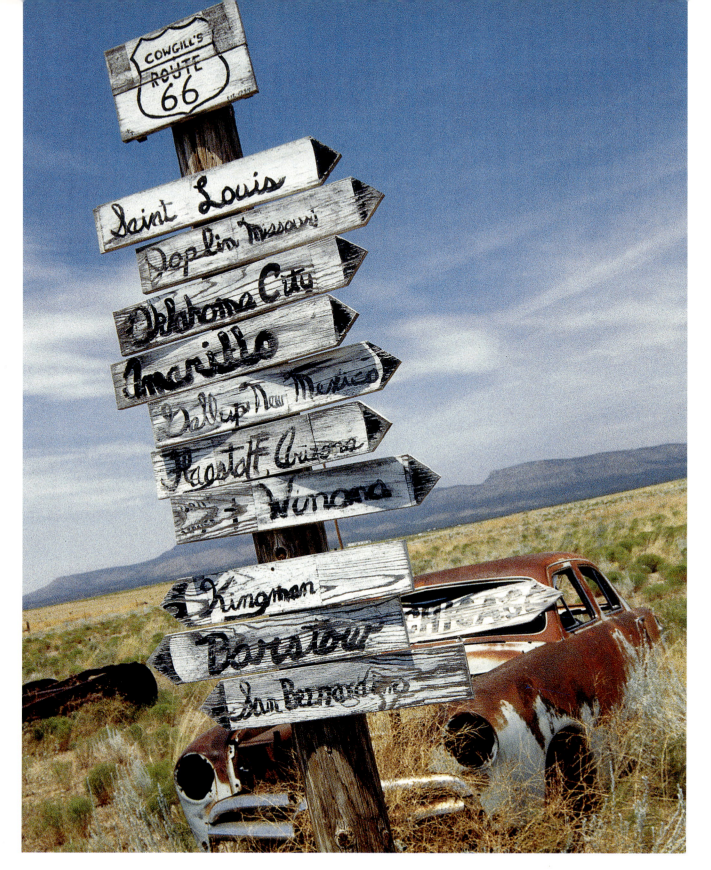

The remains of a vintage Ford and unofficial signpost near Hackberry hearken to the era when this route was known as "the Main Street of America."

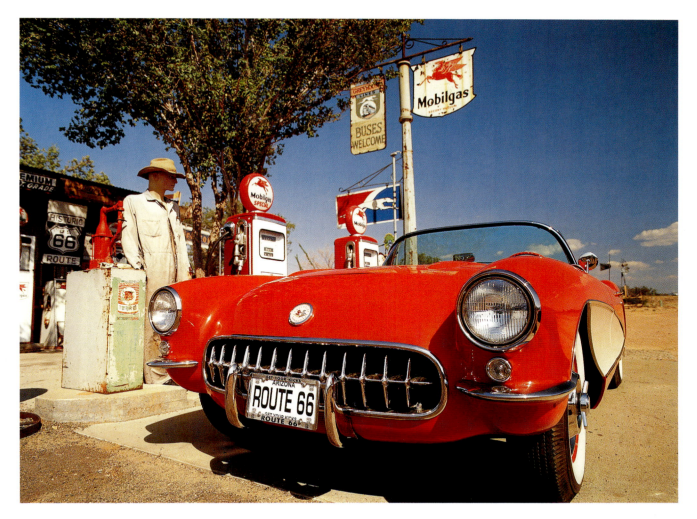

A vintage Corvette at the Hackberry General Store on Route 66 enhances the illusion that stopping here is a step back in time.

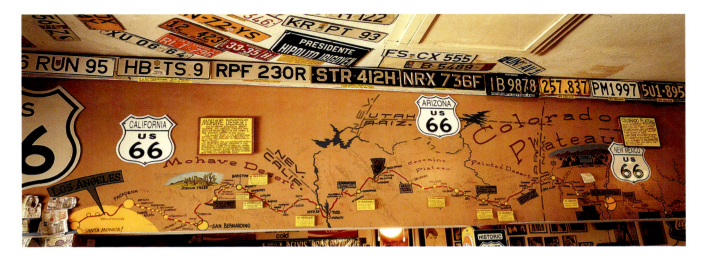

This map in the Hackberry General Store and Route 66 Museum is the work of the legendary Route 66 artist Bob Waldmire.

outcroppings of volcanic rock that hint of the area's violent past—seems comforting rather than disconcerting.

Within a few miles, a narrow draw funnels the road to the top of a series of rolling hills. A vintage concrete bridge and the colorful Burlington Northern Santa Fe train roaring underneath it add color and period atmosphere to a landscape that hasn't changed much since Spanish explorers first came to this territory more than three hundred years ago.

In the sleepy frontier town of Seligman, the legendary highway serves as Main Street, and numerous remnants from the glory days of the iconoclastic highway abound, including the zany, world-famous Snow Cap Drive-In. To discover the town's secret treasures, from when it was a rollicking railroad and ranching center, park the car and walk the shade-dappled streets.

West of Seligman is the wide Aubrey Valley, bordered by deeply shadowed mountains. Here, prairie dogs, antelopes, and ferrets still run free, as they did when the valley's namesake, Francois Xavier Aubrey, first passed through in the late 1850s. A colorful frontier character, Aubrey was legendary for his exploits, such as when he collected on a bet of $1,000 for making a ride from Santa Fe to Independence, Missouri, in less than eight days.

The valley soon gives way to gently rolling hills that shelter Grand Canyon Caverns, a roadside stop from the era when the station wagon was king and the Edsel and tail fins represented the latest offerings from Detroit. After a lengthy period of decline, the facility's resurrection to its former glory is well underway, and expansion projects include adding riding stables, an RV park, and bicycle trails along earlier alignments of Route 66 into the scenic cedar-studded hills.

The descent into Peach Springs is a moderate one, with vistas of the canyons to the north tinged purple with distance. There is little hint that at the bottom of the next hill are true gems for the Route 66 aficionado, as well as good eats.

Peach Springs serves as the headquarters for the Hualapai tribe. The town's vintage stone buildings, including its only gas station, provide numerous opportunities for the shutterbug. The gas station dates to 1927, making it the oldest continuously operated service station on Route 66. At the other end of the spectrum is the Hualapai Lodge, which offers modern lodging amenities and interesting dining fare, such as Hualapai tacos.

From Peach Springs, it's possible to reach the Colorado River via Diamond Creek Road, the only opportunity to drive to the bottom of the Grand Canyon. Permits are required and are available at the tribal tourism office or at Hualapai Lodge. Inquire as to current road conditions, as the road is gravel and is subject to wash outs.

Route 66 rolls west from Peach Springs with only Truxton, the proverbial "wide spot in the road," providing a brief break in scenery. This little community never amounted to more than a roadside service facility, but in 1983 when the highway bypassed it, it was almost erased

from the map. Today, a garage, a closed wrecking yard, a café, a bar, one motel, and numerous foundations and building shells are all that remain.

A short distance from Truxton, the highway abruptly descends through Truxton Canyon into a narrow valley squeezed on both sides by hulking buttes and mountains that appear to be composed of little more than boulder piles. Nestled among the rocks along the roadside are adobe ruins, abandoned schools, historic ranches sheltered in quiet oases, and deep-green threads of towering cottonwood trees that mark rare desert riparian areas.

As the valley widens, so do the vistas, and on the horizon the towering peaks of the Hualapai Mountains, snowcovered during much of the winter, loom larger with each passing mile. Additional remnants from when Route 66 was truly the "Main Street of America" also await you as you continue this drive.

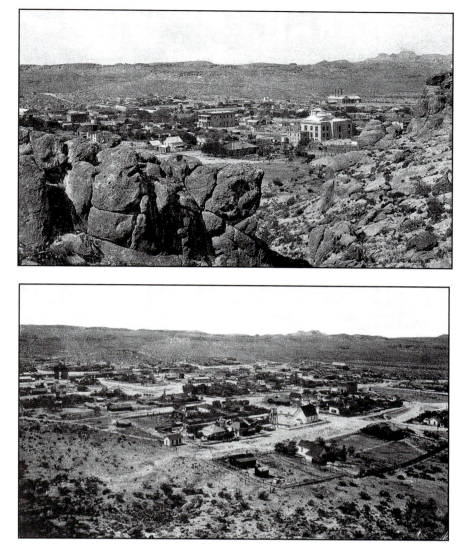

The circa-1908 postcard above shows Kingman when it was still a small frontier community. As evidenced by the 1918 card at the top, a decade brought dramatic change, including an imposing stone courthouse, a modern concrete jail, a state-of-the-art power plant, and tourists on the National Old Trails Highway. Author's collection

The old mining town of Hackberry, named for a hardy native tree, lies just to the south of the highway, across the railroad tracks. The once-thriving community is less than a shadow of its former self. Only a mission-style two-room schoolhouse, a miniscule post office, an old boarding house, a wind-blown hillside cemetery, and some scattered building shells remain. Nevertheless, there is a true diamond in the rough directly across the railroad tracks from town. The Hackberry General Store has been transformed into a living time capsule, where it takes little imagination to believe you have stepped back thirty, forty, or even fifty years in time. The vintage cars often found out front enhance the illusion. Many belong to the store's owners, but, as this route is quite popular with automotive enthusiasts from around the world, you can never be sure what you'll see parked in the dust out front.

The landscape makes another dramatic change within a few miles of the Hackberry General Store. The wide Hualapai Valley, hemmed on all sides by rugged, towering mountains and dotted with the shadows of passing clouds, has a truly stark beauty that is both disturbing and alluring. This

A sighting of Elvis on Route 66 would be unusual anywhere except Seligman.

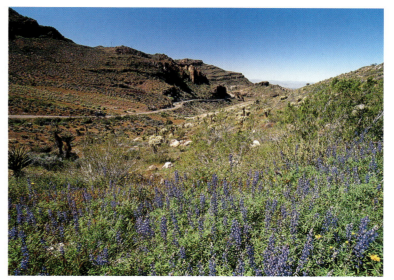

In the early months of spring, a multihued carpet of colorful wild flowers softens the harsh landscapes of Sitgreaves Pass.

In Oatman, feeding the wild burros that roam the streets is part of the adventure.

Beale Wagon Road, the railroad, and Route 66 have all used the Crozier Canyon—an ancient trade route linking the Pueblo tribes with those on the coast of California—as passage to the desert from the high plains of the Colorado Plateau. Author's collection

interlude with desert wilderness is a short one, though, and signs of modern civilization soon replace open space as you continue the drive.

An industrial park and airport in Kingman are quickly becoming the town's cornerstones. Sixty-five years ago, this area was still open range for vast cattle empires. But with the advent of World War II, much of this desert valley was transformed into one of the largest flexible gunnery schools in America: the Kingman Army Airfield. Decommissioned after the war, the base became Storage Depot 41, the final resting place for thousands of warbirds.

Remnants from this forgotten chapter of history are found throughout the industrial park, including the airport control tower (one of only two surviving from World War II in the United States), a few hangars, and numerous building foundations. The original machine shop is currently undergoing restoration; it houses a museum preserving the history of the base and the men who trained here.

The drive through Kingman is a trip down memory lane. Interestingly enough, from east to west the drive is almost chronological. It begins with the modern culture of the interstate-highway off-ramp, including motels, truck stops, and fast-food establishments. Within a few short miles, remains from the highway's glory days begin to crowd in on both sides: vintage motels with neon dimmed by the years, diners, and the now-legendary Dambar Steakhouse, with a larger-than-life steer mounted high on the highway-facing wall.

A steep descent through a deeply cut hillside of red volcanic cinder serves as a portal to frontier-era Arizona. The historic district of Kingman is a bit down on its heels, but an incomparable western skyline of buttes, hidden antique shops, and a fully restored turn-of-the-century hotel with a million-dollar view make a stop here worthwhile. When it comes time to quench your thirst, there is Mr. D'z Route 66 Diner, a re-created 1950s eatery where a local brand of root beer served in frosted, heavy glass mugs is a specialty.

From Kingman, the highway hugs one rock wall of a narrow canyon. Its predecessor, an earlier alignment of Route 66 that follows the National Old Trails Highway, and the railroad hug the other side of the canyon during the descent to the Sacramento Valley. This valley and the highway run a straight course toward the picturesque but foreboding Black Mountains. After a late spring rain, this portion of the drive is an aromatic one, with the smell of creosote and sage heavy in the air.

The drive through the Black Mountains is not for the faint of heart. Before the bypass of this portion of the highway was built in 1953, the narrow

An Oasis from the Desert

In Kingman, the summer traveler who wishes for a respite from desert heat, or the winter traveler who longs for snow, only has to make a detour south of Route 66. Here, a dozen miles is all that separates the desert from forested mountains and cool, pine-scented breezes.

The Hualapai Mountain Park is a veritable oasis. In addition to wonderful views, there are miles of hiking trails, pleasant picnic areas, rustic cabins, and a lodge with fine dining.

The drive is an easy one that begins at the junction of Hualapai Mountain Road and Andy Devine Avenue, Route 66, in Kingman. This junction is not easily missed, as the legendary Dambar Steakhouse dominates the southeast corner. The road is paved, but it is narrow and steep; in the winter, it can be icy in spots. Just the same, few drives exemplify the diversity of Arizona across such a short distance, and even fewer provide such wonderful views.

road, precipitous drops, and hairpin curves inspired an enterprising garage owner in Goldroad to supplement his income by towing vehicles over the summit for those drivers gripped by fear. Arguably, this is the most scenic portion of the legendary highway. Every twist and turn presents views that are ever more dramatic, and the vista from the summit of Sitgreaves Pass is nothing short of extraordinary.

The descent into the ghost town of Goldroad culminates with the sharpest curve anywhere on Route 66. When this was an active highway, buses making the ascent often let off passengers at the bottom of the hill, then backed up into a cut where passengers reboarded, as the curve was too sharp for a bus to make.

The old town of Goldroad is now nothing but mine tailings, ruins, and one operating gold mine. A short tour of an original mine tunnel provides a unique opportunity to experience history and to acquire a one-of-a-kind souvenir—your photograph with a sign that says you got your kicks *under* Route 66, as the tunnel passes under the highway.

A few more curves and the looming rock formation known as the Elephant's Tooth, with the quasi-mining camp of Oatman nestled below, beckons a traveler to stop. Tourism has replaced mining, and as a result, staged gunfights, as well as wild burros, have free reign on the narrow main street that is Route 66.

Few of Oatman's buildings date to the first decades of the twentieth century, when this was a boomtown, but among those that have survived is the Oatman Hotel. Built in 1902, it is the largest adobe structure in Mohave County. Legend has it that this is where Clark Gable and Carol Lombard stopped for the evening, after marrying in Kingman in 1939.

Leaving Oatman, the road begins a gentle descent through dramatic desert landscapes of sun-scorched rock, where tantalizing peeks of the Colorado River valley are offered with the cresting of each rise. Then, with almost startling abruptness, the mirage becomes reality, as the road enters the shadows of towering salt cedars and runs parallel to the river and along the Topock Marshes.

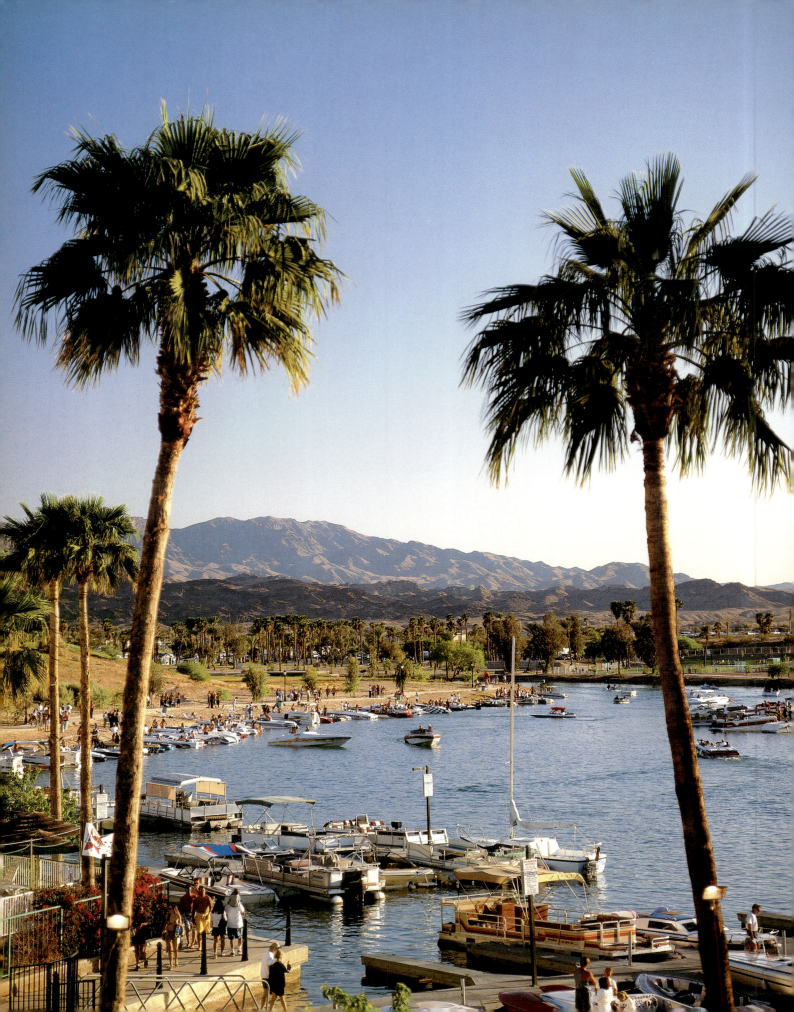

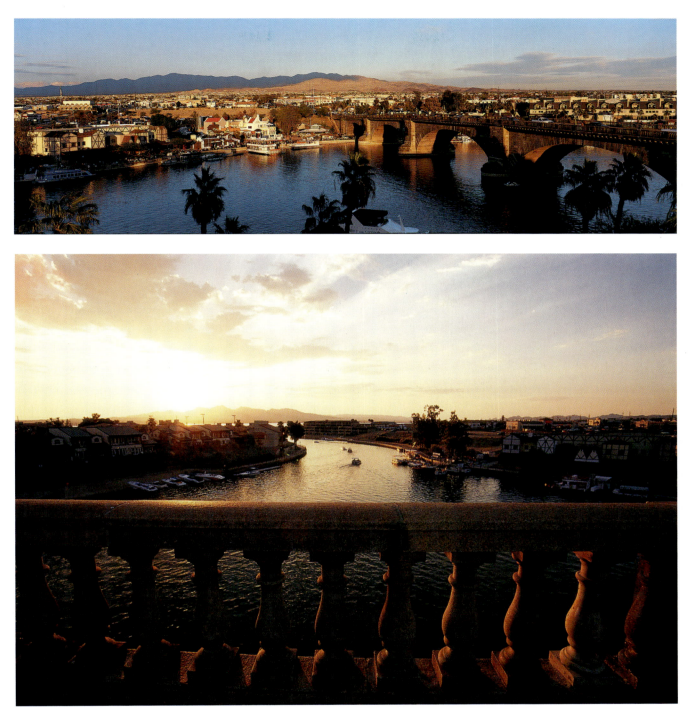

FACING PAGE AND TOP:
Lake Havasu City is an oasis in the desert that attracts thousands of visitors annually.

BOTTOM:
Enjoying a beautiful Arizona sunset from the historic London Bridge is just one of the unexpected pleasures found in Lake Havasu City.

THE ARIZONA COAST
HIGHWAY 95 THROUGH YUMA COUNTY

ROUTE 2

From the parking lot of the Colorado River Museum at Davis Camp north of Bullhead City, turn south on Arizona Highway 68. A few hundred yards south of the museum is Laughlin Bridge, where Highway 68 becomes Arizona Highway 95. Follow Highway 95 South toward Bullhead City along the Colorado River to Interstate 40. Turn east on the interstate and follow it to exit 9, taking Highway 95 South 21 miles to Lake Havasu City and an additional 156 miles to Yuma.

The west "coast" of Arizona is an anomaly, an oasis surrounded by stone and sand. A drive through this area is an adventure few expect to find in the midst of the desert. Surrounded by some of the harshest landscapes on earth are beautiful marshes, serene lakes, and miles of farms. For those unfamiliar with the state, the abundance of water, lakes, and marshes along this drive may come as quite a surprise. The drive is a fascinating blend of scenery, historic sites, quaint farming communities, and modern boomtowns. Each of these unique communities is set against a backdrop of astounding natural beauty.

This route can be easily driven in one day, but two days are preferable because there are numerous attractions along the way. The best times of the year for this drive are fall, spring, or winter, as summer temperatures along the Colorado River often exceed 120 degrees.

Yuma County, at the southern end of this drive, has become the nation's salad bar. Between November and March, more than 90 percent of the winter vegetables sold in the United States come from farms in this county.

It should come as no surprise to learn this river valley has a long and colorful history. Long before the arrival of the conquistadors, farmers were exploiting the rich soils of the river bottom and were providing respite from the desert to traders crossing Pacific coast routes to visit the Pueblo tribes in what is today New Mexico.

Before the arrival of the railroad, the Colorado River was the thoroughfare for the commerce of the Arizona Territory. All manner of goods flowed to remote settlements, and untold fortunes poured from countless mines. In the modern era, the river was channeled for irrigation, harnessed for power, and transformed into a string of gemlike lakes that have become the center of a multimillion-dollar recreation business. As a result, the entire Southwest was transformed.

The ideal place to begin this route is at the Colorado River Museum on Arizona Highway 68, just north of the Laughlin Bridge and the junction of Arizona Highway 95. Through well-conceived exhibits, this wonderful little museum provides insight to the area's rich history, many traces of which have been lost due to the construction of Davis Dam and the creation of Lake Mohave, as well as urban sprawl.

The initial miles of this drive on Highway 95 are through a cornucopia representing forty years of urban development. Surprisingly, there is still an element of natural and scenic beauty found here. The rugged Black Mountains press in on Bullhead City from the east, and on the west, the Colorado River mirrors the glittering neon and towering casinos of Laughlin on the Nevada side of the river.

The asphalt, glitter, adult-entertainment emporiums, strip malls, and fast-food palaces soon give way to a blend of desert scenery and alfalfa farms as the road enters the Fort Mohave Indian Reservation. In the frontier period, roughly 1865 to 1880, Fort Mohave and nearby Hardyville were key to the development of the mining, ranching, and river-traffic industries that served as the foundation for settlement of the northwest portion of the state.

For a brief moment, Highway 95 then enters an oasis shaded by towering salt cedar. This is but an introduction to something even scarcer—some of the last remaining Colorado River marshes at Havasu National Wildlife Refuge.

The heart of this treasure is a thirteen-mile section known as the Topock Gorge, home to wildlife that includes desert bighorn sheep, bald eagles, and peregrine falcons. Petroglyphs on the canyon walls attest to a human history spanning more than a thousand years.

A brief jog east on I-40 clearly shows what a rarity the Colorado River valley is in this desert land. Then, head south again on Highway 95 to see a harsh landscape of sunbaked stone sprinkled with a surprising variety of desert flora. As the highway begins its steep descent to the river valley, you can see teasing glimpses of Lake Havasu in the distance.

Lake Havasu City is in large part a recent phenomenon, with a history as a community that spans little more than forty years. The town's primary attraction is a bridge that predates the town by several centuries. Purchased in 1968, the London Bridge was dismantled, each piece was carefully numbered, and it was shipped to Arizona, where it was reassembled. An entire English village in miniature was then created around it. The London Bridge complex is the second-most-popular attraction in Arizona, after the Grand Canyon.

The island created by the digging of a channel under the reassembled bridge also has an interesting history. During World War II, this was Site 6, an auxiliary emergency landing field for the Kingman Army Airfield, as well as a recreation getaway for men stationed there.

Shortly after leaving Lake Havasu City, the highway passes several riverside state parks and then skirts Bill Williams National Wildlife Refuge, a wild marsh where the Bill Williams River meets the Colorado River. Even among history buffs, the importance of the confluence of these desert waterways is an unknown chapter in Arizona history.

In 1604, Juan de Onate arrived here at the Colorado River on his way from New Mexico to Yuma Crossing. Some of the first Americans on the Colorado River camped here in the 1820s to trap beaver. In 1854, the initial survey for a possible railroad route across the northern Arizona Territory followed the Big Sandy River to the Bill Williams River and on to the Colorado. Aubrey Landing, located here, marked the northern extent of steamboat traffic on the river until 1865.

The next point of interest is Parker Dam, which is the deepest in the world; more than two-thirds of the dam is located below the riverbed. The

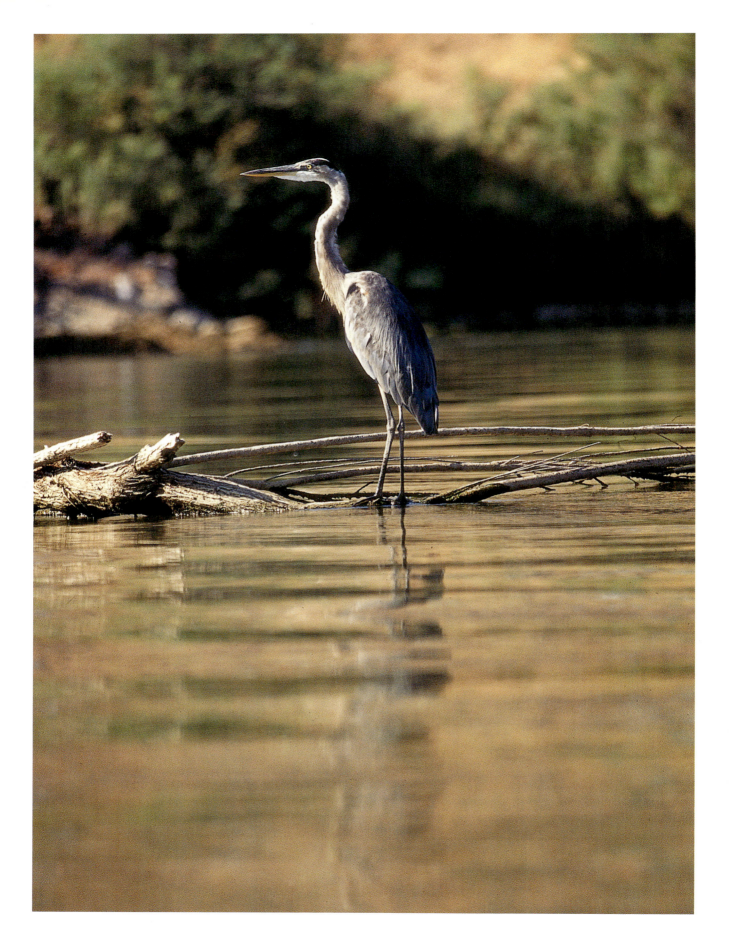

FACING PAGE:

The Bill Williams River National Wildlife Reserve is a haven for a large variety of water birds, such as this great blue heron.

RIGHT:

This monument near Quartzsite marks the final resting place for Hadji Ali, or "Hi Jolly," the camel driver who played an important role in the 1857 experiment to use camels for military transport in the desert Southwest.

BELOW:

The best way to enjoy the solitude of the rare desert oasis at the confluence of the Bill Williams and Colorado rivers is by kayak.

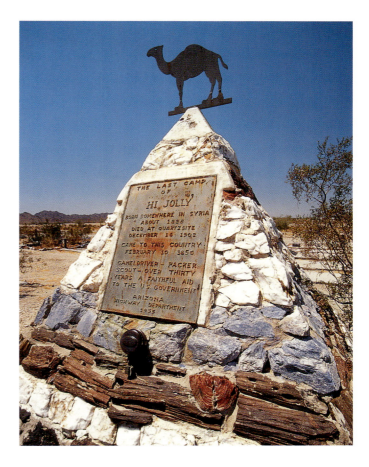

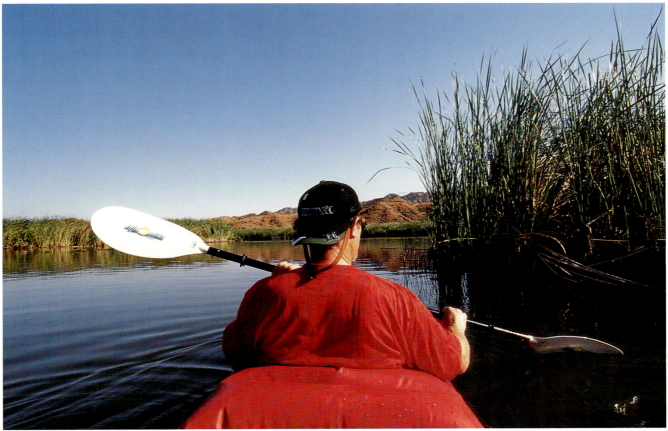

entire ten-mile Parker Strip and the community of Parker have become quite an attraction as a premier water playground, and the Emerald Canyon Golf Course received rave reviews from *Golf Digest*, which noted the course featured a "fantastic, unusual layout with stunning surroundings." Then there are the historical aspects of the area, preserved at the Parker Historical Society Museum. The museum has an extensive display of native crafts and mining artifacts, plus extensive photo documentation of Parker Dam's construction and of the World War II Japanese internment camp that was located at nearby Poston.

The Colorado River Indian Reservation is home to members of the Mohave and Chemehuevi tribes, but members of the Hopi and Navajo tribes reside here as well. In 1874, the Hualapai tribe was kept here after a forced march from Fort Beale at Kingman. The Colorado River Indian Tribes Museum and Library is open to the public and features the world's largest collection of Chemehuevi baskets, rare Mohave pottery, and many artifacts that document the rich Native American history of this area.

A narrow belt of farmland and the Colorado River, surrounded by some of the most stark desert landscape to be found in the Southwest, dominate the next few miles of the drive on Mohave Road, with only the small farming community of Poston offering diversion. As this area was pivotal in the development of frontier Arizona, there are numerous historic sites of interest to be found here.

One such site is Ehrenberg, now known for its truck stops more than its history. In the past, the community served as a port for the riverboats that plied the river. It was a boomtown, attracting legends of the old West, both good and bad, such as Wyatt Earp. This is also where the Goldwater family dynasty began, when the brothers Mike and Joe opened a store here in the early 1860s.

The route then skirts back into the desert and on to the one-of-a-kind community of Quartzsite. Most weekends during January and February, the Quartzsite population of just over three thousand swells to tens of thousands, as people swarm to this town for a world-famous combination gem/mineral show/swap meet of unimaginable proportions. If this isn't enough to ensure the community will be viewed as unique and memorable, the town also houses a monument to Hadji Ali, or "Hi Jolly," an Arab camel driver who was at the center of the forgotten experiment to use camels for military transport in the desert during the mid-nineteenth century.

The drive from Quartzsite to Yuma is through quintessential desert landscapes of sand dunes, sunbaked plains of rock, and endless vistas. To the west, Dome Rock and the Chocolate Mountains, located on the Yuma Proving Grounds military reservation, border this portion of the highway. To the east is the 660,000-acre Kofa National Wildlife Refuge, site of Palm Canyon, where the only native date palms in the state are found.

The jagged Castle Dome Mountains form a large part of the southern end of this refuge. A ten-mile detour on Castle Dome Road provides access to a unique open-air museum, profiling rich geologic treasures and showcasing historic remnants that date to the formation of this mining district in 1858.

In recent years, Yuma has become rather cosmopolitan, and it is today widely recognized as a retirement community and golfing destination, with thirteen courses in the immediate area. This is but the latest incarnation for this charming little city of some 120,000 people, located at the junction of the Gila and Colorado rivers. Yuma has a rich history that spans centuries.

In 1540, when Spanish conquistador Hernando de Alarcon crested the hill overlooking the narrow Colorado River crossing, he noted a verdant valley and hundreds of cooking fires, as the area was the breadbasket for many tribes in the area. For the Quechan, Cocopahs, and Mohave, this location was a primary crossing for their trade routes.

Two excellent state historic parks, Yuma Territorial Prison and Yuma Crossing, preserve more recent history. The centerpiece of the former is a daunting, formidable edifice on a bluff overlooking the Colorado River. It housed some of the most dangerous and notorious outlaws in the Arizona Territory between 1876 and 1909.

Yuma Crossing captures an almost forgotten chapter in Southwestern frontier history. Fort Yuma was established near the crossing in 1849 as a protected supply depot for steamboats that brought supplies from California, via the lower Colorado River, for other military outposts in the territory. The fort was crucial in the initial American exploration of the Arizona Territory.

Because the fort was located along the only viable southern route to California, more than sixty thousand travelers passed by it between 1849 and 1850. Yuma Crossing State Historic Park preserves this history, including

THE COLORADO RIVER RESERVATION

The Colorado River Indian Reservation is rather unusual in that it is not home to a single tribe, but four tribes. Originally established in 1865 for the Mojave Indians, in the traditional homeland of the Chemehuevi who lived farther north along the river, the reservation also became home to the Navajo and to the Hopi in 1945.

By the late 1930s, the population of the reservation had declined to a point where there were no longer enough men to work the farms. The tribal council devised a unique way to resolve the problem—it offered land to Navajo and Hopi farmers who would renounce affiliation with their tribe.

In 1945, the four tribes officially came together as the Colorado River Nation. Interestingly enough, the Chemehuevi tribe was later given a separate reservation on the California side of Lake Mohave. However, many families had homes and roots on the Colorado River Indian Reservation and chose to stay rather than relocate.

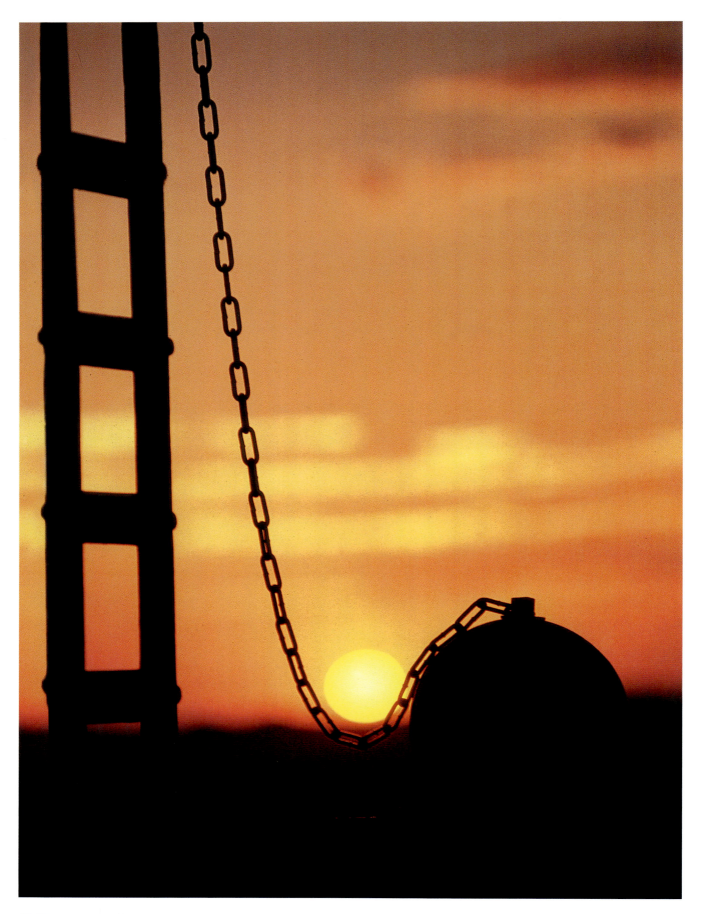

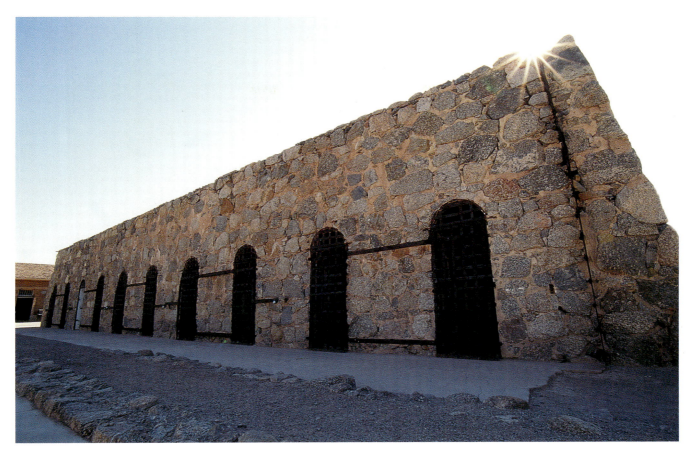

FACING PAGE:
An Arizona sunrise softens the harshness of a ball and chain at Yuma Territorial Prison State Park.

ABOVE:
From 1876 to 1909, the Yuma Territorial Prison housed many of the most dangerous criminals in the Arizona Territory.

RIGHT:
The prisoners serving time at the Yuma Territorial Prison enjoyed few amenities and long months of blistering heat.

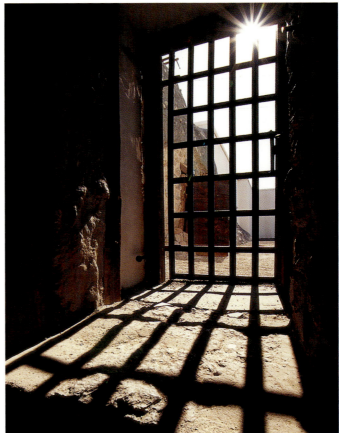

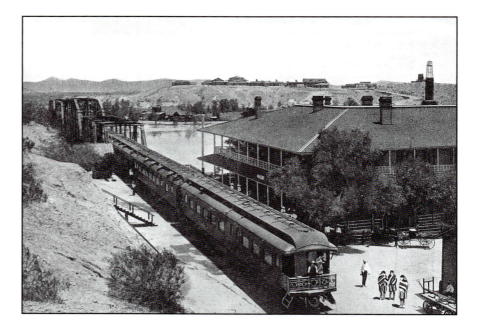

With the arrival of the railroad, Yuma began promoting itself as a cosmopolitan community with a climate that is pleasant for most of the year, "save for a short period in midsummer," according to this postcard. Author's collection

the original 1865 quartermaster depot, numerous historic buildings, and an interesting display of transportation from this period, all in a beautiful parklike setting.

In the city of Yuma proper, the historic north-end district features numerous architectural gems. Among these are historic homes and the recently renovated Yuma Theater, built in 1911. From Yuma, Highway 95 continues south for another twenty-three miles to the Mexican border.

THE "GRAND" COLORADO RIVER

The river that is the Arizona's western border wasn't called the Colorado until a relatively recent act of Congress in July 1921. For most of the century before that date, much of the river was known as the Grand River and was officially described as "formed by the Green and Grand rivers in southeastern Utah in northwest part of San Juan County" in the Colorado River Compact of 1922.

The first European explorer to reach its shores, Melchoir Diaz, designated it *Rio del Tizon* in 1540, but shortly after it was noted on Spanish maps as *Rio de Buenaguia*, "River of Good Guidance." In 1776, the intrepid and tireless explorer and missionary Father Francisco Garces called it *Rio de los Martyrs*, "River of Martyrs," an eerily prophetic name. Garces and three others were later murdered by Yuma Indians near where the Gila and Colorado rivers come together.

Before the damming of the Colorado River, flooding often turned it into a torrent of rich red mud. As the word *Colorado* is from the Spanish word for *red*, an explorer who came to the river during flood stage more than likely first applied this name.

Early American pioneers also used the term *red* to describe the river. Various accounts refer to it as the "Red River of the West" or as the "Red River of California." Even in the dry season, the silts filled the river. Many pioneers commented it was too thick to drink but too thin to plow.

WOODEN PASSAGEWAYS

Heading west from Yuma, early motorists faced the same challenges their pioneering predecessors did: harsh desert, the Colorado River, and deep sand hills. This country looked so much like the Sahara Desert that Hollywood's silent filmmakers often came here to film swashbuckling romance epics such as *Beau Geste* and *Garden of Allah*.

By late 1912, the route for the proposed Ocean-to-Ocean Highway was finalized, with the exception of the portion between Yuma and El Centro in California. The Colorado River and the sand hills were two daunting obstacles. Enter Colonel Ed Fletcher, a San Diego businessman.

Tackling the sand hills was job one. Fletcher devised a novel solution of using planks to build a "floating" road across fifty of the worst miles in the sands hills. The most amazing aspect of this highway is that from the time construction began in January 1915 until the road's replacement by Arizona Highway 80 in 1926, the planks worked.

The crossing of the Colorado River was approached with similar outside-of-the-box thinking. The wooden Yuma Wagon and Automobile Bridge, built on a Bureau of Reclamation barge, was floated into position and secured at each end to shore supports. The road was completed in 1915, just in time for use by travelers heading to the exposition in San Diego.

One of the more fascinating and overlooked chapters from the history of the automobile was the building of a highway of planks across the shifting sands west of Yuma. Author Earl Stanley Gardner said that the road was so rough at speeds of twelve miles per hour that a driver would see double during the ride. Author's collection

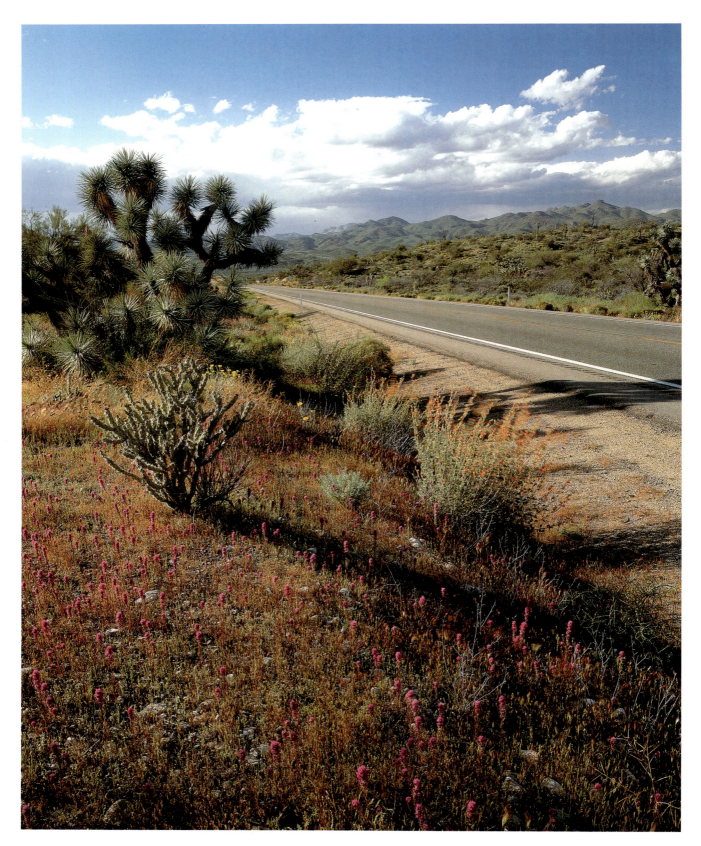

A twisted, spike-topped Joshua Tree dominates the rugged landscape that borders the Joshua Tree Parkway.

ABOVE:
From Windy Point at the crest of the Cerbat Mountains, the view is truly breathtaking.

RIGHT:
Aspen Peak Trail in the Hualapai Mountains is a wonderful way to experience the rare gem of this forested island surrounded by a sea of desert.

Search for Time Capsules
Highway 93 from Kingman to the Hoover Dam

ROUTE 3

From the parking lot of the Mohave Museum of History and Arts on West Beale Street in Kingman, take U.S. Highway 93 (Beale Street) north, which is also the business route for Interstate 40. Directions to and permits for historic Fort Beale, which lies just to the north of the highway at the edge of the city limits, are available at the Mohave Museum of History and Arts. After visiting the fort, continue north on U.S. 93 to County Road 125. The junction is well posted and the drive to Chloride is just 4 miles farther. After returning to U.S. 93, turn right (north) and drive about 3 miles to Big Wash Road. The 11-mile drive to Windy Point campground is scenic, narrow, steep, and graded. On returning to U.S. 93, continue north approximately 30 miles to Temple Bar Road for the next detour. From Temple Bar Road to Hoover Dam is approximately 19 miles.

Highway 93 between Kingman and the Hoover Dam is an interesting blend of a modern four-lane road and roadside time capsules from the era when Packard was king of the road. Short detours here and there enhance this drive with surprises, such as ghost towns, lakeside resorts, and awe-inspiring vistas. The highway is well marked, and notice of historic markers is ample.

An excellent place to begin this drive is at Kingman's Mohave Museum of History and Arts on Beale Street, which serves as part of the I-40/Highway 93 business loop. In addition to providing insight about the area's unique history, the museum is within walking distance of the Powerhouse, a massive turn-of-the-century concrete structure that now serves as a visitor center. The Powerhouse has an award-winning Route 66 museum. Also nearby is Locomotive Park, which showcases a vintage Baldwin mountain steam locomotive.

The hustle and bustle of fast-food restaurants, truck stops, and service facilities comes to an abrupt end at the foot of Coyote Pass, where the highway begins a rather steep ascent into the Cerbat range, following the path of the Beale Wagon Road from Beale Springs, once site of a remote military outpost and center for the first Hualapai Indian Reservation. Overshadowed by routes such as the Oregon and the Santa Fe trails, Beale Wagon Road, from its completion in 1859 to the coming of the railroad some twenty years later, served as a vital link between the East and the state of California. The railroad and Route 66 followed a great deal of the road's path across northern Arizona.

At the summit of Coyote Pass, the vista is stunning, and even the urban sprawl below is not enough to detract from the beauty of Golden Valley and its backdrop, the Black Mountains. The descent is rapid, and soon the highway is skirting the valley and hugging the scenic foothills of the Cerbat Mountains.

Historic markers abound along this section of the highway, as these mountains were once home to some of the richest mining strikes in the country. As a result, numerous mining camps sprang to life, became boomtowns, and then returned to the dust. A four-mile detour north on County Road 125 from Grasshopper Junction provides access to a lone surviving mining camp.

Dating to the mid-1860s, the sleepy village of Chloride is nestled against the steep slopes of the Cerbat Mountains. The post office is the oldest continuously operated one in the state, and Shep's, an eatery that dates to the mid-1930s, still serves old-fashioned food with a Southwestern touch. The town's railroad depot hints to a time when this community was more than just a wide spot on a bypassed highway. The best way to enjoy all that this dusty little time capsule has to offer is to park and walk its quiet streets.

An unexpected sight for those driving between Kingman and Hoover Dam during the early 1960s was Santa Claus, Arizona, with its adjoining Santa's Village. Today the complex is abandoned and is well on the way to becoming another lost icon of the American highway.
Author's collection

Less than five miles after rejoining the highway is a second opportunity for a short detour: Big Wash Road. This detour is eleven miles each way, and only vehicles with high ground clearance should tackle the drive, as unpaved Big Wash Road is steep (with grades near 20 percent in some places) and rocky, depending on the last time it was graded or the last time it rained.

Big Wash Road provides access to the rugged Mount Tipton Wilderness Area and it runs along the ridge crest, allowing for breathtaking views of the Hualapai Valley. The true reward is the view of Chloride, which lies far below, and of the Sacramento Valley, which can be seen from the promontory of the Windy Point campground.

A few miles from the Big Wash Road exit, there is another opportunity for a short side trip. The draws here are views of a desert world reflected in the deep-blue waters of one of the largest manmade lakes in the world. The pleasant drive to Temple Bar Marina is on a paved road that follows the contours of the land as it descends to the lake. As you draw closer to the marina, the views become more panoramic.

Temple Bar Marina features camping, boat rentals, boat launches, a café, a mini-mart, a small motel, and an RV park. A visit to Temple Bar on a busy summer afternoon will drive home the fact that Arizona rates in the top five states for per-capita boat ownership.

At the north end of the Detrital Valley, Highway 93 crosses through stereotypical desert. It is an almost sterile landscape, but looming on the horizon is the northern end of the Black Mountains, which seem to be in a state of constant color transformation because of shadowy deep canyons and rock formations. Leaving the wide Detrital Valley, the highway begins to flow through a series of deep cuts in the stone that alternate with awe-inspiring views of a surreal landscape of colorful formations and canyons sweeping toward the Colorado River far below.

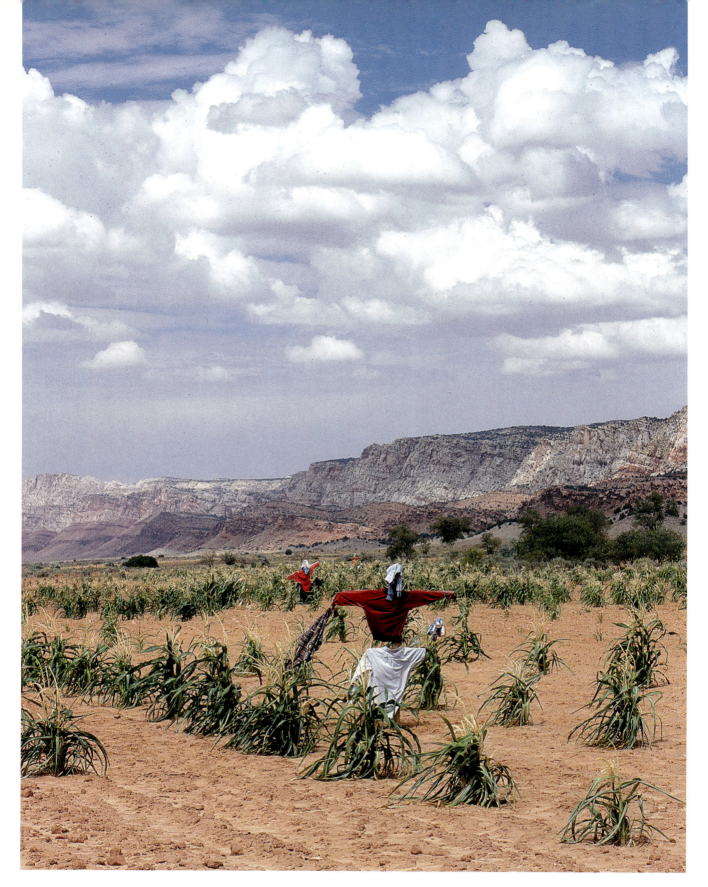

A Navajo scarecrow stands guard as the thunderheads build in the distance.

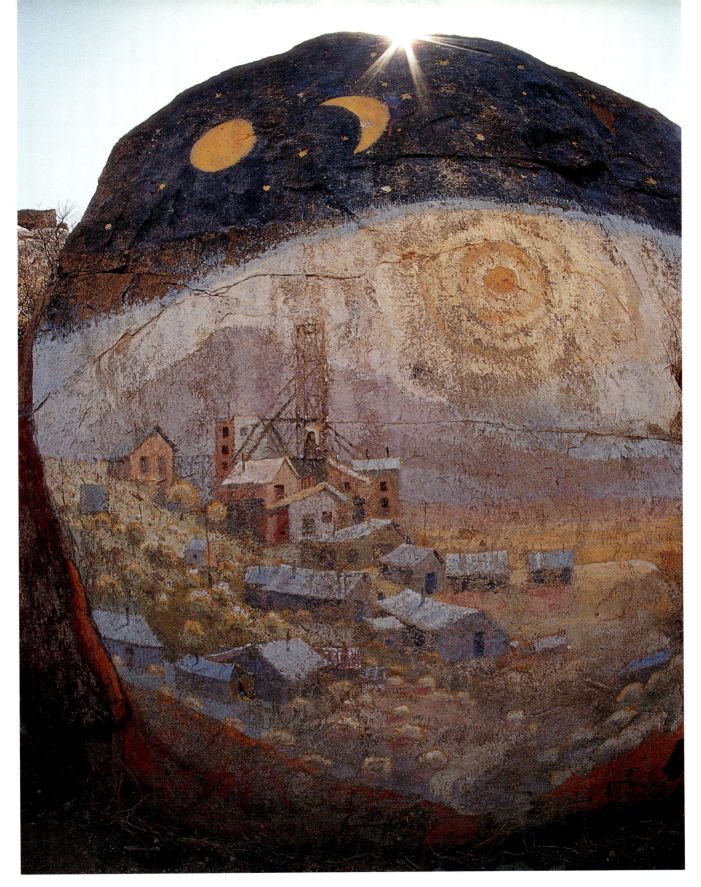

In Chloride, the cliff murals of artist Roy Purcell attract visitors from throughout the world.

Kingman has long been a place people stop for supplies. However, few people are aware of how many celebrities from the past century had ties with this desert community.

Charles Lindbergh laid out the first real airport here as a stop for the airline company he was building at the time. When he stayed in Kingman, the Hotel Beale was his residence. The hotel was also for guests, including Amelia Earhart, who came for the airport's inauguration on July 8, 1928.

For the movie or television fan, Kingman is a treasure trove of trivia. Andy Devine, with his unmistakable gravely voice, was a staple of Hollywood films for decades. Though born in Flagstaff, he moved to Kingman at an early age, when his father became proprietor of the Hotel Beale. He always considered Kingman his hometown, and in the mid-1950s, the main drag through town, Route 66, was renamed Andy Devine Avenue.

Clark Gable and Carol Lombard were married at the old Methodist church in town. Clayton Moore,

The room Clark Gable and Carol Lombard reportedly stayed in at the Oatman Hotel during their honeymoon after being married in Kingman.

the Lone Ranger, received his military training during World War II at the Kingman Army Airfield, at the time one of the largest flexible gunnery schools in the United States.

The modern U.S. Highway 93 parallels the old Transcontinental Highway along much of the route between Temple Bar Junction and Hoover Dam. As a result, the dramatic scenery along this drive often serves as an incredible frame for equally picturesque vintage bridges. Author's collection

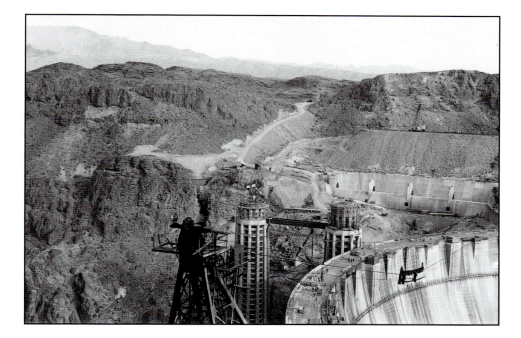

The crown jewel of this drive is Hoover Dam in Black Canyon, a beautiful display of God's finest handiwork and a towering testimony to man's creative genius. In any other setting, this engineering marvel would be breathtaking, but when joined with the deep colors of a cathedral of stone, the raw beauty of the gorge below, and the deep-blue waters of Lake Mead, it becomes almost indescribable in its beauty.

DRY LAKES, JOSHUA TREES, AND THE GRAND CANYON
KINGMAN TO GRAND CANYON WEST

This drive is unique in many ways. Most notably, it provides a rare opportunity to experience the grandeur of the Grand Canyon without strenuous hikes or having to endure miles of rugged roads accessible only by four-wheel-drive vehicles.

Begin in Kingman at the intersection of Route 66 (named Andy Devine Avenue in honor of the town's favorite son) and Stockton Hill Road. Follow Stockton Hill Road north. As this community is on the fast track to becoming a small city, the first few miles are through modern urban sprawl peppered with remnants of a time not so long ago when this area was the hinterlands. Nevertheless, even along this portion of the drive there is an abundance of natural beauty, as the Cerbat Mountains form a hedge of picturesque buttes, mesas, and steep slopes along the west side of Stockton Hill Road. The mountains provide more than a scenic backstop for the quaint cemetery nestled against the road's flanks or for the high ground that holds exclusive homes with a view. In times past, the canyons that cut through these mountains funneled traffic on the Beale Wagon Road up a narrow pass to Beale Springs and

ROUTE 4

Begin in Kingman at the intersection of Route 66 (Andy Devine Avenue) and Stockton Hill Road. Follow Stockton Hill Road north to the junction of Pierce Ferry Road. Continue north on Pierce Ferry Road toward Meadview. Just south of Meadview, turn right onto Diamond Bar Road and follow the signs to Grand Canyon West.

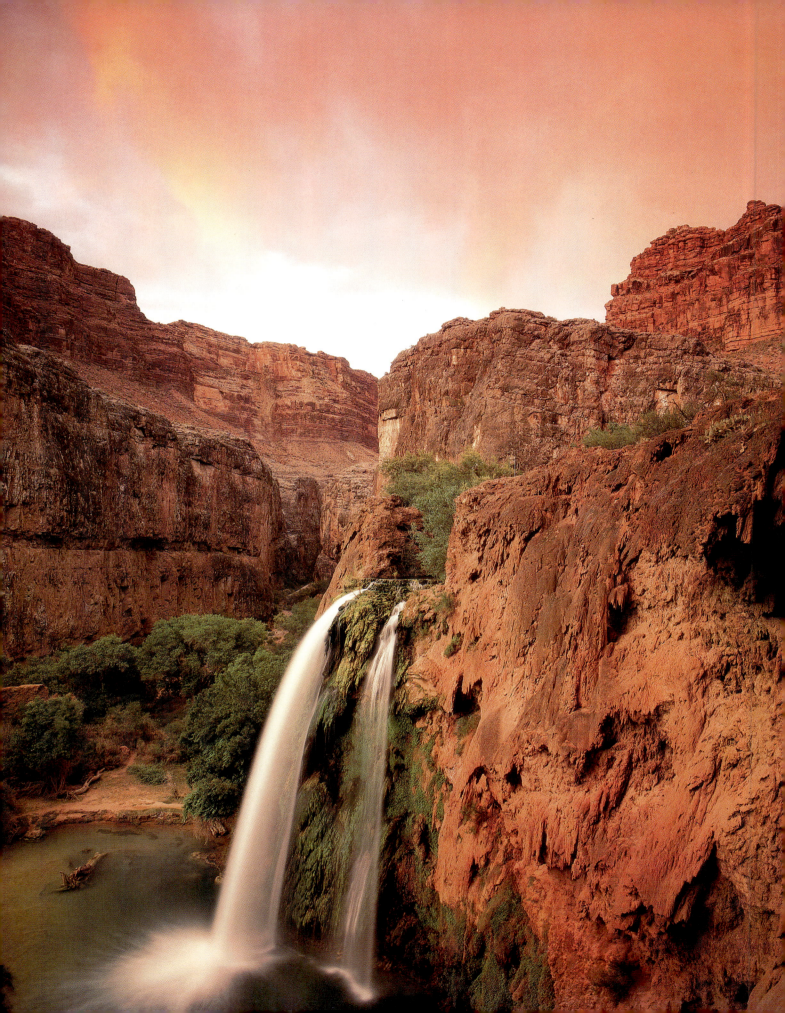

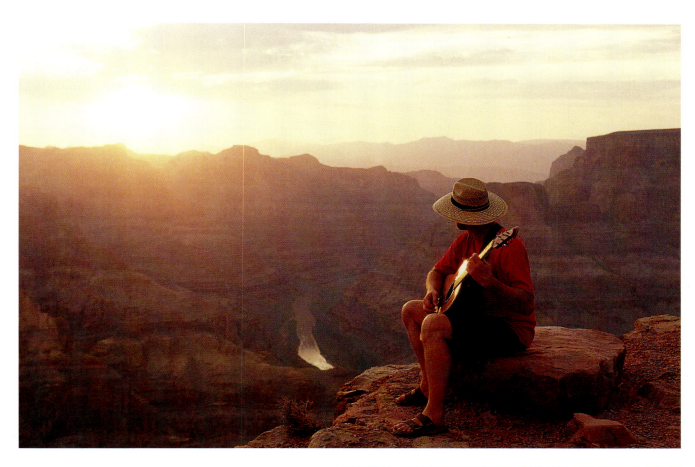

FACING PAGE:
Sunset at Havasu Falls near Supai enhances the illusion that this is the Garden of Eden.

ABOVE:
The grandeur of Guano Point at the west end of the Grand Canyon serves as a backdrop for a lone guitar player.

RIGHT:
Kayaking in Emerald Cave in the Black Canyon of the Colorado River is an experience not easily forgotten.

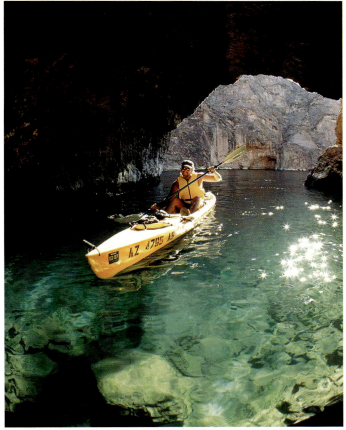

channeled loaded ore wagons from the mines near Stockton Hill to the railhead in Kingman.

Shortly after signage indicates the end of Kingman city limits, Stockton Hill Road passes through a picturesque little valley of cedar trees that is becoming an exclusive housing development with delightful views of the Hualapai Valley. Long before there was a Kingman, a small mining camp named Stockton Hill (the namesake for this road) was located here. With the exception of faint mine tailings and a few roads carved precariously along the mountainsides, little now remains of this mining camp.

Stockton Hill Road crests at a small rise at the north end of this valley and then hugs the foothills of the Cerbat Mountains, providing sweeping views of the Hualapai Valley, broken only by Long Mountain. In the distance are the escarpments of the Music Mountains and the Grand Wash Cliffs. During spring months, especially after a week or so of rain, the valley floor becomes as garish as a casino carpet, with a sea of mariposa lilies, California poppies, and Indian paintbrushes flowing to the mountains in the distance.

With a gentle series of grades and curves, the road then descends to run along the western edge of Red Lake, a lakebed that is cracked and dry for large portions of the year. Quite often, heat waves rising from the lakebed present the illusion there is water here, but only in the wettest of winters or springs is that actually the case.

After passing the dry lake and before ending at the junction of County Road 25 where you will turn right, the road enters a strange forest worthy of illustrating a Dr. Seuss book. The last few miles of Stockton Hill are graded gravel, but the county plans to have it paved by the end of 2006. Joshua trees are spike-topped members of the lily family that can reach heights of more than thirty feet, and this is the world's largest concentration of these unique plants. The looming Grand Wash Cliffs serve as a background for this almost-surreal setting. This strange landscape becomes even more noticeable after you turn onto Diamond Bar Road (Indian Road 7), just south of Meadview.

The cliffs that tower above the road like the ruins of an ancient castle, the overwhelming harshness of the land, and the historic Diamond Bar Ranch (now a western-themed resort) blend into a wonderful tapestry that makes it difficult to concentrate on the task of driving. The road is dirt and relatively rough for almost ten miles, but if you are careful and use a touch of common sense, a truck or SUV is not needed. The very fact that this road portion is rough, with several small streams to ford, serves to enhance the adventure and the illusion that you are really getting into Arizona back-country. The gravel abruptly then gives way to asphalt, and the canyon that channels Grapevine Wash opens to a rolling grassy plain with seemingly limitless horizons. On this mesa, the road enters Hualapai tribal land and is paved from the reservation line to the Grand Canyon West visitor center. (Any deviation from the main road requires a permit.)

The road ends shortly beyond, at the visitor center, but the adventure and surprises do not. Maintained and operated by the Hualapai Indians, the visitor center aims to provide access to the Grand Canyon in as pristine a state as possible. In addition, there is a concentrated effort to educate visitors about the life of Native Americans in the pre-Anglo world.

Guided tours make several stops along the canyon rim, where there is nothing but sagebrush between you and the edge. A clear skywalk that will allow visitors to walk out nearly sixty feet over the chasm is being constructed here, and, near the canyon rim, the Hualapai tribe is also adding an interpretive exhibit of traditional Native American homes, including the Hualapai wickieup and the Navajo hogan. The homes are being constructed in the historic methods of the tribes, and the materials are being brought in from the respective reservations. From this spot, you can also take a quick helicopter ride to the river below the rim, followed by a quiet boat ride upriver into the colorful gorge.

With an adventure such as this, it might be difficult to select a highlight. But for me, the highlight is eating a wonderful open-air lunch, shaded by a large tent, on the very edge of the canyon, site of one of the most overlooked engineering marvels of modern times.

In the 1950s, a rich deposit of bat guano, highly valued as fertilizer because of its nitrate concentrations, was discovered on the north side of the canyon, just above the river in a series of caves. Mining the guano was a small challenge compared to getting it to a shipping location. Initially, the guano was lowered to the river, loaded onto boats, moved downstream out of the canyon to Pierce Ferry, and then trucked to Route 66 and the railhead in Kingman. Yet Bill Freiday of Kingman had another idea: an amazing system of cable cars that would run up and across the canyon to the present site of the Grand Canyon West's lunch facilities. Today, only photos, a few towers, and the old winch shed remain from this incredible venture.

To the Edge of the World and Back Again
Highway 18 to Supai

If there ever was a lost highway, it is Indian Highway 18. In atlases and on maps, it is a thin black line that twists and turns from a point on Route 66 east of Peach Springs north to a blank spot about an eighth of an inch from a dot with the notation "Supai." At its southern terminus, a large sign lists the mileage to three different locations: one location is in ruins, another is nothing more than a fire observation tower, and the third is a parking lot with corrals at the road's end.

While there may be other routes in America where, within such a short distance, you can experience a diversity of climate and scenery that runs the gamut from high-desert prairies to forested mountains, deep canyons, and rolling hills, none provides the opportunity for travel through different

ROUTE 5

The Indian Highway 18–Route 66 junction is located about 15 miles east of Peach Springs and 40 miles west of Seligman. At the junction, turn north on Indian Highway 18 and follow it about 65 miles to Havasupai Indian Reservation. All visitors to the village, located 9 miles from the Hualapai Hilltop, or to the waterfalls are required to have a permit. For information, contact the Havasupai tribal offices at 928-448-2120 or 928-448-2111.

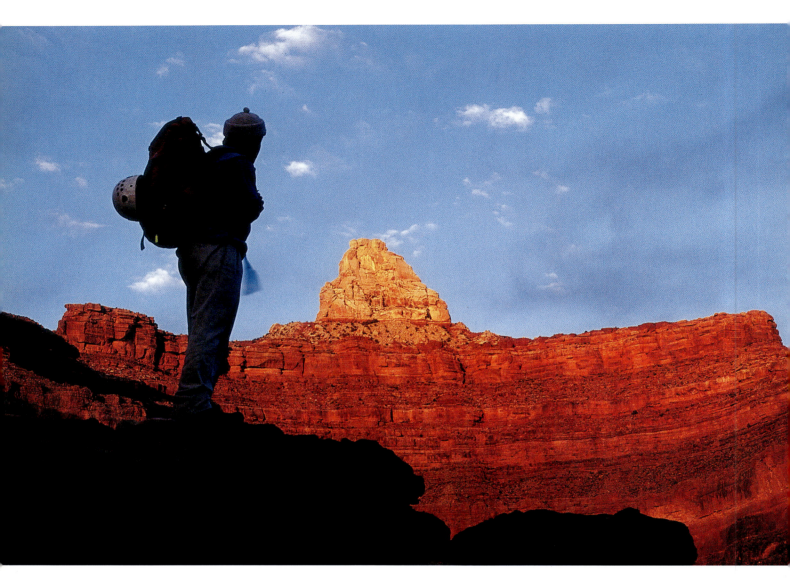

Zoroaster Temple in Grand Canyon National Park towers with majesty above climber Matt Brown.

Longhorn cattle still roam the range in northern Arizona but are raised today more for show than for beef.

Just off Highway 18 near Supai, summer flowers enhance a scene of exquisite natural beauty.

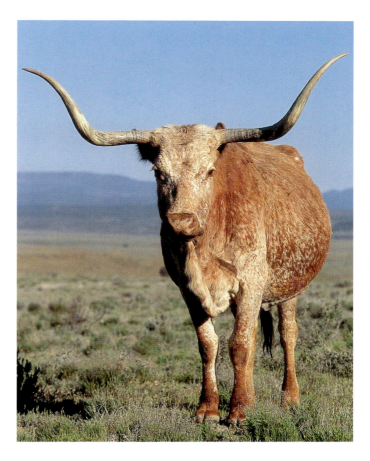

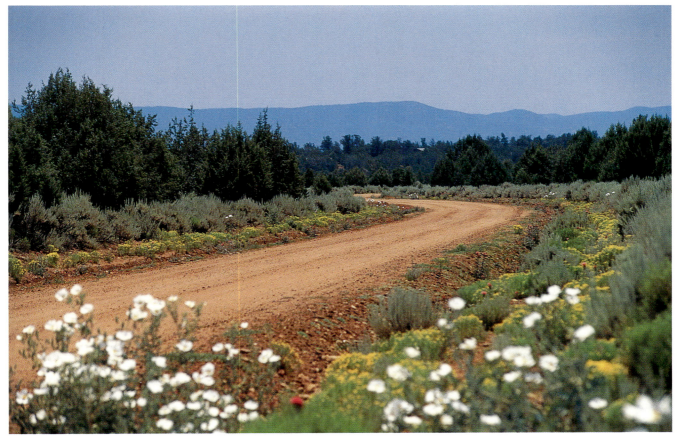

centuries. The entire journey is less than eighty miles, but it is like no other in that it links the twenty-first century with the very beginning of time. Only the first sixty miles of this route is along paved roads. It begins with the romanticism of Route 66 and ends in a breathtakingly beautiful land of thundering waterfalls that plunge over precipitous red rock walls into translucent turquoise lagoons.

As remote as this journey seems today, less than a century ago, the trip from Seligman to Supai, about ninety miles, was at best a two-day affair. The ruins of Frazier Wells, a woodcutting camp established in the late 1930s, marked the end of the road until the 1960s. More than a decade then passed before Highway 18 became an all-weather highway.

Throughout Arizona, elevation changes create diverse climates within short distances. As a result, it can be a mild, sunny day in one location, and cold with deep snow just a few miles down the road. This is especially true of Highway 18, which can reach elevations close to seven thousand feet; during winter months, large portions of the highway can be icy or snow-covered. Inquire about road conditions at Peach Springs or at Grand Canyon Caverns. There are no services of any kind along this drive, so it is imperative that your vehicle is in good condition.

The drive begins in rolling hills accentuated with groves of cedar. Within a few miles, the gentle grades and curves carry travelers to a higher elevation, where towering pines cast deep shadows and increasingly rare clearings frame wondrous views of distant colorful mountains.

The silence that engulfs every stop accentuates the remoteness of this drive. The abundance of wildlife—deer, turkey, and coyote, to name just a few—enhances the feeling of driving through wilderness. The names of the mountains and canyons along the route—Robbers Roost Canyon, Tower of Babylon, Mount Spoonhead, and Little Coyote—ring with historical mystery and whimsical flights of fancy. The harsh outlines of the ruined Frazer's Well school and other structures soon break the spell, if only for a moment.

The ruins pass from sight in the rearview mirror only moments before the highway drops quickly from the forest to a high-desert plain. This portion of the highway traverses an increasingly rare Southwestern phenomenon known as open range, where there are no fences. Cattle roam free and have the right-of-way, so extreme caution when driving through should be exercised. The stark beauty of the seemingly sterile plain contrasts with the often snow-covered San Francisco Peaks that loom on the horizon and the blue- and purple-tinged canyons to the north. Then, with a short series of sharp curves, the landscape changes again, and the road is alternately squeezed between rough rock walls and suspended above seemingly bottomless gorges.

The road abruptly ends in a vast parking lot and corral complex atop a rock spur, surrounded on three sides by precipitous drops to the canyon floor far below. This is Hualapai Hilltop, the trailhead for the journey to Supai and a loading area for mule trains. The final nine miles to the remote

village of Supai, the last community in America where the mule train delivers the mail, require a good set of hiking books, reservations for a helicopter, or the willingness to saddle-up for a long but scenic ride. All visitors to the village or to the waterfalls beyond it are required to have a permit. (For information, contact the Havasupai tribal offices at 928-448-2120 or 928-448-2111.)

Even if you don't make the descent to Supai, home to the Havasupai people for centuries, the hilltop alone makes the drive an unforgettable one. Automobile traffic on the narrow stone finger vies for space with mule trains laden with cargo of every kind and greenhorns in the saddle for the first time. And the views are incomparable.

THE ARIZONA STRIP
COLORADO CITY TO PAGE

This drive offers an increasingly rare opportunity to experience the grandeur of the Grand Canyon State as it appeared several decades ago. Awe-inspiring scenic beauty, limited facilities, isolated rural communities nestled among some of the most beautiful real estate on earth, miles of near-virgin wilderness with little more than two lanes of asphalt, and a few dirt trails linking this land to civilization are just part of the lure to explore here.

The area known as "the strip" is an anomaly. Because it is severed from the rest of the state by the Grand Canyon and the Colorado River, common sense dictates it should be part of Utah. However, as common sense has little to do with politics, it is part of Arizona. As a result, a citizen residing near Mount Trumbull has to travel more than four hundred miles through three states to reach the county seat in Kingman.

Founded as a Mormon farming community in the 1860s, Colorado City (called Short Creek until 1958), near the Utah border, is short on most everything save history and natural beauty. In 1890, when the Church of Jesus Christ of Latter-day Saints outlawed polygamy, church fundamentalists headed for this remote community. Over the years, several attempts have been made to end the practice, but only limited success has been achieved. However, the history of Colorado City is a rather lengthy one that predates the arrival of the Mormons by several centuries. Attesting to this is the current archeological excavation of an Anasazi village in the center of town, which should be included on your list of places to stop.

The drive east on Arizona Highway 389 from Colorado City is a pleasant one. Junipers, sagebrush, and pinion pines accent the stereotypical colorful bluffs associated with the state. A wonderful little side trip of sixty miles each way to Toroweap Point will give you a complete feel for just how remote the area is, as well as access to one of the most spectacular overlooks in the entire Grand Canyon. The access to this overlook is

ROUTE 6

This drive begins just south of the Utah-Arizona border in Colorado City. Follow Arizona Highway 389 east until it connects with U.S. Highway 89A at Fredonia, a drive of about 30 miles. At Fredonia, drive southeast 30 miles on U.S. 89A to Jacob Lake. From Jacob Lake, turn south on Arizona Highway 67 and drive 45 miles to the North Rim. Please note that Highway 67 is closed during the winter. After visiting the North Rim, drive north on Highway 67, returning to U.S. 89A. On returning to U.S. 89A, go east and then southeast to Marble Canyon, 45 miles from the junction of Highway 67.

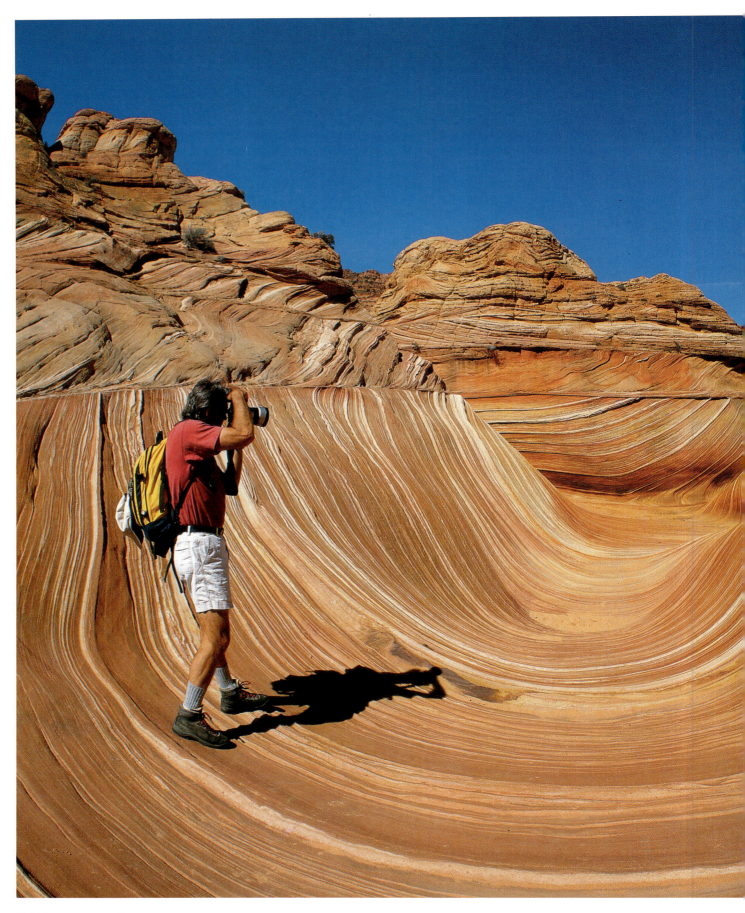

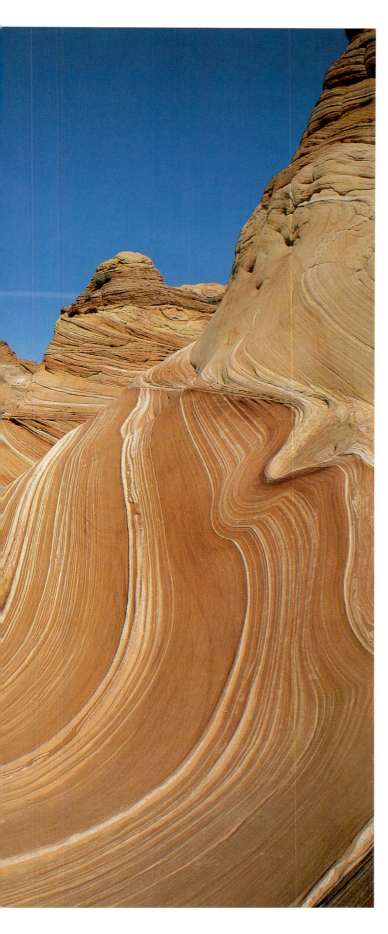

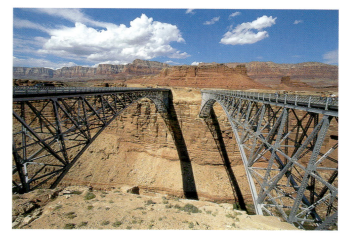

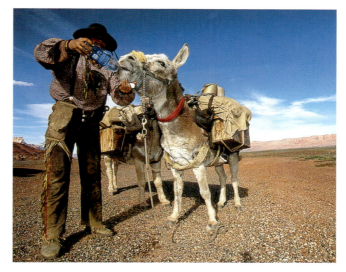

OPPOSITE PAGE:
The colorful swirls of Coyote Buttes present a variety of challenges and opportunities for the seasoned photographer.

TOP:
The bridge that crosses Marble Canyon, connecting the Grand Canyon's northern and southern rims.

BOTTOM:
"Three Feathers" and his burro seem to have traveled to Marble Canyon from another era.

off County Road 237 (Clayhole Road), which begins just four miles south of Colorado City. At the end of this long, scenic gravel road, only a guardrail separates you from the chasm that drops some three thousand feet to the Colorado River below.

The next point of interest along Highway 389 as you continue east is Pipe Springs National Monument. Constructed of locally quarried stone, brick, and wood, this historic fort provides a wonderful photo opportunity. In 1852, Mormon pioneers first visited the springs, the only dependable source of water for sixty miles, and attempted to settle here a decade later. Following a massacre by local natives, Mormon ranchers began construction of the imposing fort. As remote as the location is, it was here in 1871 that the first telegraph in the northern portion of the Arizona Territory went into operation (or so the legend goes).

Numerous scenic overlooks and pullouts, most notably Le Fevre, allow you to simply savor the incomparable beauty of this land. They also allow for a deeper sensation of the timelessness that presses in upon the highway from both sides.

After passing through Fredonia, where you'll turn south on U.S. 89A, the highway gently twists and turns onto the Kanab Plateau. A side trip south on Arizona Highway 67 from Jacob Lake through the Kaibab National Forest—a vast land of towering ponderosa pine, quaking aspen, Douglas fir, blue spruce, and wide meadows—to the North Rim in Grand Canyon National Park is highly recommended. The North Rim is 1,200 feet higher than the famous and more-often visited South Rim. As a result, the views are even more spectacular, but then again, the snows are even deeper. For this reason, Highway 67 is closed from mid-October to mid-May.

Visitors to the North Rim will find it little changed from when the Grand Canyon Lodge opened in 1936, with an incredible dining-room view and a wide veranda overlooking the canyon. As less than 10 percent of all visitors to the Grand Canyon make the trek to the remote North Rim, the opportunity to meditate on nature's handiwork in solitude is relatively easy to find there.

Returning to U.S. 89A and continuing east, the next surprise along the drive is the stunning Vermillion Cliffs. John Wesley Powell, the first explorer to traverse the Grand Canyon on the Colorado River, described them as "a long bank of purple cliffs plowed from the horizon high into the heavens" in Bryd Granger's *X Marks the Place*.

An intriguing detour found to the south of the cliffs is the well-marked House Rock Ranch Road, a gravel road to House Rock Ranch. The road, passable most of the year, provides access to the House Rock Valley, where antelope, deer, and bighorn sheep still run free. (Inquire with the North Kaibab Ranger District, 928-643-7395, as to road conditions.) The highlight is the ranch itself, established in the 1920s for the commercial

raising of buffalo for hunting. The ranch is now state-managed, and a herd of about one hundred of these impressive animals still roams here.

The climax of this backroads route is Marble Canyon. The gorge here is relatively narrow and much shallower than just downstream in the Grand Canyon itself. The Navajo Bridge, an engineering marvel bypassed in 1995, is now a footbridge that provides a one-of-kind opportunity to walk out over the powerful Colorado River far below.

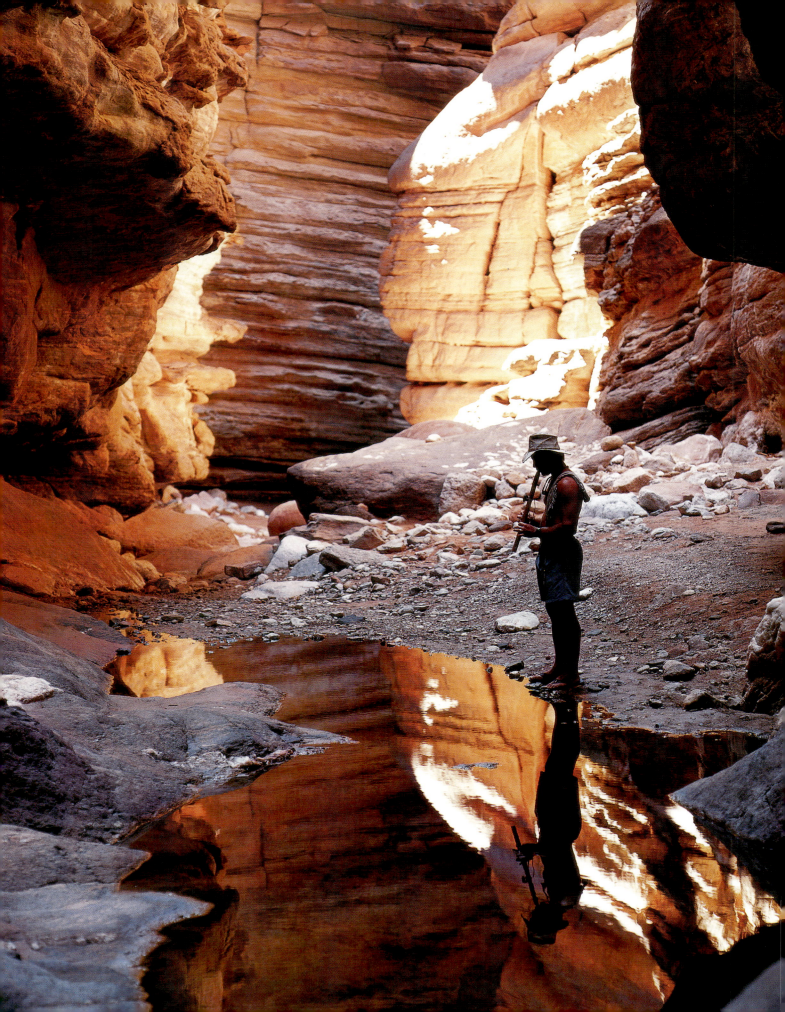

THE NORTHEAST

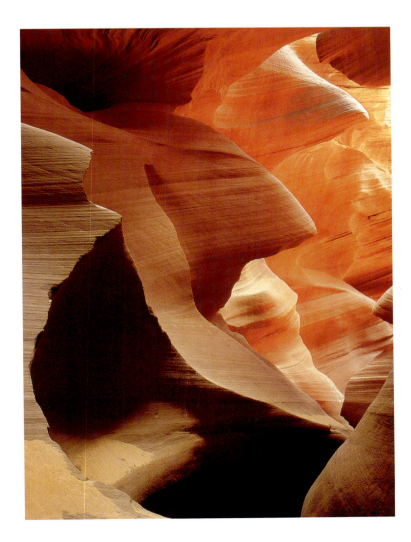

Because the Monument Valley and the Painted Desert have served as the setting for countless cinematic epics, these areas often spring to mind when people think of Arizona. For the first-time visitor, the initial impression can be that of overwhelming awe, in spite of this cinematic familiarity. Movies and photographs prepare you for the beauty of the land, but not for the overwhelming sensory experience of complete immersion in the landscape.

Losing track of time is easy here, as everything seems timeless—the horizon with its buttes and mesas silhouetted against a flaming sunset, the coursing hills of sand, the forest of trees turned to stone. The communities found here often seem as ancient as the land from which they sprung. The ghostly ruins in Canyon de Chelly, the stone homes of Oraibi, and even the old Hubbell Trading Post all seem to be outcroppings rather than dwellings.

Adding to the illusion that this area is timeless are the people who have called this beautiful but harsh land home for centuries—the Hopi and the Navajo. While the traditional hogan has given way to more modern housing, the horse is still often the best means of transportation in many areas.

For the traveler in search of raw natural beauty and a slower pace of life, there is no place like northeastern Arizona. This is the land where time stands still.

THE FABLED LAND
PAGE LOOP

ROUTE 7

Begin at the Carl Hayden Visitor Center, about 2 miles north of Page. Follow Arizona Highway 98 south to the junction of U.S. Highway 160 and turn west. Twelve miles past Tuba City is the junction of U.S. Highway 89. At the junction, turn north on U.S. 89 toward Page.

Glen Canyon National Recreation Area, with Lake Powell as its centerpiece, is more than an oasis of astounding beauty. It is an aquatic utopia unlike anything on earth. In 1963, when the gates of the Glen Canyon Dam closed, the Colorado River began to fill a veritable maze of colorful canyons. The result is that Lake Powell today is a boating enthusiast's paradise, with more than 1,900 miles of shoreline that includes beaches hidden in deep remote canyons. Natural arches and towering stone monoliths line the horizon and often seem to rise from the depths of the lake.

The list of Lake Powell sites worthy of a visit could fill a book unto itself. If you're able to visit only one, make it Rainbow Bridge. At 290 feet, Rainbow Bridge is the world's tallest stone arch, and it serves as an awe-inspiring frame for a panorama of incomparable natural beauty.

The creation of Lake Powell did more than submerge miles of scenic canyon lands; its waters covered numerous historic sites, including the Vados de los Padres ("Crossing of the Fathers") used by Fathers Escalante and Dominguez during their expeditions in 1776.

The dam and the Carl Hayden Visitor Center, located just north of Page, serve both as the beginning and the end for this loop drive. The visitor center provides an excellent introduction to the rich history and prehistory

The Northeast

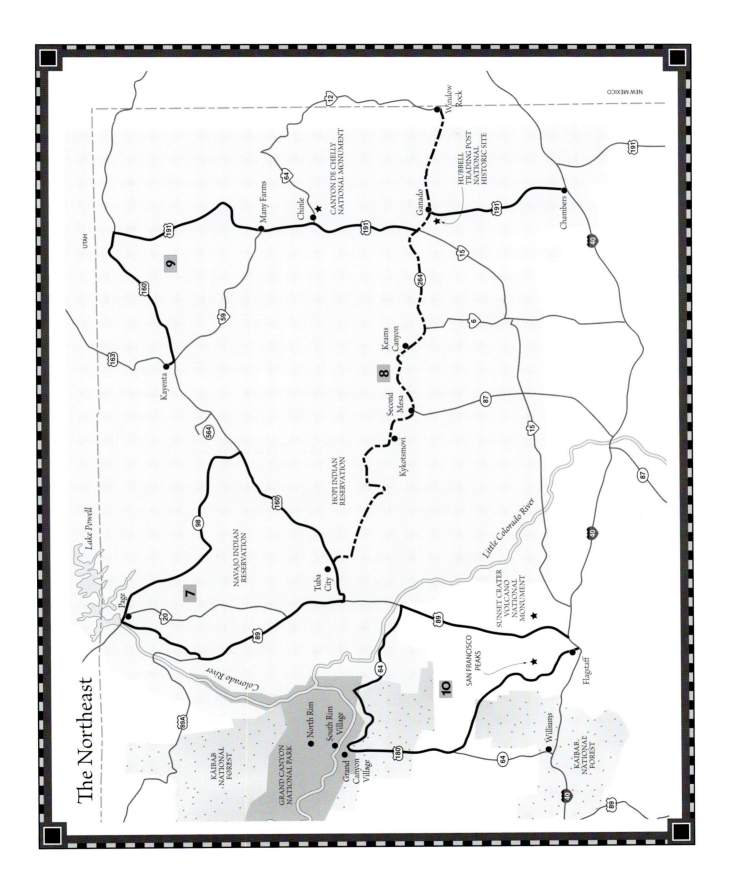

NEW MEXICO

UTAH

Window
Rock

12

64

191

Many Farms

Chinle

CANYON DE CHELLY
NATIONAL MONUMENT

Ganado

HUBBELL
TRADING POST
NATIONAL
HISTORIC SITE

191

191

191

Chambers

40

9

160

15

59

264

6

163

Kayenta

Keams
Canyon

8

564

Second
Mesa

87

15

160

Kykotsmovi

HOPI INDIAN
RESERVATION

87

98

40

Lake Powell

NAVAJO INDIAN
RESERVATION

Tuba
City

Little Colorado River

SUNSET CRATER
VOLCANO
NATIONAL
MONUMENT

7

Page

20

89

89

SAN FRANCISCO
PEAKS

Flagstaff

Colorado River

64

10

89A

North Rim

South Rim
Village

KAIBAB
NATIONAL
FOREST

GRAND CANYON
NATIONAL PARK

Grand
Canyon Village

180

Williams

64

KAIBAB
NATIONAL
FOREST

40

89

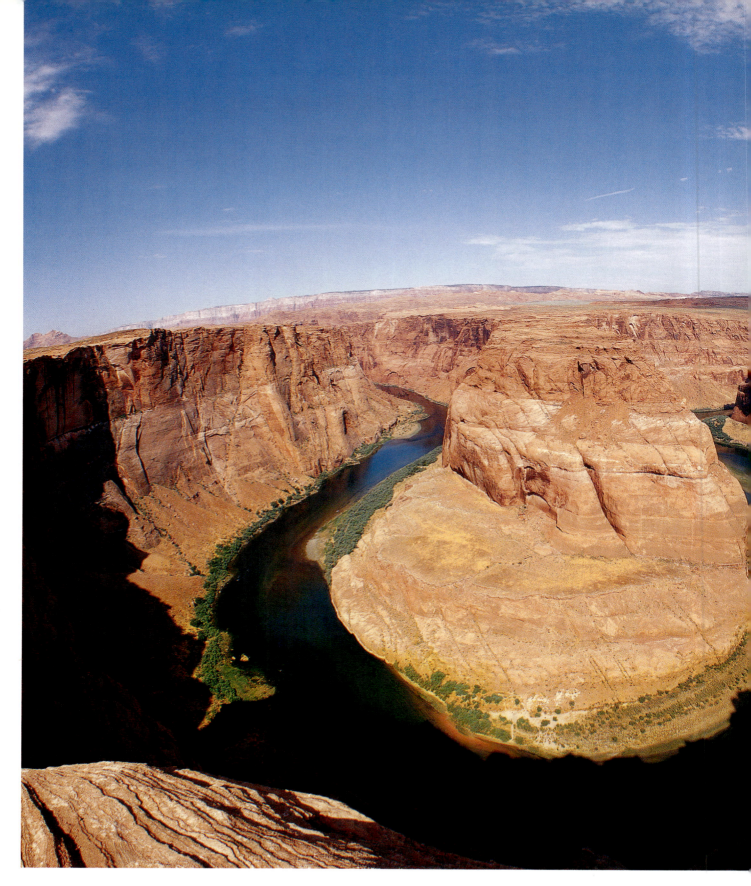

Near Page is the aptly named Horseshoe Bend of the Colorado River.

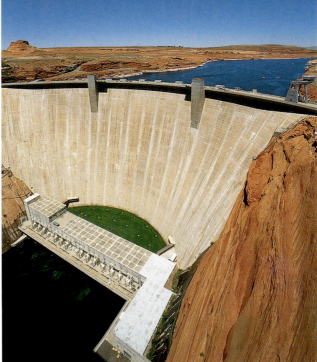

Near Page, Glen Canyon Dam harnesses the power of the Colorado River and impounds its waters as Lake Powell.

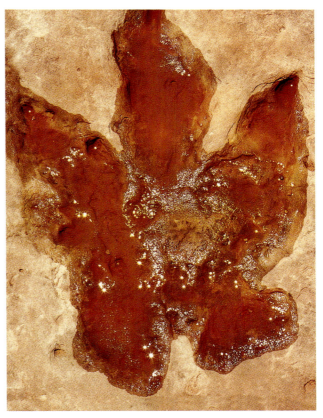

Dinosaur footprints in the wild lands at Moenave near Tuba City are remnants from a lost world.

THE FORGOTTEN TRAILS

The settlement of the West and the Southwest was heavily dependent on a system of established trails, along which travelers could find dependable sources of water at regular intervals, cross imposing mountain ranges through passes with smaller elevation gradients, and avoid the harshest portions of the desert. While many of these trails, such as the Santa Fe and the Oregon, are well known, others have faded into obscurity.

One of the lesser known trails is the Honeymoon Trail, which followed the base of the Echo Cliffs—roughly the current route of U.S. 89 between Cameron and Cedar Ridge. Mormon pioneers living in the communities along the Little Colorado River used this trail from 1877 to 1890 to travel to St. George, Utah, to be married in the temple there.

The Honeymoon Trail began in Winslow; passed over Tanner's Crossing at Cameron; ran across the Painted Desert, then along the Echo Cliffs and the Vermillion Cliffs; crossed the Colorado River at Lees Ferry; and passed through House Rock Valley, around the Buckskin Mountains into what is now Pipe Springs National Monument, and then into St. George. The entire journey was about three hundred miles.

of the area. The dam, the second highest in the United States, seems oddly dwarfed by the immensity of the land that surrounds it.

One of the highlights of any visit to the area is renting a houseboat and using it to seek out the innumerable treasures buried within the surrounding canyons. Exploring a vast desert labyrinth surrounded by trackless wilderness in near total isolation, yet with all the comforts of home in easy reach, is an experience not easily forgotten.

Drivers should be aware that in summer months temperatures often exceed 100 degrees here, and during winter months, snow and even occasional blizzards are common. Winter snows serve as stark contrast to the kaleidoscope of colors that otherwise dominate the land. During summer rains, when cloud shadows dance across the plains and towering thunderheads loom on the horizon, the sky captivates and overwhelms the senses.

Page is a modern though remote community that features many amenities, including an award-winning golf course. It is best to stock up on amenities before setting out, as the majority of this drive is through sparsely populated desert wilderness peppered with dusty villages that offer few services, with the exception of Tuba City. Tuba City, named not for a musical instrument but for a Hopi chief named Toova, is actually a bit north of the highway and is somewhat gritty, but makes for an excellent pit stop.

Running southeast, Arizona Highway 98 roughly follows the contours of the land; as a result, it gently twists and turns through a colorful landscape that alternates between high-desert plains and colorful, whimsical stone outcroppings. The few communities you'll encounter, such as Kaibito, break the almost magical feeling that you have stepped back into an era as ancient and timeless as the stones of the buildings themselves.

The turn toward the southwest on U.S. Highway 160 continues the theme of multicolored landscapes and breathtaking vistas. An astute observer will note subtle but significant changes in the lay of the land. The illusion of timelessness is then broken by the intrusion of the modern at Tuba City.

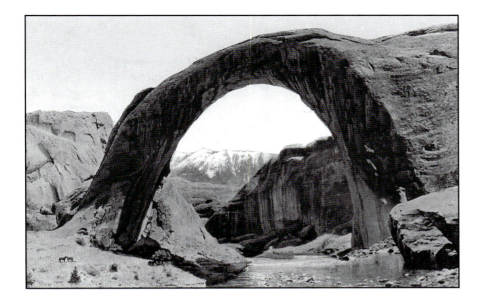

Even though the creation of Lake Powell has made it easier to reach the breathtaking Rainbow Bridge, to stand in its shadow still requires a strenuous hike or time in the saddle. Author's collection

The pristine desert landscape quickly returns after leaving Tuba City. Subtly eroded knobs of colorfully banded clays and volcanic ash begin appearing in ever-increasing numbers until the plains are awash in color; this is the northern edge of the multihued Painted Desert.

In some parts of America, fruit and vegetable stands are a roadside tradition during the summer months. Here in the land of the Navajo, you may be surprised to find small roadside stands offering the wares of native weavers or of silversmiths, in what seems to be the most desolate locale imaginable.

Along the northern leg of this drive, you'll find another relic from an earlier time—the trading post. Listed simply as "The Gap" on maps, this trading post still serves as a vital link to the outside world for those who call this wild land home.

Intermittent groves of sparse cedar, the towering ramparts of Echo Cliffs, and dancing cloud shadows encourage even amateur photographers to try to capture the raw beauty found here. As traffic can be surprisingly heavy along this route, take advantage of the numerous pullouts and overlooks to savor the smells and sights of this ancient land.

THE LAND OF THE HOPI
TUBA CITY TO WINDOW ROCK

The beauty of the Painted Desert and the high-desert plains predominates along this drive. However, the scenery is merely the backdrop for this cultural adventure.

From Tuba City, Arizona Highway 264 twists and turns with the contours of the land. At times it seems as though every color in a crayon box was mixed, melted, and poured over the hills, knobs, and valleys. In spite of this raw beauty, the land here seems to be stark and almost sterile. This is, however, an illusion. Nestled among the canyons and mesas are

ROUTE 8

From the junction with U.S. Highway 160, about 2 miles south of Tuba City, follow Arizona Highway 264 east 62 miles to Second Mesa. To reach Inscription Rock, continue east on Highway 264 18 miles to the Keams Canyon Trading Post (permits and directions for the 2.5-mile hike can be obtained here). From Keams Canyon Trading Post, continue east 70 miles on Highway 264 to Indian Highway 12. To see the stone formation known as Window Rock, turn north on Indian Highway 12 and drive 1.5 miles. Please note that on some maps Indian highways may also be designated as tribal highways (e.g., Navajo 12, Hopi 6)

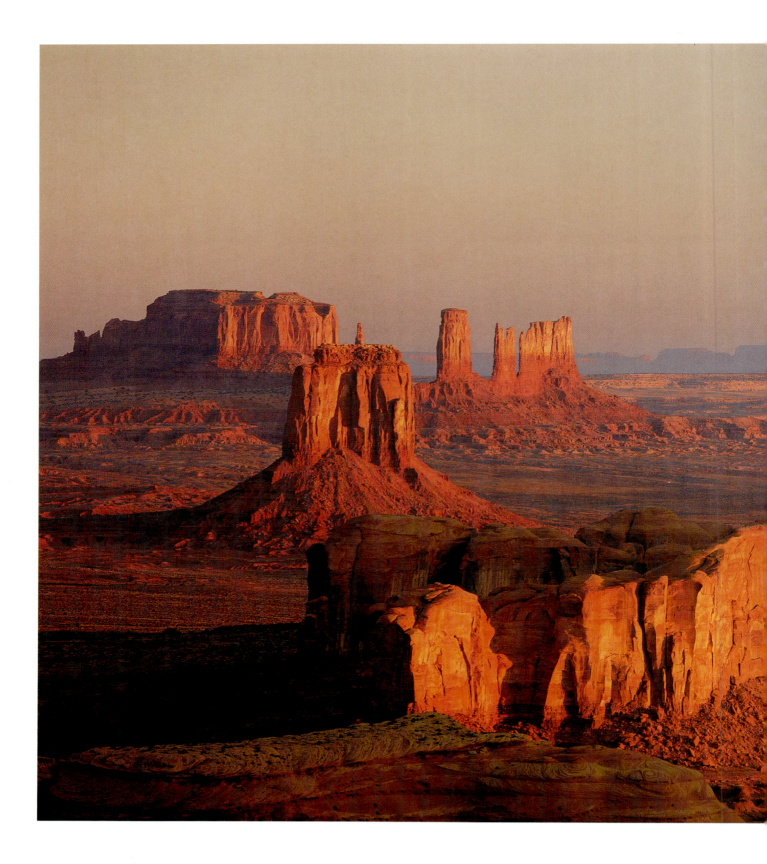

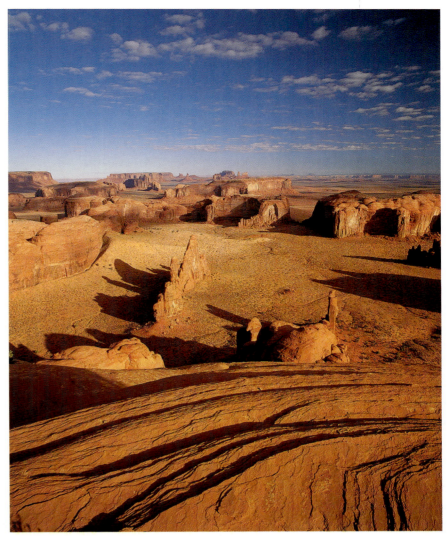

The breathtaking views from Hunts Mesa in Monument Valley are without equal.

THE ANCIENT LAND

The area around Tuba City and Kayenta is often referred to as "the ancient land." In 1942, this moniker took on a completely new meaning with the discovery of extensive sets of dinosaur tracks in two separate locations.

What makes these tracks even more interesting is the fact they are the first ever found from dinosaurs on the run. They remained one-of-a-kind until the 1980s, when similar tracks were found in China.

The easiest access to the tracks is on a one-eighth-mile dirt road off Arizona Highway 160, between the Highway 89 turnoff and Tuba City. Usually there are locals waiting to act as guides for a small fee.

oases that have nurtured the Hopi people and their culture for centuries. The little village of Oraibi, recognized as the oldest continuously inhabited community in the United States, dates to A.D. 1100.

Most of the Hopi villages are nestled on a group of three mesas known as First Mesa, Second Mesa, and Third Mesa. The Hopi Cultural Center is located on Second Mesa and is replete with a museum, a motel, a gift shop, and a restaurant that serves many traditional foods. The cultural center is an excellent source for information on tribal ceremonies open to the public, as well as proper etiquette for a reservation visitor.

As Arizona Highway 264 draws near Keams Canyon, the seat of tribal government for the Hopi, there is a subtle but distinctly different feel to the land, and the canyons become more pronounced. As a result, the shadowing on distant hillsides appears often as purple gashes.

For those interested in stretching their legs with a short hike, there is a hidden treasure several miles from the Keams Canyon Trading Post. Deep in the canyon, a sandstone wall known as Inscription Rock bears a rich tapestry of petroglyphs and several famous signatures, including that of Kit Carson. Carson was assigned to deliver an ultimatum to the Navajo: relocate to the established reservation at Bosque Redondo on the Pecos River in New Mexico or face annihilation. This dark period became the Navajo "trail of tears."

Crossing from the Hopi to the Navajo reservation may happen with little notice, as the land remains a delightful mix of desert, canyons, small family farms, and beautiful views of horizons dominated by towering cloud formations and ridges. For the people who reside in this rugged land, much of the area has been and still is contested, with both tribes claiming ownership of it.

Take time during this drive to experience the rare, rich tapestry that unfolds at every turn. The St. Michaels Historical Museum, a few miles west of Window Rock, is a native stone building that was home to Franciscan friars during the mid-1890s. The friars came to Arizona to establish schools for Native Americans that would also serve to spread the Gospel. In so doing, the friars became integral to the creation of a written language for the Navajo. Exhibits and displays at the museum encapsulate this forgotten chapter of western history.

Housed next door to the museum is a sculpture called the *Redemption of Mankind*, often called the American *Pieta*. In the mid-1980s, Ludwig Schumacher of Germany immigrated to America and fell deeply in love with the harsh beauty of northern Arizona. An artisan and sculptor equal in skill to the masters of the Renaissance, he found a towering section of juniper tree, which he carved into a representation of Michelangelo's legendary *Pieta*. Unlike the original marble work, Schumacher's sculpture is a sixteen-foot vertical depiction of Christ being lowered from the cross to where Mary awaits. This work of art and the St. Michaels Historical Museum are just two of the many surprises that can be found and enjoyed only when you slow your pace as you traverse this route.

The next site you'll encounter is Window Rock, about thirty miles west of Ganado, almost astride the New Mexico state line. As the capital of the Navajo Nation, there are several notable attractions, but the Window Rock Tribal Park and the Veterans Memorial, with its tribute to the code talkers of World War II, top the list. There is also the Navajo Museum and a gift shop.

Other points of interest include the red rock formation with a 130-foot hole in the center, for which the community was named. The Navajo name *Tseghabodzani* translates as "the rock with the hole in it."

TECHNICOLOR DREAMLAND
KAYENTA TO CHAMBERS

This adventure begins in Kayenta, located to the south of Monument Valley, with its spires of stone made famous in countless John Ford western epics. The drive ends with the modern era, the romanticized version of Route 66, and the generic world of the interstate highway. In between is a drive through a land of technicolor dreams, the ancient home of the Navajo people.

ROUTE 9

Beginning in Kayenta, take U.S. Highway 163 south 3 miles to U.S Highway 160 and turn east. Continue east 40 miles on U.S. 160 to the junction with U.S. Highway 191 and then turn south. The historic Mexican Water Trading Post is 1.5 miles east of this junction on U.S. 160. Continue south on U.S. 191 62 miles to the junction of Indian Road 7, then turn east and drive 4 miles to Chinle and the visitor center for Canyon de Chelly National Monument. On returning to U.S. 191, turn south and drive 81 miles to Chambers.

ANOTHER NATIVE AMERICAN TRACK STAR

Jim Thorpe, a 1912 Olympic gold medalist and professional football and baseball star, has become legendary in the annals of American history. However, one of his contemporaries and classmates at the Carlisle Indian School in Pennsylvania, Louis Tewanima from Shongopovi, has been almost totally forgotten. In light of Tewanima's many accomplishments, this is quite surprising.

The long-distance running skills of Tewanima were well known on the Hopi reservation. Legend has it that on one occasion he decided to see the trains in Winslow, so he set out on a run to that city, sixty-seven miles to the south, and arrived by nightfall. At Carlisle, athletics were encouraged, and Tewanima excelled in several sports, but track and field events were his specialty.

In the 1908 Olympics, Tewanima finished ninth in the marathon, and in 1912, he won the Olympic silver medal for the 10,000 meters. No other American matched his record in the latter event until 1964, when the record was eclipsed by Billy Mills, another Native American.

Tewanima died in 1969, at the age of ninety-two, as the result of a tragic accident. Walking home late one evening, he took a wrong turn at Second Mesa and fell seventy feet to his death.

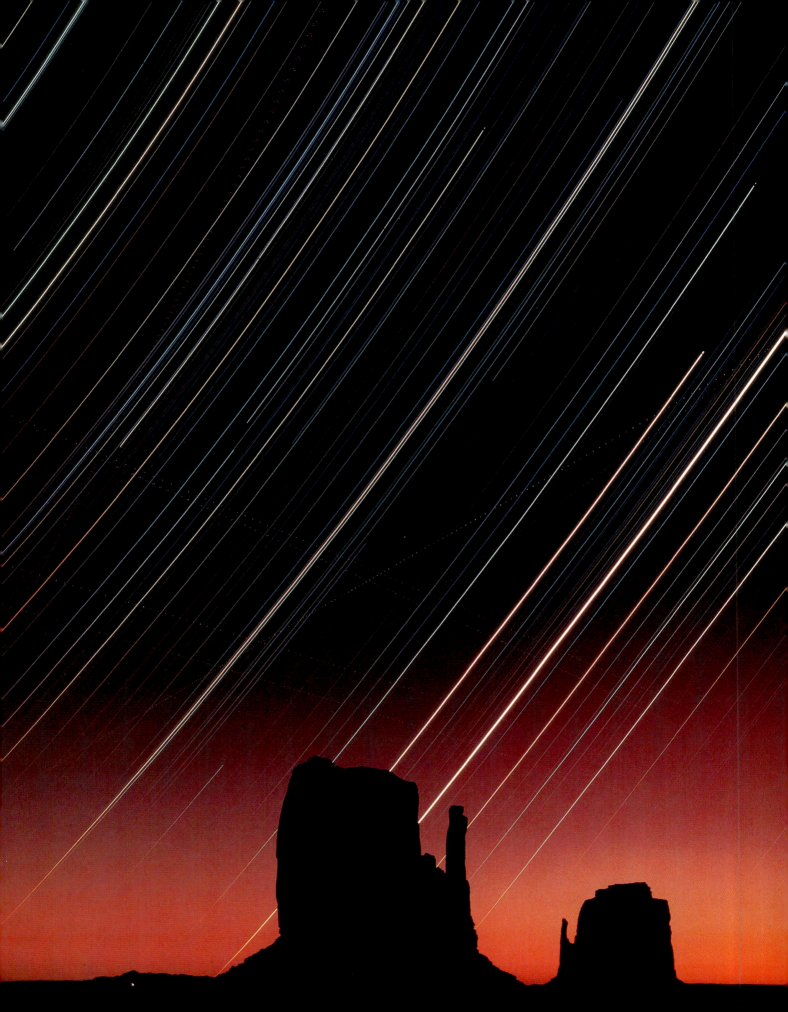

Near Ganado, a herd of Navajo-owned sheep seem dwarfed by the immensity of the land.

At Second Mesa, the Hopi grow corn in the rocky soil as they have for centuries.

Opposite Page:
Star tracks over the Mittens in Monument Valley hint at the timelessness of this rugged land.

At more than 27,000 square miles, the Navajo nation is larger than ten of the fifty states. Because it has a population of only several hundred thousand, you can travel many miles and see little but unbroken landscapes of desert wilderness unchanged for centuries. When driving through the reservation, remember that you are technically entering an independent nation. Always respect the laws, the customs, and the culture. To learn what these laws, customs, and culture are, inquire at a visitor center.

In Kayenta, the visitor center is the Kayenta Trading Post at 1000 Main Street, just off U.S. Highway 163. This trading post is an intriguing blend of the traditional and the modern. In addition to native crafts, you can buy all the fare found at a modern mini-mart. The trading post also sells livestock feed and other necessities for those who still stock up on supplies in their weekly or monthly visits to town from outlying ranches. Red bluffs and deep-blue skies frame the brightly colored mural that illustrates the Navajo creation story on the trading post's outside walls. This beautiful mural is the work of world-famous Navajo artist Carlos Begay.

Driving northeast from Kayenta on U.S. Highway 160 is a pleasant journey across high-desert plains, with only occasional whimsical rock formations to break the sameness. With the turn south on U.S. Highway 191 near Mexican Water, a new realm of adventure begins, with a memorable 150-mile drive. Here and there, villages that are little more than wide spots in the road seem to spring abruptly from the land. The names of these quiet little communities, as well as those found just off the beaten path, ring with the sound of the Old West—Rock Point, Many Farms, Rough Rock, and Round Rock, to name a few.

AN OLD-FASHIONED TRADING POST

The Hubbell Trading Post outside of Ganado remains almost exactly as it was when it was built in 1883. The noticeable exception is the addition of electric lighting, but even here, there is a vintage feel, as many of the fixtures date to the 1920s.

During the frontier period in the Arizona Territory, the trading post was a vital link between the Native Americans and the broader world that was rapidly bringing change. Here natives could barter goods such as brightly colored woven wool blankets for sugar, canned goods, or clothes.

At its peak during the closing years of the nineteenth century, the Hubbell Trading Post was one of the largest Southwestern trading posts in volume: a quarter million dollars in hides and wool were traded in a single year. The key to this trading post's success was its founder, John Lorenzo Hubbell.

Born in 1853 in Pajarito, New Mexico, Hubbell possessed a sharp intellect, business acumen, and an honest respect for the native people. Fluent in four languages—English, Spanish, Navajo, and Hopi—he constantly strove to find ways to improve the living standards of the Native Americans he encountered; for example, he once hired a Mexican silversmith to teach the trade to native artisans.

Hubbell's efforts to help the native people eventually extended to politics. In 1882, he was elected sheriff of Apache County, then to the territorial legislature. He was elected to the state senate after statehood was granted to Arizona in 1912. Because of his far-reaching contacts and the respect the Navajo gave him, the Navajo wanted him to keep his homestead after the expansion of the Navajo reservation. But it took an act of Congress and an intervention by Hubbell's friend President Theodore Roosevelt to accomplish this, as all homesteads were rescinded within the new boundaries.

The first must-stop, must-see attraction requires a short detour to Chinle and Canyon de Chelly National Monument on Indian Road 7, thirty miles south of Round Rock. Here, almost a thousand years of history and breathtaking scenery collide. The visitor center at Canyon de Chelly houses a museum highlighting the centuries-old history of Native Americans in the canyon and surrounding areas, as well as an art gallery and a craft center, where native artisans demonstrate traditional crafts. At the visitor center, you can either obtain a map of the available rim drives or make arrangements to hire a guide for access to the inner sanctum of this desert treasure.

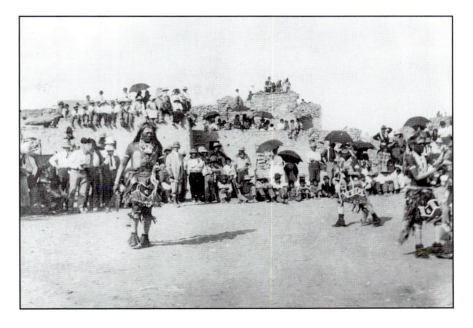

Members of the Hopi tribe perform their traditional snake dance near the turn of the century.
Library of Congress

At the entrance to Canyon de Chelly, walls of stone that are only about thirty feet in height flank the narrow canyon. Within its depths, the walls soar to one thousand feet high in places, and the spire known as Spider Rock stands as a sentinel, at eight hundred feet tall.

Nestled among the imposing stone walls are a number of cliff dwellings, once home to the mysterious Anasazi (loosely interpreted as "the ancient ones"). Without a guide, only the White House Ruin at the end of a steep 2.5-mile trail is accessible. But a visit to this intriguing and scenic wonder, which is estimated to date to A.D. 1060, will surely whet the appetite for more-expansive guided adventures to such treasures as Antelope House and Mummy Cave. If you are hardy enough for serious hiking, there are numerous ruins in the area, each more breathtaking than the previous one.

As you continue south along the main route, U.S. 191, the wide-open landscape gives a first impression of desolation and, as a result, can be some-what intimidating. For those who take the time to savor the land, however, there is a raw, intoxicating, beauty.

Just to the west of the little town of Ganado is the historic Hubbell Trading Post. Dating to 1878, it is the oldest continuously operated trading post in Navajo country and it is a national historic site. It features all manner of native handicrafts and artwork. There is a visitor center next door that is not to be overlooked; its highlight is a highly detailed and informative exhibit profiling the pivotal role of the trading post on the western frontier.

The drive from Ganado to Chambers, located along I-40, does little to prepare you for a return to the modern era. The wide desert plains; horizons broken by little more than clouds and colorful, stark knobs of rock; and wide spots in the road with names like Wide Ruin make it easy to forget you are in the twenty-first century.

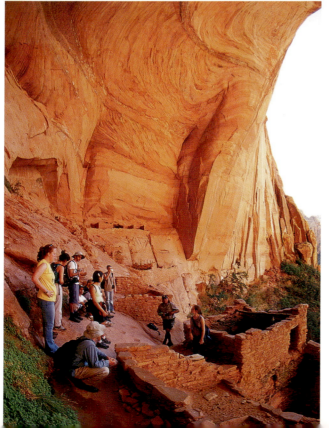

ABOVE:
The "eye dazzler," a 1940s rug design, adds color to the interior of the historic Hubbell Trading Post at Ganado.

LEFT:
The Betatakin Ruin in Navajo National Monument leaves visitors with a sense of awe and wonder.

OPPOSITE PAGE:
The sun rises over Wukoki Ruins in Wupatki National Monument with the snowcapped San Francisco Peaks serving as a backdrop.

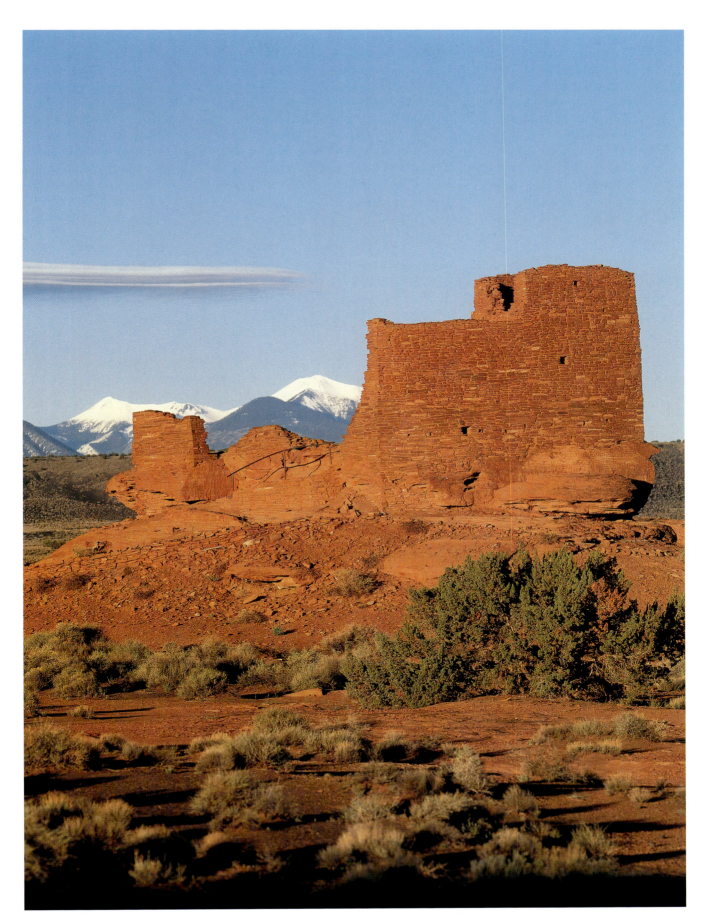

THE SOUTH RIM LOOP
FLAGSTAFF TO THE GRAND CANYON AND BACK

ROUTE 10

This drive begins at the junction of historic Highway 66 (Arizona State Highway 66) and U.S. Highway 180 (Fort Valley Road) in downtown Flagstaff. Follow U.S. 180 north 51 miles to the junction of Arizona Highway 64. Continue north 30 miles on Highway 64 to the headquarters and visitor center for Grand Canyon National Park. From the visitor center, drive east on Highway 64 (East Rim Drive) 57 miles to the junction with U.S. Highway 89. Turn south on U.S. 89 and drive 20 miles to Forest Service Loop Road 545 for access to Wupatki National Monument and Sunset Crater. After visiting the monument and crater, drive south from the southern junction of this loop road and U.S. 89 11 miles to rejoin Route 66 in Flagstaff.

The city of Flagstaff, carved from a forest of towering ponderosa pines under the shadow of the San Francisco Peaks, is well on its way to becoming a metropolis. In spots, well-preserved survivors from territorial days can be found, along with vestiges from when Route 66 was the main drag. This drive begins in the heart of the historic district at the junction of U.S Highway 180, Fort Valley Road, and Route 66. The overall loop is about 170 miles.

The initial miles take you through neighborhoods of beautiful older homes nestled among the trees. The Museum of Northern Arizona, founded in 1928, with its award-winning interpretive exhibits on native cultures and natural sciences, and the Pioneer Museum are two highly recommended stops.

After leaving the city limits, U.S. Highway 180 becomes a gently twisting ribbon of asphalt through the Kaibab National Forest, a deep forest of pine and white aspen interspersed with grassy meadows. During summer months, this portion of the drive offers respite from the desert heat for which Arizona is well known, and in the winter, the road is commonly closed because of deep snow. Found here is a real surprise for those unfamiliar with Arizona: the Snowbowl Ski Resort, with thirty-two runs and two lodges. During winter, the Snowbowl is a first-class skiing area, while in summer, it is a haven for mountain bikers and hikers.

The forest then abruptly gives way to high-desert landscapes of cedar groves, rocky outcroppings, and open vistas that stretch toward the deep canyons that lie to the north. A gentle series of descending grades and sweeping curves lead to the Coconino Plateau and to the junction with Arizona Highway 64, with its grassy plains.

Driving north, there are deep arroyos that appear as incisions in the gently rolling hills and a gradual return to forested country near Tusayan are central to this portion of the drive. Just six miles from this tourist mecca is the storied, world-famous South Rim of the Grand Canyon.

The Grand Canyon is without equal in its beauty. Even man's intrusions—including the recently renovated El Tovar Hotel, built in 1905 on the canyon rim—cannot diminish the sense of awe inspired by standing on the precipice above this gorge and watching an ever-changing kaleidoscope of color and shadows sweep across the canyon.

During summer months, traffic congestion becomes a serious and often frustrating problem here. Park at Grand Canyon Village and utilize the free shuttle service that provides access to some of the more scenic locations. Another option is to park in Williams, sixty miles to the south, and take the historic Grand Canyon Railway. From 1901 to 1968, the railroad served as a key link to the Grand Canyon. In 1989, after a twenty-year closure, restoration was completed and steam engines were once again pulling a string of vintage coaches transporting visitors to the canyon. (For more

FLAGSTAFF: ALMOST HOLLYWOOD?

Flagstaff is a modern, bustling community, known throughout the world for Northern Arizona University, the city's association with Route 66, and world-class skiing under the shadow of the San Francisco Peaks that rise above town. However, in 1911, an icy wind and a touch of snow was all that kept it from being world famous for another reason.

It was in 1911 that Cecil B. DeMille and Jesse Laskey decided their New York–based motion picture company needed a new location, somewhere with clear skies and open space for the filming of outdoor movies. When the westbound train pulled into Flagstaff, the deep-blue skies and the breathtaking beauty of the towering San Francisco Peaks contrasting with the surrounding forest of ponderosa pines immediately appealed to their artistic sensibilities.

Their excitement was short-lived. A few days later, a bone-chilling wind swept through the streets. An icy drizzle followed by a heavy snow came in on its heels, and the itinerant filmmakers quietly packed their gear along with their dreams onto the next westbound train. They did not stop until they came to sunny southern California, and the rest, as they say, is history.

information about the railroad or the restored Fray Marcos Hotel, which also serves as the depot, call 800-843-8724.)

The drive east from Grand Canyon Village along Arizona Highway 64 (East Rim Drive) is thirty-seven miles of scenic wonder and diversity. Glimpses of the Painted Desert, shadowed forest, vistas that show the Grand Canyon from different angles (such as that at South Rim Desert View), and the raw beauty of the Little Colorado River squeezed into a narrow chasm of colorful stone are a foretaste of what is to come on the return to Flagstaff via U.S. Highway 89.

Long before the junction with U.S. 89, the landscape takes on a more stereotypical Arizona feel. This is the northern end of the Painted Desert. Multihued hillsides, broken only by dark volcanic outcroppings, seem to march to the eastern horizon, while the often snow-covered San Francisco Peaks loom to the south.

The return to Flagstaff via U.S. Highway 89 should include a short detour through Wupatki National Monument and Sunset Crater Volcano National Monument. This loop drive is of scenic as well as historic interest.

Wupatki, Hopi for "tall house," is the largest collection of prehistoric ruins discovered in northern Arizona. Of particular interest is the only prehistoric ball court (a clay court with stone loops on walls for teams to toss rubber balls through) found in the Southwest and an intriguing hole where warm air from deep underground billows. Nearby is Siapu Canyon, where the Hopi people believe a pair of caverns is found that serve as the opening from which their ancestors arrived from the underworld.

Sunset Crater is a cinder cone that rises to a thousand feet above a volcanic plain. The plain is almost eerie and seems to be a scene from another planet. John Wesley Powell, the legendary one-armed explorer of the Grand Canyon, noted during his expedition in 1869 that "[w]hen seen from a distance in the setting sun the bright red cinders seem to be on fire. From this we gave it the name Sunset Mountain."

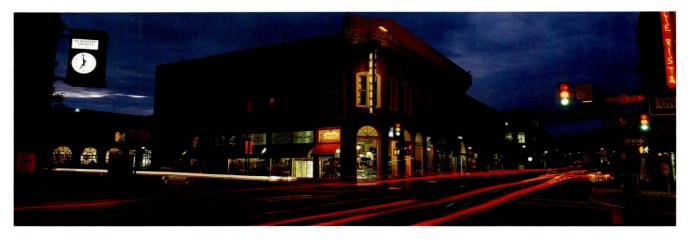

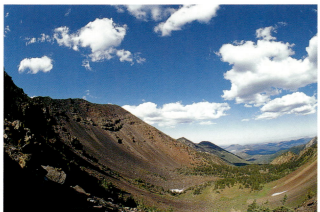

ABOVE:
Night descends on Aspen Avenue in the historic district of Flagstaff.

LEFT:
The inner basin below Humphreys Peak, elevation 12,600 feet, makes for an excellent summer escape from the desert heat.

BELOW:
Towering aspens like these in Lockett Meadows abound in the San Francisco Peaks.

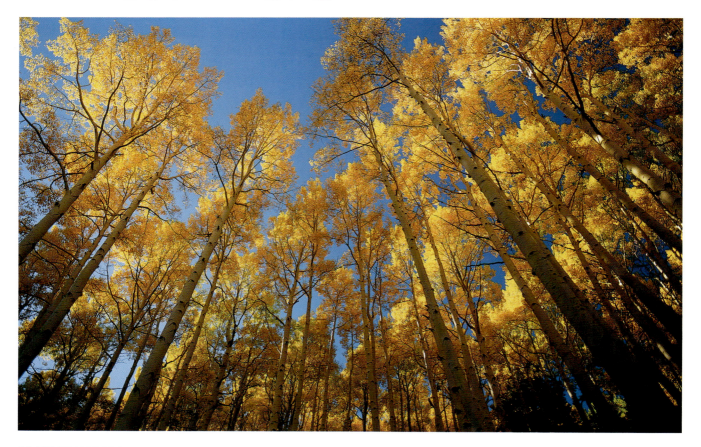

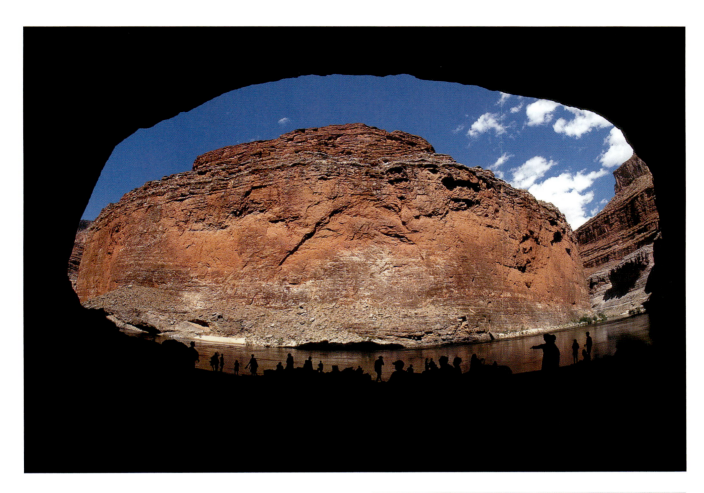

ABOVE:
The opening of Redwall Cavern in Grand Canyon National Park appears to be a portal to another world.

RIGHT:
As tourists have for nearly a century, visitors to the Grand Canyon travel via mule into the canyon's depths.

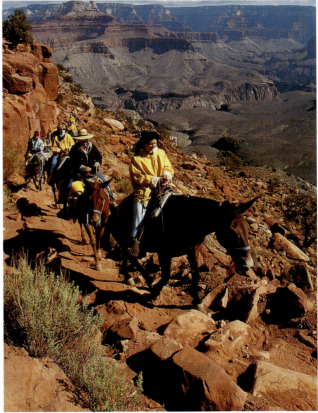

A PERFECT PLACE TO STARGAZE

In 1893, Dr. Percival Lowell chose Flagstaff for its elevation, location, and clear mountain air as the site for an observatory where he could chart the path of Mars. Additionally, he hoped to verify his theory that intelligent life had constructed canals on the red planet.

Even though Lowell's observatory never enabled the founder to prove his pet theory, it did enable other astronomers to verify his prediction of the discovery of a ninth planet. In 1930, fourteen years after Lowell's death, Clyde Tombaugh found the planet now known as Pluto while studying photographic plates.

Today, the Lowell Observatory at the top of Mars Hill is a major attraction. It continues to be an important instrument in our exploration of the final frontier.

The Lowell Observatory, where astronomers verified the existence of Pluto.

Adding to the almost-mythical aspects of the wild landscape of this volcanic park are several caves where it is so cold, even during the warmest summer months, that the inner walls are lined with ice. In the 1880s, enterprising saloonkeepers in nearby Flagstaff hired freighters to haul ice from these caves.

For a short distance after the return to U.S. 89, the road seems to be suspended between a colorful desert of volcanic cinder and the forested flanks of the San Francisco Peaks. The illusion is soon broken as the highway cuts a swath through thick forest of towering ponderosa pine near Flagstaff.

The return to Flagstaff's historic district is via historic Route 66. While survivors from the glory days of the highway are numerous, one true gem, a veritable icon worthy of a stop, is the historic Museum Club, a roadhouse that seems to have been immune to the passing of decades.

The towering San Francisco Peaks near Flagstaff are considered sacred by the native people who originally lived in the area, as well as by the Hopi and the Navajo.
Author's collection

Spanish explorers were the first Europeans to visit the Grand Canyon, but American trappers and explorers made more inroads into its depths. Major John Wesley Powell made a treacherous trip by boat down the length of the canyon in 1869 and Colonel Theodore Roosevelt took a party down the Bright Angel Trail in 1911, eight years before the Grand Canyon became a national park.
Library of Congress

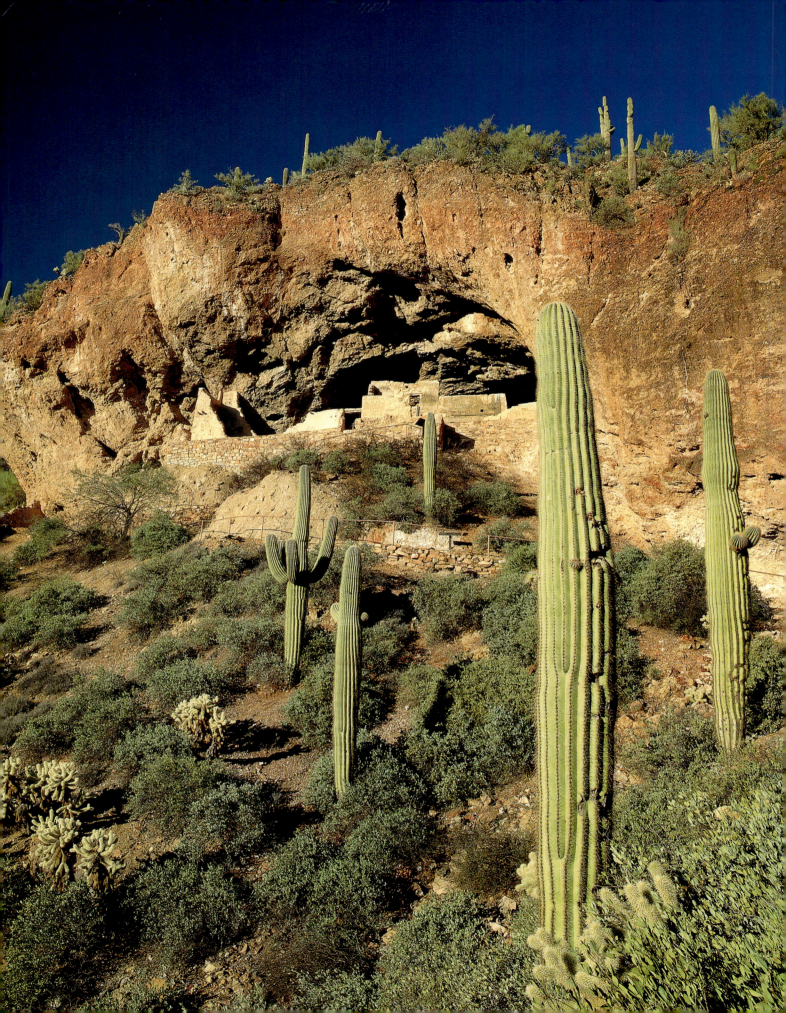

CENTRAL ARIZONA

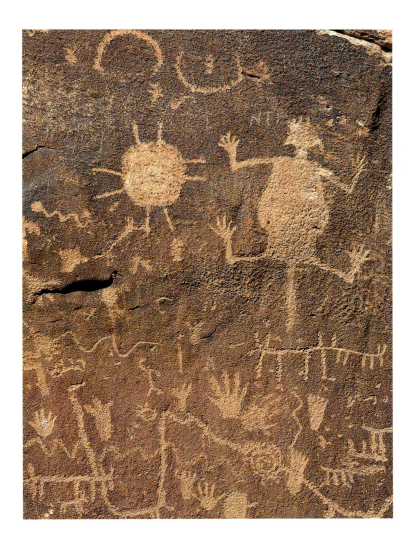

FACING PAGE:

Sheltered in an alcove of stone, the lower ruin in Tonto National Monument has stood for centuries in this harsh land.

ABOVE:

The petroglyphs on Newspaper Rock in Petrified Forest National Park tell a tale no one can now read.

For those unfamiliar with Arizona, the central portion of the state will be the most surprising. Deep forests of towering pines, flower-filled meadows, quiet brooks, and quaint mountain communities are just a few of the treasures found here.

Opportunities for outdoor recreation abound. For those who enjoy hunting with gun, bow, or camera, a wide variety of game abound here, from deer and elk to turkey and antelope. Anglers will thrill at the miles of streams, and in the winter they can even try their hand at ice fishing.

For those who enjoy camping under a starlit sky, there are nearly unlimited opportunities that run the gamut from primitive and remote to easily accessed. If hiking or mountain biking is your passion, hundreds of miles of trails and old roads wind through the forests, over mountain slopes, and to overlooks with million-dollar views.

As with all of Arizona, this region is rich in history. The old territorial capital of Prescott (pronounced to rhyme with *biscuit*) is a cornucopia of architectural gems. Jerome combines a ghost-town experience with all the comforts of the modern era. For those willing to make the challenging journey to Crown King, the reward is good food, quaint lodging, and a quiet respite from the rest of the world.

At first, central Arizona seems almost out of place with what most people expect to find in this state. But as you drive its quiet backroads, talk with those who call these mountains home, and savor the smells, sights, and sounds of the area, it becomes apparent this is one of the unique patches in the crazy quilt that is Arizona.

THE CORONADO TRAIL
HOLBROOK TO CLIFTON

ROUTE 11

From the Holbrook historic district, follow U.S. Highway 180 south to the entrance of the Petrified Forest National Park. U.S. 180 joins with U.S. Highway 191 at St. Johns, 36 miles south of the Petrified Forest National Park entrance, and together they run to Alpine before separating. From Alpine, take U.S. 191 south, which is marked as the Coronado Trail Scenic Byway from Springerville.

The historic district of Holbrook has seen better times, but there are some dusty architectural treasures here, wonderful traces from when this area was civilization in a sea of wilderness. There are also buildings that remind visitors of a time when the highway sign with two sixes on it was akin to the Yellow Brick Road.

The picturesque old railroad depot, constructed of locally quarried stone, hearkens to the era of the western frontier. The refurbished Wigwam Village Motel represents a later time—the golden age of station wagons and family vacations. This unique lodging attraction, with its individual cabins disguised as teepees, has become an icon of Route 66. In actuality, the concept was conceived in Kentucky and sold as plans to lodging entrepreneurs during the 1950s; three such lodges remain—one in Kentucky, one in Arizona, and one in California.

Leaving Holbrook on U.S. 180 on the vintage bridge that spans the Little Colorado River fosters the illusion that somehow you have managed to slip back in time. The colorful rolling hills of the Painted Desert, broken only by the thin ribbon of asphalt, are just as they were in the 1950s.

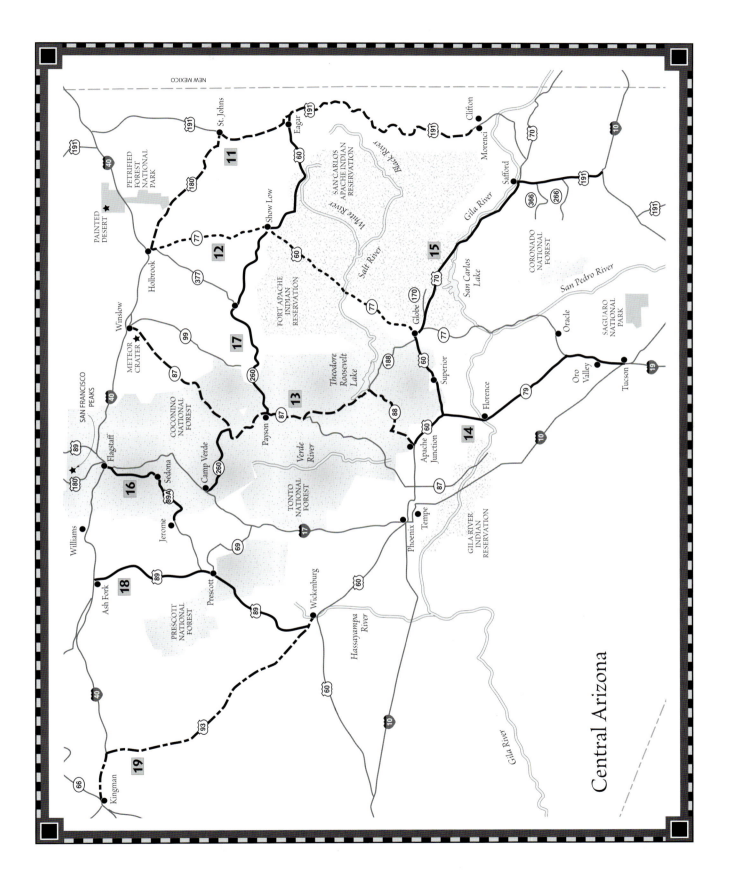

Central Arizona

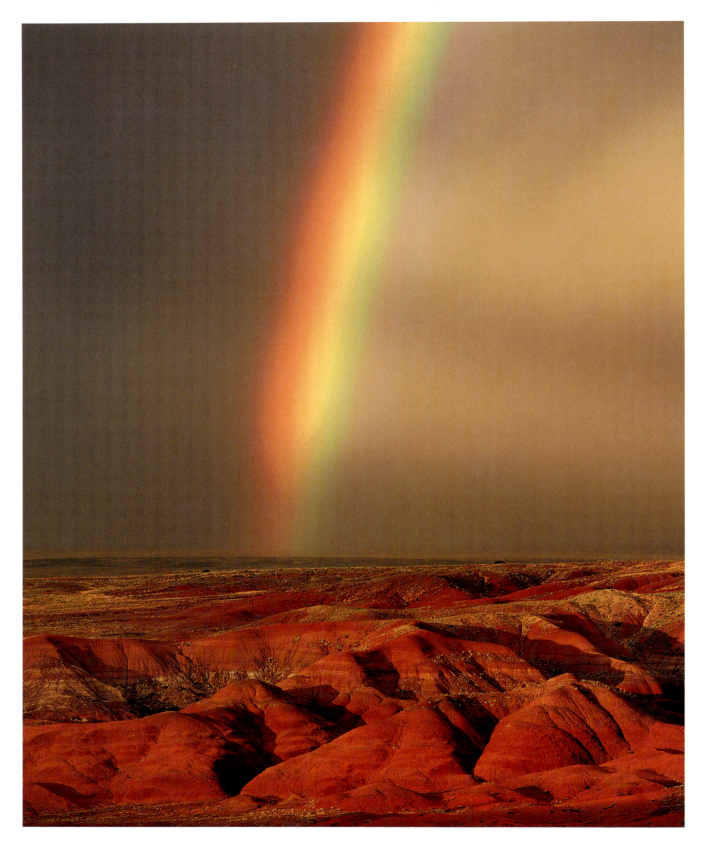

A monsoon rainbow seems to spring from the colorful hills of Tawa Point in the Painted Desert at Petrified Forest National Park.

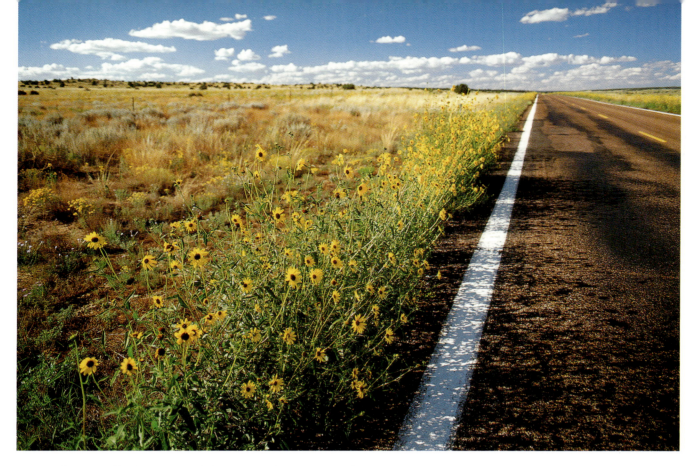

Spring flowers add color to a stark landscape of stone south of Sanders on Highway 191.

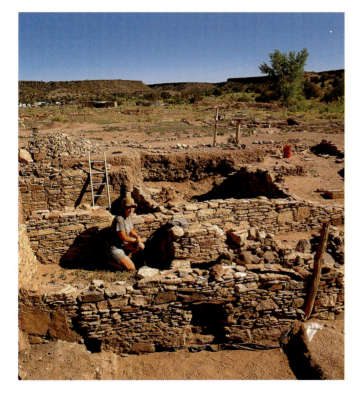

Archaeologist Katie Skovron seeks answers to the unsolved mysteries of the desert as she excavates the Raven Site in the hills above the Little Colorado River.

The intricacies of precious petrified wood are captured in this closeup shot taken at Crystal Forest in the Petrified Forest National Park.

The multihued landscapes of the Painted Desert, dotted with an intriguing forest of stone trees, have long been a major attraction for Arizona visitors. This postcard dates to the 1920s. Author's collection

For additional travel back in time, try the short, scenic detour loop (up and back on the same road) through the Petrified Forest National Park. Littered across the colorful moonscape here is a veritable forest of stone logs, remnants from when a thick coniferous forest covered this land and when dinosaurs dominated the earth.

The south entrance to Petrified Forest National Park, off U.S. Highway 180, is well marked. This detour begins with a stop at the park's visitor center and museum, which has an excellent display of fossilized remains of the reptiles that once roamed this forest, as well as souvenir pieces of petrified wood and other fossils. Here, you can pick up a descriptive brochure with a map that designates the highlights of a drive through the park.

From St. Johns and into Springerville, U.S. 180 is a relaxing drive through grassy plains littered with dark volcanic rubble. Here and there, small farms and sleepy communities nestled in little valleys serve to offset the harshness of the land.

It is Spanish legend that during the Moorish invasion in the Middle Ages, seven bishops and many members of their congregations set sail from Spain for a new land, where they founded seven cities of gold—the cities of Cibola. In 1540, Spanish conquistador Francisco Vasquez de Coronado, accompanied by three hundred soldiers and nearly one thousand Tlaxcalan Indians, entered what is now eastern Arizona, in search of these legendary cities. As Coronado headed north toward the Zuni Pueblos, the route he chose roughly parallels what is today U.S. Highway 191, also known as the Coronado Trail. Today, it is a beautiful, scenic, 130-mile drive through the Apache-Sitgreaves National Forests. (The Coronado Trail Scenic Byway is well maintained, but inquire about road conditions during winter months, because of the dramatic elevation changes.)

Breathtaking vistas, miles of hiking and biking trails, ancient volcanoes, and, in winter months, ice fishing opportunities are just a few of the highlights found along this portion of the drive. For the angler, U.S. 191

provides access to 450 miles of fishable streams, making this area one of the top-ten fishing areas in the entire national forest system.

Springerville and its neighbor Eagar are rather quaint, quiet little farming and ranching communities that seem locked between the frontier era and modern time. They serve as a base camp for hunters and anglers who come to the White Mountains in search of adventure. They are also excellent places to top off the gas tank and fill the ice chest as, with the exception of Alpine, there are almost no services between here and Morenci.

The modern incarnation of the civilization that is Springerville began in 1879 with the arrival of Mormon pioneers. Casa Malpais Archaeological Park to the north of town provides evidence that this beautiful valley was once an important center of commerce more than six hundred years before the arrival of the Mormons. In downtown Springerville, across from the post office on Main Street is a monument to the community's importance as an outpost both for old-time pioneers and for modern-day pioneering motorists. The *Madonna of the Trail* statue was one of twelve placed along the National Old Trails Highway in the 1920s by the Daughters of the American Revolution.

A few miles from Springerville, as U.S. 191 begins a steep ascent to higher elevations, there are awe-inspiring views of the deep-green valley that seems to stretch to the horizon. These views are abruptly cut off as the road goes through a series of twists and turns, then drops over a rise and squeezes into a small valley dominated by Nelson Reservoir, a sixty-acre lake that is well stocked with rainbow, German brown, and brook trout.

The pine-covered slopes of Escudilla Mountain soon give way to deeply shadowed forests of aspen and spruce interspersed with rolling high-country meadows. This portion of the Coronado Trail is a favorite for those in search of fall color or late-spring wildflowers.

The community of Alpine, which received its name as pioneers noted the similarities between the surrounding mountains and the Swiss Alps, is at the heart of this forested oasis. Today, the community is quickly attracting the attention of those who seek respite from the heat of summer in the deserts to the south and those who enjoy winter sports such as dogsledding.

From Alpine, the highway gently threads its way through thick forests broken only by sunny meadows. In season, an observant traveler can spot deer, elk, wild turkey, bear, and even Mexican gray wolves. For those with an adventuresome spirit who choose to hike into the bordering Blue Range Primitive Area, it is possible to experience Arizona as it was upon the arrival of the first Anglo explorers, though without the Apache encampments and grizzly bears.

Until the postwar years, the only stop on the eighty-nine-mile drive between Alpine and the mining community of Morenci was Hannagan Meadows. A rustic lodge and a small store are still there, as are a wildflower-filled meadow with a thick forest surrounding it. Amenities now also include horseback-riding stables, a small campground, and cabins.

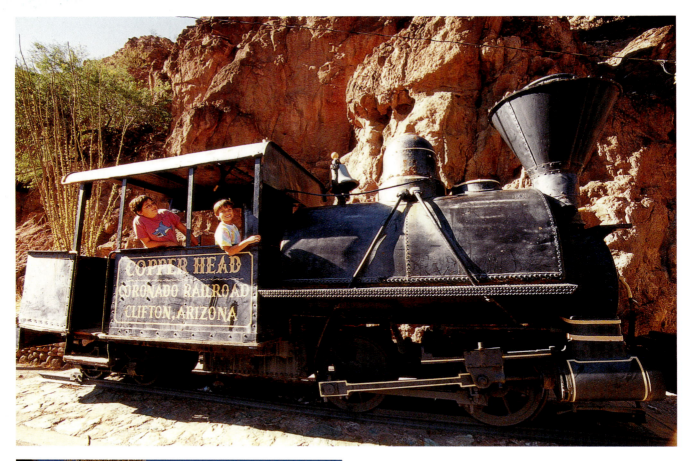

ABOVE:
In Clifton, a vintage locomotive once used on the Coronado Railroad serves as a link to the past for younger generations.

LEFT:
The first resident of the old Clifton jail, hewn from a rock face above the San Francisco River in 1881, was the miner who dug the jail's tunnels.

OPPOSITE PAGE:
The San Francisco River is a rare gem in the deserts of southeastern Arizona.

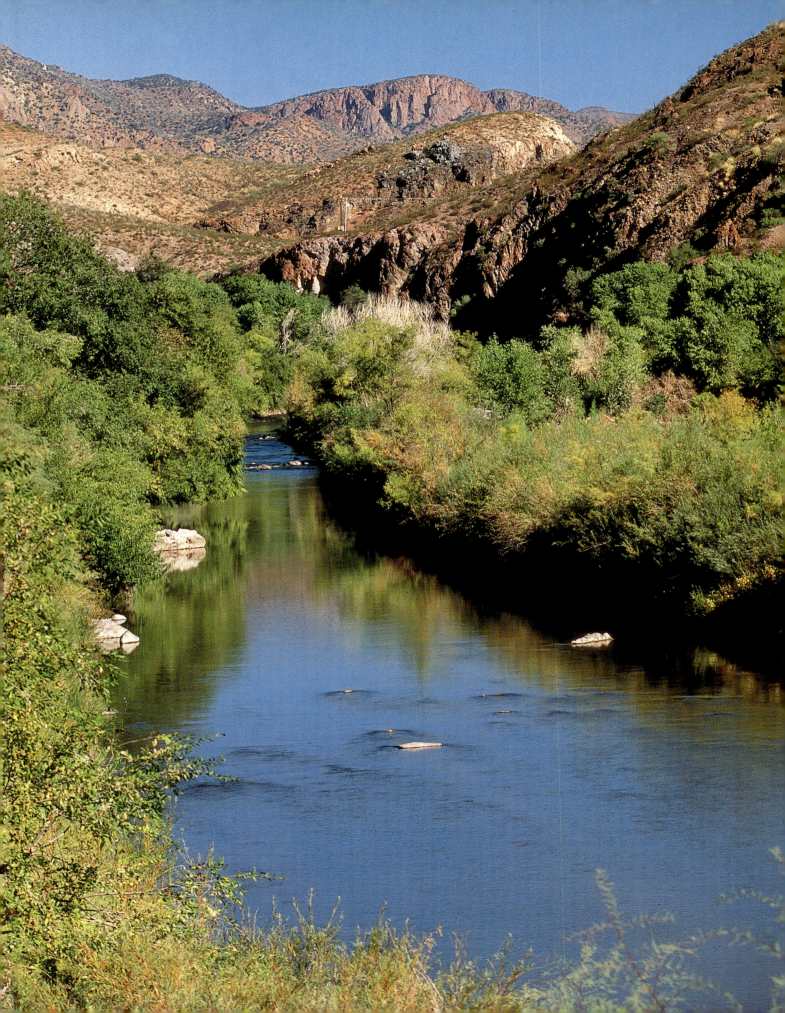

The drive south initially is through forested country similar to that found between Alpine and Hannagan Meadows. With a series of steep, sharp curves, the highway then begins a precipitous descent to the desert far below. Along the way, each twist and turn awards breathtaking vistas that stretch to the western horizon.

After an almost uninterrupted drive of more than one hundred miles through Arizona wilderness, rounding a sharp turn to view the gaping maw of the Phelps-Dodge open-pit copper mine at Morenci can be shocking. Manmade wonders are part of the beauty found in this drive.

Morenci is an old mining community that dates to 1872. By the late 1950s, the Phelps-Dodge mine located here was the second-largest open-pit operation in the United States and the fourth largest in the world. Unfortunately, as the pit grew, the town was often relocated, and now there is little left from the frontier period.

Clifton, on the other hand, which lies just a few miles to the south, is an almost perfectly preserved representation from Victorian times. Victorian-era homes, a vintage red-brick train depot on the banks of the San Francisco River, and a historic business district little changed over the past century give this small community a unique atmosphere. What really sets it apart is its one-of-a-kind jail. Carved in 1881 from a solid rock face on the plain above the river, the Clifton jail was truly escape-proof. There was only one way in and one way out. Legend has it that the hard-rock miner contracted to dig the main shaft into the mountain and the cells that adjoined it celebrated the jail's completion with a wild time at Hovey's Dance Hall. As a result, he became the new jail's first resident.

It is estimated that a climb of one thousand feet in elevation is equivalent in flora and fauna changes to that found if you drove six hundred miles from south to north. If this is true, then a drive on the Coronado Trail between Clifton and Springerville is equal to a drive from Mexico to Canada.

COWBOYS, MINERS, AND APACHES
HOLBROOK TO GLOBE

ROUTE 12

From Holbrook, take Arizona Highway 77 south 48 miles to Show Low, and then go south on U.S. Highway 60 to Globe. To reach Fort Apache, turn east on Indian Highway 73. The junction of Highways 60 and 73 is 25 miles south of Show Low at Carrizo Junction.

What is now the sleepy community of Holbrook was a century ago the epitome of a Wild West frontier town. One journalist from the East Coast noted that this town was "too tough for woman or children." Drunken shootouts in aptly named establishments, such as the Bucket of Blood Saloon, and fights over control of the rich grasslands were the norm.

The best place to begin this driving adventure is at the Navajo County Courthouse at 100 East Arizona Street. Listed on the National Register of Historic Places, the courthouse was built in 1898 and today serves as an informative museum and visitor center. A Holbrook walking-tour guide lists numerous historic sites.

The drive south on Arizona Highway 77 takes you into rolling hills carpeted with deep grasses, which once served as the foundation for vast cattle

A TRUE OLD WEST KIND OF TOWN

Today, Holbrook is a sleepy, dusty little town heavily dependent on the traffic that passes by on Interstate 40, visitors to the nearby Petrified Forest National Park, and Route 66 enthusiasts. However, just over a century ago, this was a boomtown, the center of what would become one of the largest ranching enterprises in the nation: the fabled two-million-acre Aztec Land and Cattle Company, better known as the Hashknife outfit. Legendary Tombstone had nothing on Holbrook when it came to colorful characters, gunfighters, and lawmen.

Commodore Perry Owens was a handsome man with long flowing hair who wore his pistols turned backwards. Many in the community thought he wasn't very tough. Then came the day in 1887 when he rode to the home of the Blevins family to serve a warrant on Andy Cooper for stealing horses. Within minutes, Cooper, Mose Roberts (a distant relative), John Blevins, and Sam Houston Blevins (fourteen years of age) were all either dead or mortally wounded. Even though the men had been heavily armed, only one shot was fired before Owens took them all down.

Then there was Sheriff Frank Wattron. In 1899, he received a written reprimand from President William McKinley for the invitation he sent for a hanging: "George Smiley—Murderer. His soul will be swung into eternity on December 8, 1899, at 2 o'clock P.M. sharp. The latest improved methods of scientific strangulation will be employed and everything possible will be done to make the surroundings cheerful and the execution a success."

empires and still support smaller spreads. At the crest of each hill, there are pleasant views of a land unchanged through generations.

The small farming community of Snowflake is the first town south of Holbrook. Contrary to popular legend, this little town, one of the first Mormon settlements in the state, was not named for anything that fell from the sky, but rather for its founders, William Flake and Erastus Snow. In 1878, Flake purchased the land for the original town site from James Stinson, a local rancher. Shortly after his partner, Snow, joined the venture, they found that the title for the property originally belonged to the Santa Fe Railroad, which had in turn sold it to the now-legendary Hashknife Ranch. These land troubles, and hostility toward Flake's religious beliefs about polygamy, landed Flake in the infamous Yuma Territorial Prison in 1884.

Until quite recently, the community passed the years with little change. However, like much of rural Arizona, Snowflake is now undergoing a dramatic transformation, as newcomers to the state discover it and other hideaways. In spite of the many recent changes, its historic district, with its cornucopia of well-preserved Victorian and Greek Revival homes, is a true gem that is best enjoyed on foot.

A few miles south of town, Highway 77 enters the Apache-Sitgreaves National Forests, and the roadside is dappled with the shade of towering pines. This area is an excellent summer getaway, a fact attested to by the growth of such communities as Show Low, where the construction of summer homes is booming.

While the main route for the remainder of this drive, U.S. Highway 60, is quite scenic as it passes through the Fort Apache Indian Reservation, travelers searching for authentic Arizona history should consider a short

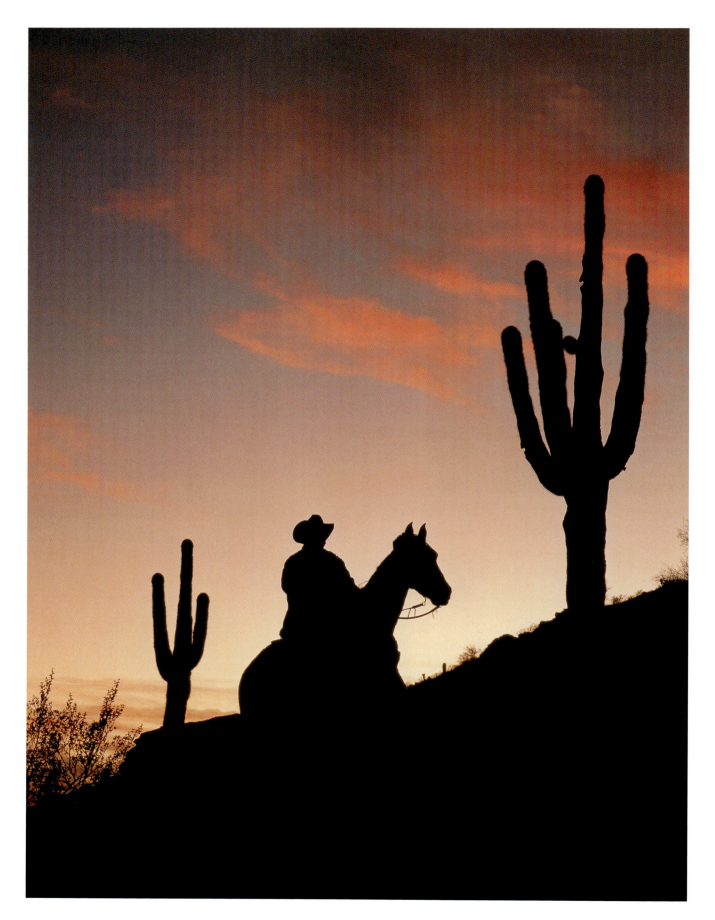

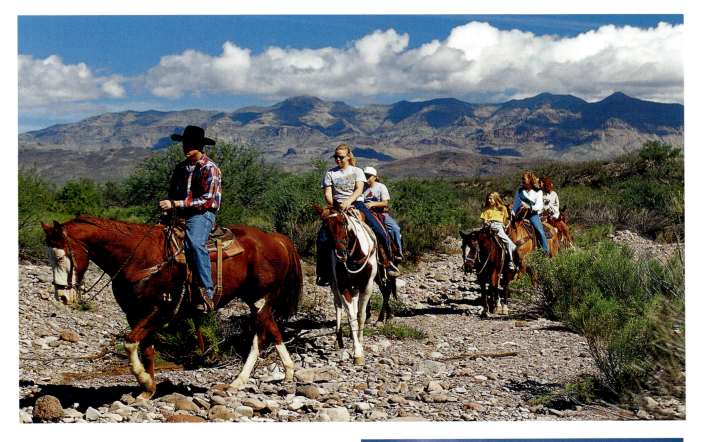

detour to Fort Apache on Indian Highway 73. This well-preserved outpost is a symbol of frontier Arizona. From 1870 to 1922, the fort served U.S. government troops as a base for the campaign against Geronimo and Cochise and later as a site for keeping the peace.

A recent addition to Fort Apache Historic Park is the Apache Cultural Center. The highly detailed exhibits profile the evolution of the Apache culture and people, providing contrast as well as balance to understanding the history of the area.

On the border between the Fort Apache Indian Reservation and the San Carlos Apache Indian Reservation is a delightful picnic area and scenic overlook. The attractions here are striking views of the rocky chasm known as the Salt River Canyon.

From this point, the combined Highway 77 and 60 begins a series of twists and turns as it descends from the Natanes Plateau to the desert. The reward for some white-knuckle mountain driving is impressive views of the rugged escarpment that serves as a buttress for the Salt River Canyon Wilderness or views of the desert valley below.

This journey ends in the historic mining community of Globe, which was once a roaring mining camp but is now well on its way to becoming an arts-and-crafts community. The historic district is composed of a little more than two-dozen buildings that date from just before the turn of the twentieth century up until the mid-1920s. Many buildings are being reborn as antique stores.

Located in the former rescue station for the Old Dominion Mine, built in 1920, is the Gila County Historical Museum, where, in addition to discovering the rich history of the area, you can obtain information and directions to Besh-Ba-Gowah Archaeological Park—an excavated, reconstructed pueblo house. Besh-Ba-Gowah is a very rare remnant of the Salado people, who occupied the area around A.D. 1225. A self-guided tour allows for exploration on the same trails used by the original settlers, and a rough-hewn ladder provides access to the house's first floor, giving you a feel for what life must have been like so long ago. An on-site museum features the largest collection of Salado pottery in the world.

LOST TREASURE, ICE CREAM, AND PINE-SCENTED BREEZES
APACHE JUNCTION TO WINSLOW

In the eastern corner of the Valley of the Sun, nestled in the foothills of the legendary Superstition Mountains, lies the frontier town of Apache Junction. Even though the area is experiencing meteoritic growth and the town is fast becoming a bedroom community for nearby Mesa, remnants of its rich past are treasured by the community.

Memorialized every February during Lost Dutchman Days is one of the town's most famous residents, a miner named Jacob Waltz, who was

The rugged Superstition Mountains have become legendary for their association with tales of treasure, such as the Lost Dutchman's Mine. Author's collection

better known as "the Dutchman." The event also commemorates the town's frontier heritage with a rodeo and a parade.

The Superstition Mountains—a rugged mountain range of volcanic origin that has claimed the lives of many adventures who have sought the legendary Dutchman's treasure—serve as backdrop to the town. Numerous well-marked trails provide access to the heart of this desert wilderness and to Lost Dutchman State Park, but these trails are not for novice hikers or for those unfamiliar with the desert's unique dangers.

The drive between Apache Junction and Tonto National Monument is unique in that much of the route, as well as the scenery, has changed little over the past century. Even the name of the road, Apache Trail Scenic Byway (Arizona Highway 88), hearkens to an earlier time when stagecoaches followed this canyon down to the desert valley. Numerous other attractions along this scenic byway serve to accentuate the desert beauty and history that abounds here. The re-created mining town of Goldfield—with its Lost Dutchman Museum, saloon, gunfight reenactments, shops, the opportunity to try your hand at gold panning, and an operating narrow-gauge railroad—add a touch of fun to the Wild West.

Perhaps the most noticeable change from the frontier era has been the damming of the Salt River and the creation of Canyon Lake. An excellent way to enjoy this scenic wonderland, known locally as the "Junior Grand Canyon," is aboard the Dolly Steamboat, which plies the waters of Canyon Lake. The modern metropolis of Phoenix is but a few short miles away, and, as a result, the Canyon Lake area is prime weekend recreation for those in search of respite from the searing heat of summer. In spite of this, there are still places that predate the era of hustle and bustle. A short distance upriver from Canyon Lake is just such a throwback.

The modern incarnation of Tortilla Flat—a combination restaurant, gift shop, motel, saloon, and grocery store—dates to the establishment of a post office there in 1927. Long before the post office even existed, there was a stagecoach station near here, which also met the needs of hot, weary trav-

ROUTE 13

Begin in Apache Junction and wind north on Arizona Highway 88 (the Apache Trail Scenic Byway) 46 miles to the junction with Arizona Highway 188. (Please note that about 20 miles of this route is over graded gravel roads.) Continue north 31 miles on Highway 188 to Arizona Highway 87, the Bee Line Highway. Follow Highway 87 north to Winslow. Homolovi State Park is 3 miles north of Winslow on Highway 87. Meteor Crater is west of Winslow at exit 233 on Interstate 40.

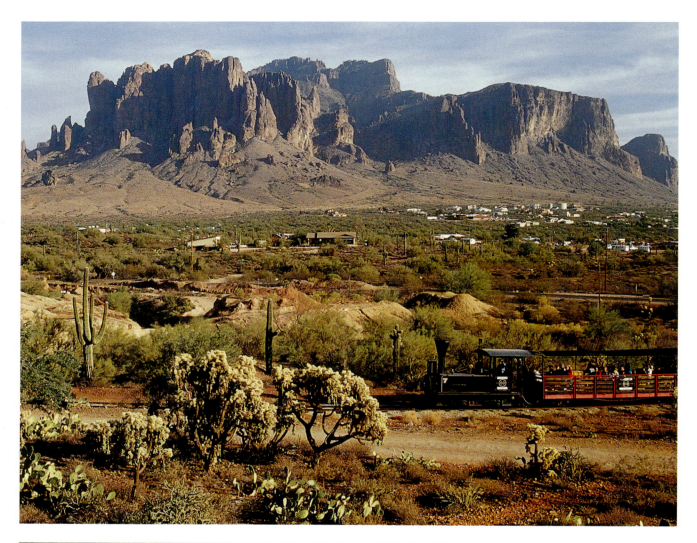

ABOVE:
With the legendary Superstition Mountains looming in the distance, the Gold Field train chugs through a landscape little changed since "the Dutchman" sought his fortune here.

LEFT:
On Rogers Canyon Road in the Superstition Mountains, spring flowers transform the forbidding landscape into a colorful carpet.

OPPOSITE PAGE:
East of Tortilla Flat, the Apache Trail twists and turns with the contortions of an ancient land.

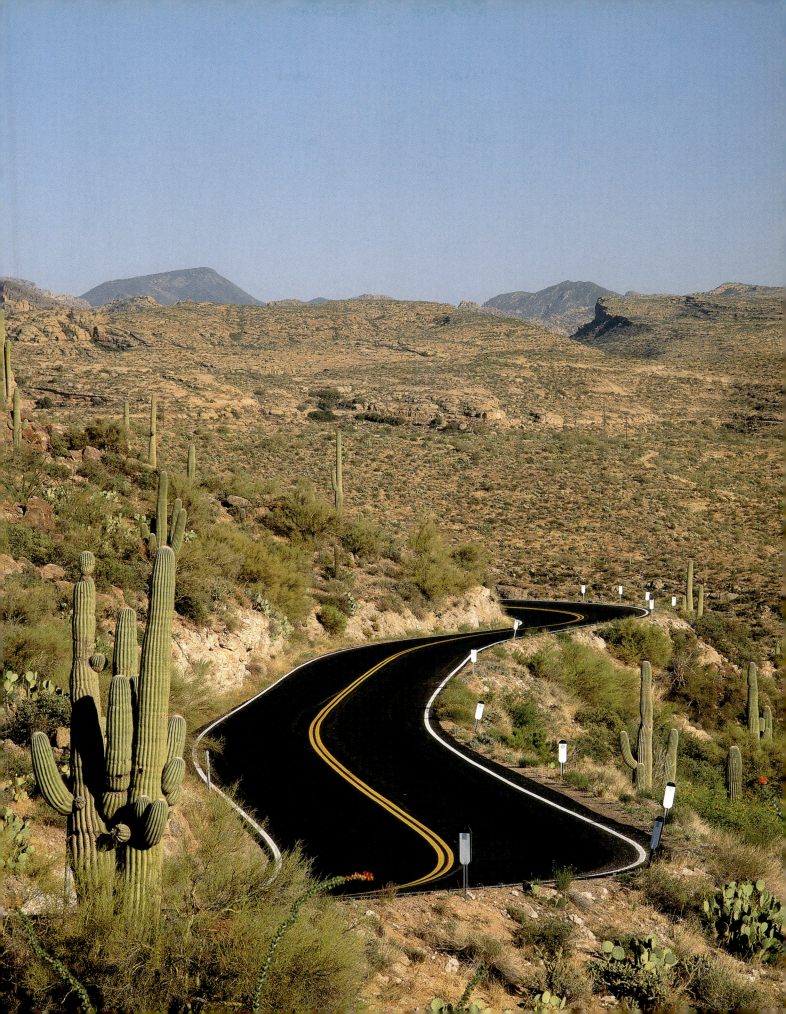

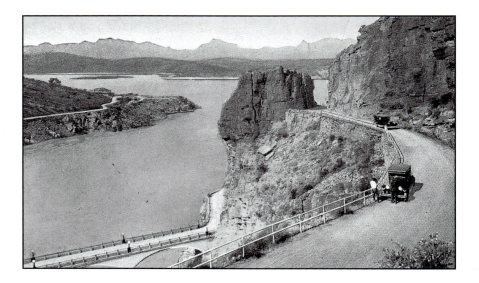

The Apache Trail effectively ends at the shores of scenic Theodore Roosevelt Lake, created when the Roosevelt Dam was constructed to impound the waters of the Salt River and of Tonto Creek. Author's collection

elers along the Apache Trail. The little roadside stop takes its name from the odd, flat-topped mountains that serve as a backdrop. While surveying the territory in 1853, boundary commissioner Major William Emory listed this small range as the Tortilla Mountains. No stop in Tortilla Flat today is complete without sampling the famous prickly pear ice cream.

The Apache Trail effectively ends at the shores of scenic Theodore Roosevelt Lake, created when the Roosevelt Dam was constructed to impound the waters of the Salt River and of Tonto Creek and to irrigate the Salt River valley, making it possible for the city of Phoenix to become an agricultural powerhouse. The first stones of this historic dam's foundation were laid on September 20, 1906, and the dedication by Theodore Roosevelt took place on March 18, 1911.

As Arizona Highway 188 heads north along the lakeshore, the saguaros, rocky hillsides, and desert landscapes soon give way to cedar-studded hillsides after joining Arizona Highway 87, the Bee Line Highway. Steep grades and sharp curves twist ever higher, until the highway enters the shade-dappled ponderosa pine forest near Payson. Then, after a bit of urban sprawl in Payson and a few more twists higher into the mountains, the land abruptly smoothes out into a series of gently rolling hills within Coconino National Forest.

Almost as suddenly, the land then begins to drop from the forest onto high-desert grassy plains dotted with stands of cedar and juniper, and the highway begins to flow gently over rolling hills. The small historic railroad town of Winslow appears closer with the cresting of each hill.

Winslow is another historic community that has seen better times. Today, it is comparable to a dusty jewelry box filled with a mix of gems and costume jewelry: there are true treasures for those who take the time to look. Topping the list of treasures is the recently renovated La Posada, an original Fred Harvey hotel.

Long before Winslow was immortalized in a song about a girl in a flatbed Ford, this beautiful sixty-thousand-square-foot hotel, designed in

The cliff dwellings found in the Tonto National Monument along the Apache Trail provide a tangible link to a forgotten civilization that tamed the desert centuries before the arrival of the Anglo. Indications are that this is a remnant of the Salados people. Author's collection

the Spanish Mission style, was recognized as one of the finest lodging and dining establishments anywhere along the Santa Fe Railroad. Built in 1930 at a cost of more than $1 million, it attracted some of the most famous celebrities of the day, and during World War II, thousands of troops passed through the dining room every day. The postwar decline in rail travel resulted in its closure in 1958.

The Minnetonka Trading Post represents an earlier frontier time in Winslow. This establishment actually began as a rough shack on the famous Hashknife Ranch, a part of the Aztec Land and Cattle Company that was one of the largest ranching outfits in the Southwest during the 1880s. Over the years, there have been a few additions to the structure, including the front wall, which is constructed almost entirely of petrified wood. Today, the Minnetonka is a popular watering hole for local cowboys, mazny of whom still earn their living on the open range.

Then there is the Old Trails Museum. Housed within its walls are artifacts from the town's namesake, General Edward Winslow, president of the St. Louis and San Francisco Railroad, along with artifacts of earlier residents who lived near here as early as A.D. 1200. However, the central focus in the museum is the history of what put this community on the map: ranching, the railroad, and Route 66.

Winslow is a central base from which to embark on numerous fascinating and unique day trips. Homolovi State Park is an archeological excavation in progress that is uncovering more than eight hundred years of Native American history. On occasion, the park allows for hands-on discovery, when visitors help with excavation and research. But this sprawling four-thousand-acre park is about more than ancient history. Numerous campgrounds and hiking trails provide access to the solitude and beauty of the high-desert plains with wind-sculpted red-stone spires, as well more-recent history, including a Mormon-pioneer cemetery.

A few miles west of Winslow, just south of I-40, lies Meteor Crater and a complex that includes the Museum of Astrogeology, a fine display

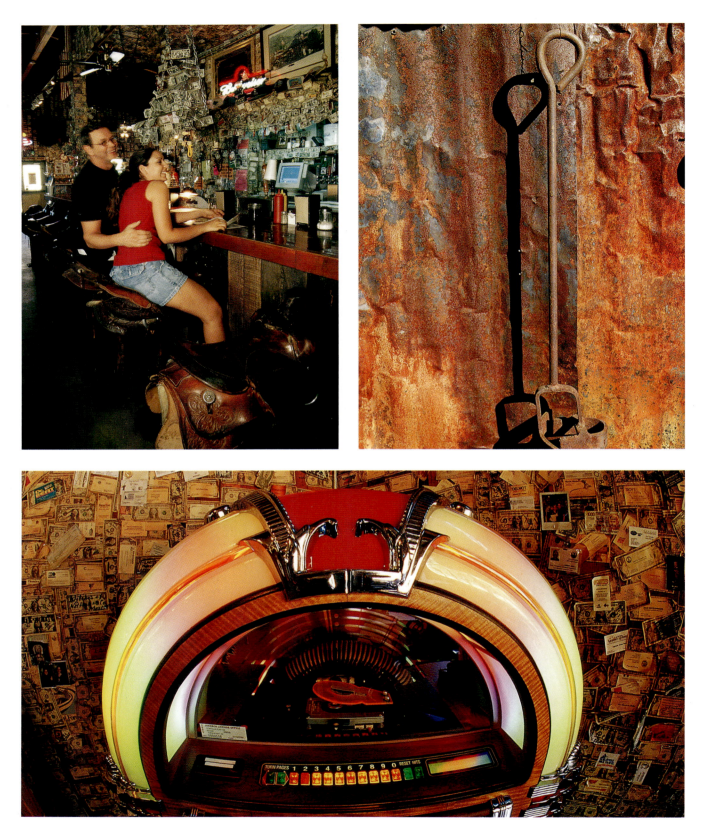

The Saddle Bar at the Tortilla Flat Saloon and Restaurant, complete with a branding iron and vintage jukebox as part of its décor, has served as a watering hole for thirsty travelers for decades.

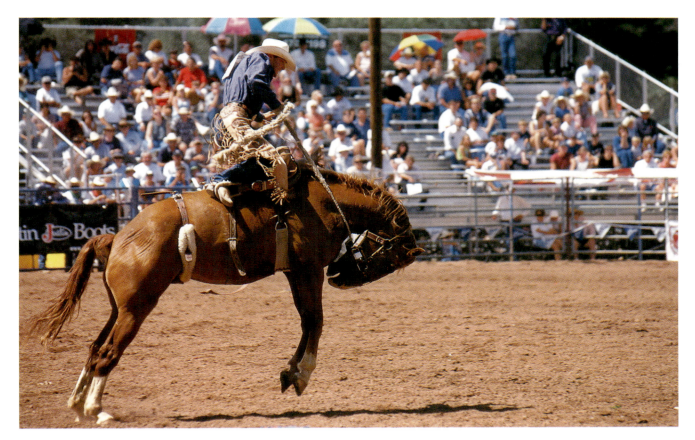

A bronc rider rides high at Payson's self-proclaimed "world's oldest rodeo," held every August.

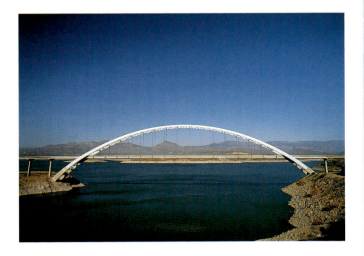

The beautiful Theodore Roosevelt Bridge on Highway 188 spans an arm of Theodore Roosevelt Lake, a favorite weekend getaway for Phoenix residents.

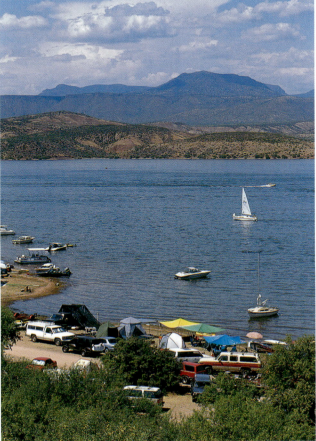

of minerals, and the Astronauts Hall of Fame. The centerpiece of this park is a massive crater—570 feet deep, nearly a mile wide, and three miles in circumference—created by meteoric impact. Apollo astronauts trained in the area in preparation for the moon landings. The area so closely resembles the moon's surface that skeptics thought images of the astronauts on the moon were actually shot here. Additionally, numerous science-fiction films have used the crater as scenery. The museum displays include a space capsule and monuments to the *Challenger* and other space-program disasters.

THE PAST, PRESENT, AND FUTURE
APACHE JUNCTION TO TUCSON

ROUTE 14

From Apache Junction, follow Arizona Highway 79 south to the Oracle junction, and then take Arizona Highway 77 (Oracle Road) into Tucson. In Tucson, follow River Road east to Sabino Canyon Road, and then drive north about 3 miles until the road ends at the Saguaro National Park visitor center. To complete this drive, reverse the route down Sabino Canyon Road to Wrightstown Road. This road ends at Harrison Road. There, turn south to Old Spanish Trail and follow the signs to Colossal Cave Mountain Park. Old Spanish Trail is also the access road to Saguaro National Park.

The drive south from Apache Junction on Arizona Highway 79 is scenic, treating travelers to a desert landscape of rocky ridges, looming fortresses of stone that seem to dominate the horizon, thorny bushes, cacti, and dry-wash gullies—the scenery one has come to expect as a result of cinematic epics and *Arizona Highways* magazine. Here and there, stands of salt cedar and mesquite can be seen as tapestry threads weaving across the desert, where dry streambeds cut across the valley floors.

The first stop along this drive is at one of those odd little places that is rich in history as well as scenery but that seems to go unnoticed by those seeking either. In the small community of Florence is a remarkably well-preserved, nationally registered Victorian-style business and residential district of 139 structures, including two courthouses. It is a true time capsule from the era when this part of the country was poised between the stirrup and the throttle.

The namesake for McFarland Historical State Park was Ernest McFarland, who served the state as an elected official in all three branches of government. The centerpieces of this park, located on the corner of Main and Ruggles streets in Florence, are the first Pinal County courthouse, built in 1878 from adobe bricks; a sheriff's office; and a court-recorder's office. The jail, built in 1882, is open for tours; it was a "modern" replacement for a facility where internment was in a windowless adobe cubicle with a burlap door. The possibility of escape was of little concern, as prisoners were chained to a large boulder that was buried in the jail floor.

The second Pinal County courthouse, which dominates the town of Pinal between Eleventh and Thirteenth streets, is a large, ornate red-brick edifice with a clock tower. Completed in 1891, the courthouse has been the stage for several pageants of Arizona history, most notably the 1899 trial of Pearl Hart, the last stagecoach robber in America.

In October 1940, in the desert south of Florence—near the Oracle junction with Arizona Highway 77 that will be the route into Tucson for this drive—speed and a shallow arroyo claimed the life of a pioneering cowboy and movie star, Tom Mix. A stone monument topped by the metal silhou-

ette of a horse marks the approximate location of the tragedy and commemorates the actor's love for his favorite steed, Tony the wonder horse.

The nearby town of Oracle has a long history that includes some of the most colorful and legendary characters of the Old West. Perhaps the most notable character is Buffalo Bill Cody, who staked a claim here in 1902 at the urging of his former partner, Curley Bill Neal. After numerous escapades, including a large cattle operation near Oracle, Neal became the successful proprietor of the Mountain View Hotel. The hotel catered to winter tourists from the north, as well as residents of Tucson who traveled to the slopes of the Santa Catalina Mountains to escape the desert heat.

One site no one would expect to see in a scenic desert landscape is a 7.2-million-cubic-foot greenhouse built in the shape of a pyramid—the ill-fated Biosphere II. Located several miles to the east of Oracle Junction on Arizona Highway 77, Biosphere II was designed to be a fully self-contained environment and is today a research facility for the testing of irrigation methods and air purification, and similar practical experimentation.

Urban sprawl mixes with towering saguaros as you draw closer to the metropolis of Tucson on Highway 77. Tucson, like many Southwestern communities, enjoys a wonderful island of forested mountains in its backyard.

The crown jewel of the Santa Catalina paradise is Sabino Canyon, a delightfully rare opportunity to experience the illusion of wilderness mere minutes from a major metropolitan area. The canyon was closed to private motor vehicles in 1981 and is today accessed only by tram, by bicycle, or on foot. The canyon is a refuge for numerous native species, making it ideal for the bird-watcher. More than three hundred miles of hiking trails, cool mountain pools for swimming, and a tram that provides a delightful, scenic, fifty-minute trip from the visitor center to the top of the canyon and back again ensures the canyon can be enjoyed by all, regardless of physical condition.

A few miles of urban and suburban driving are all that is needed to reach the flip side of Sabino Canyon, Saguaro National Park's Rincon Mountain District. Saguaro National Park preserves a vast forest of towering saguaro, which have come to symbolize Arizona, and the Rincon Mountain District can easily be enjoyed from the comfortable confines of an automobile. (The park's Tucson Mountain District is northwest of the city. Hikes of various lengths are required to experience the best views there.)

The last stop on this drive, Colossal Cave Mountain Park, is just a few scenic miles to the south of Saguaro National Park. The heart of this desert hideaway is an oasis of another kind: a huge, dry cavern of connecting rooms and passages, where the temperature remains a consistent seventy degrees on the hottest of summer days. There is evidence the cavern complex has provided shelter from the harsh elements for centuries. Perhaps the most intriguing story associated with the cave is that of a band of train robbers who used it as a hideout in 1884.

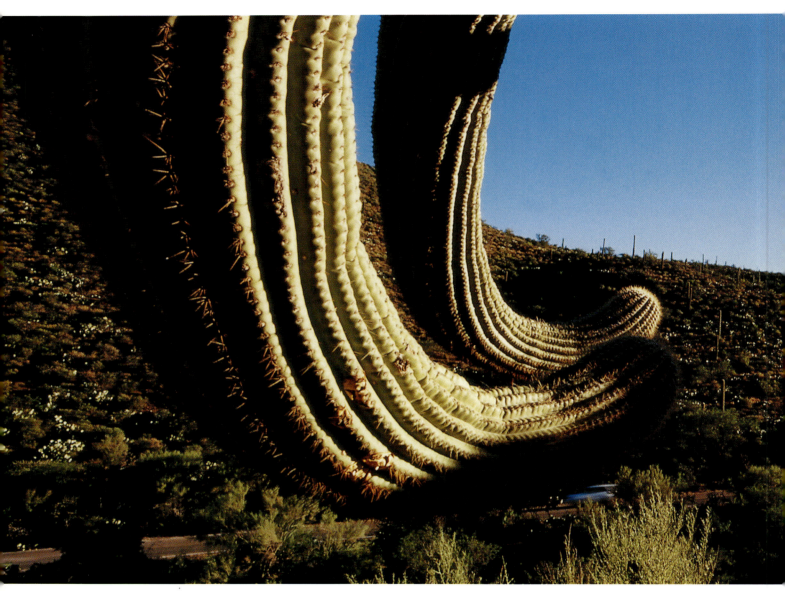

In the rugged wilderness of Grants Pass at Saguaro National Park, towering saguaro stand sentinel.

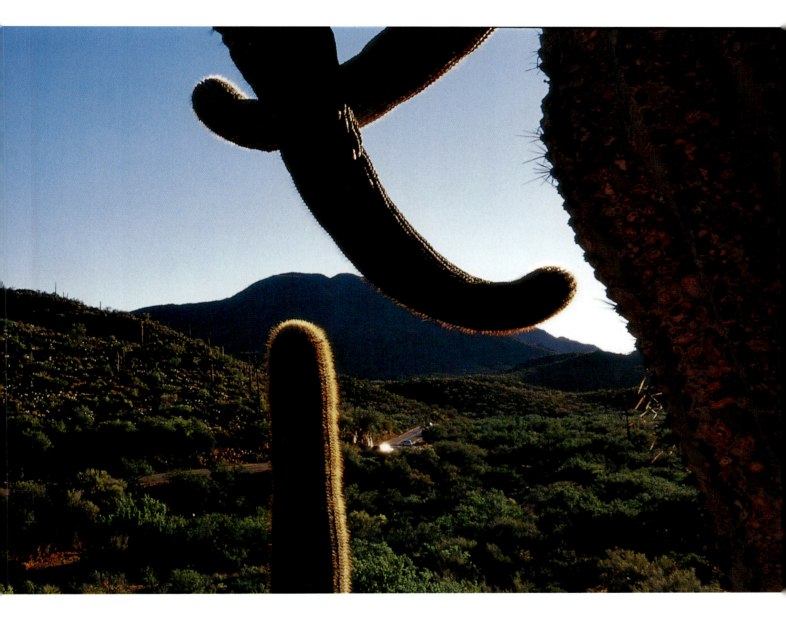

The highway of 1932 (the postmarked date of this postcard) from Globe through Queen Creek was little better than the wagon road that preceded it. Author's collection

The story claims that the pursuing posse guarded the entrance for three weeks, and even tried smoking the robbers from their lair, only to discover the robbers had another exit. A few weeks later, three members of the robbery gang died with their boots on in a gunfight at Willcox, and a fourth received a twenty-year sentence to the dreaded Yuma Territorial Prison. After he was released in 1912, Wells Fargo detectives trailed him to the cave. Legend has it that he gave them the slip, and all that was ever found from the robbery was empty money sacks.

THE ROAD LESS TRAVELED
INTERSTATE 10 TO APACHE JUNCTION

ROUTE 15

Begin with exit 352 or 355 on Interstate 10 about 16 miles east of Willcox and follow U.S. Highway 191 north. The roads for side trips to Bonita as well as Mount Graham are well marked. Bonita is accessed by turning west on Arizona Highway 266 and driving about 18 miles. To reach Mount Graham, follow U.S. 191 9 miles north of its junction with Highway 266 and turn west on Arizona Highway 366. To reach Safford, return to U.S. 191 and head north. At Safford, turn west on U.S. Highway 70 to Globe. Then continue west on U.S. Highway 60 to Apache Junction.

Your wheels will have barely left the interstate before it becomes apparent that this drive is unique. Sweeping plains draw the eye to the horizon on one side of the highway, while on the other side, towering forested peaks brush the clouds. Shaded picnic areas and quiet pullouts with simplistic unspoiled vistas encourage you to slow the pace. Side roads beckon and inspire exploration.

One such detour from the main route of U.S. Highway 191 is Arizona Highway 266, nineteen miles north of Interstate 10, through the Pinaleno Mountains to the semi–ghost town of Bonita. In the heart of this sleepy little village stands the George Atkins Saloon, which until very recently served as a general store. It was in the dusty street out front that, according to legend, Henry Antrim shot his first man in 1877. The shooting was the culmination of an argument that got out of hand between a powerful Irish laborer and skinny eighteen-year-old Antrim, better known by the moniker Billy the Kid.

Another wonderful little side trip is to follow Arizona Highway 366 to Mount Graham, an ideal respite from the desert heat. The junction for this detour is nine miles north of the junction with Arizona Highway 266. Numerous hiking trails skirt the forested, 10,713-foot summit. There are

many opportunities to simply enjoy the cool pine-scented breezes, observe the wildlife, and let the quiet sounds of the wind passing over the forested slopes usher in true relaxation.

The mountain has a colorful history; it has been used as an Apache hunting ground, as a recuperative camp for wounded soldiers from nearby Fort Grant, and for Christmas tree farms, plus it is the site for two observatories—one operated by the University of Arizona and the second by the Vatican.

For those unfamiliar with Arizona, the Safford area will be quite a surprise, as desert may be difficult to find. Instead, the highway is bordered by apple orchards, grain crops, and rich fields of cotton (one gin processes more than twenty thousand bales annually). Safford itself is a pleasant community that, like so many in Arizona, is experiencing growing pains. But there are more than a few remnants from when the Graham County seat was a small town that cast a big shadow—most notable is the Graham County Courthouse, built in 1916.

From Safford, U.S. Highway 70 gently follows the contours of the land as it cuts through farmland and rolling hills on its climb toward the mountains, which loom larger on the western horizon with the passing of each mile. In several little towns that have rich, forgotten histories, the highway serves as "Main Street."

Fort Thomas began as an outpost on the Gila River in 1876, and in 1899, it played an important role in American military history. On May 11, 1899, on the road between Forts Grant and Thomas, army paymaster Major Joseph W. Wham and an escort of the Tenth Cavalry were ambushed by a gang who knew of the $26,000 they were transporting. Two black soldiers, Sergeant Ben Brown and Corporal Isaiah Mays, received the Medal of Honor for their heroism in unsuccessfully trying to stop the robbers that day.

The landscape becomes increasingly arid as you drive west, even though U.S. 70 roughly parallels the Gila River. During early fall, the golden leaves of towering cottonwoods and the dusty green of the salt cedar along the banks of the Gila provide contrast to the desert hills. This is the land of the San Carlos Apache.

Established in 1873, the reservation along the San Carlos River, about a mile from its confluence with the Gila River, originally served as a containment sector for several tribes. The United States government overlooked a key component in its grand plan to relocate the native tribes— the tribes relocated to the area had different cultures and languages, and in some instances they had been enemies for decades. As a result, it was easy for powerful leaders such as Geronimo to gather an army of desperate, frustrated young men.

For a revealing look into the history of the Apache, the Apache Cultural Center in the town of San Carlos warrants a visit. In addition to historic photographs, there are excellent displays of traditional crafts, as well as paintings by native artists.

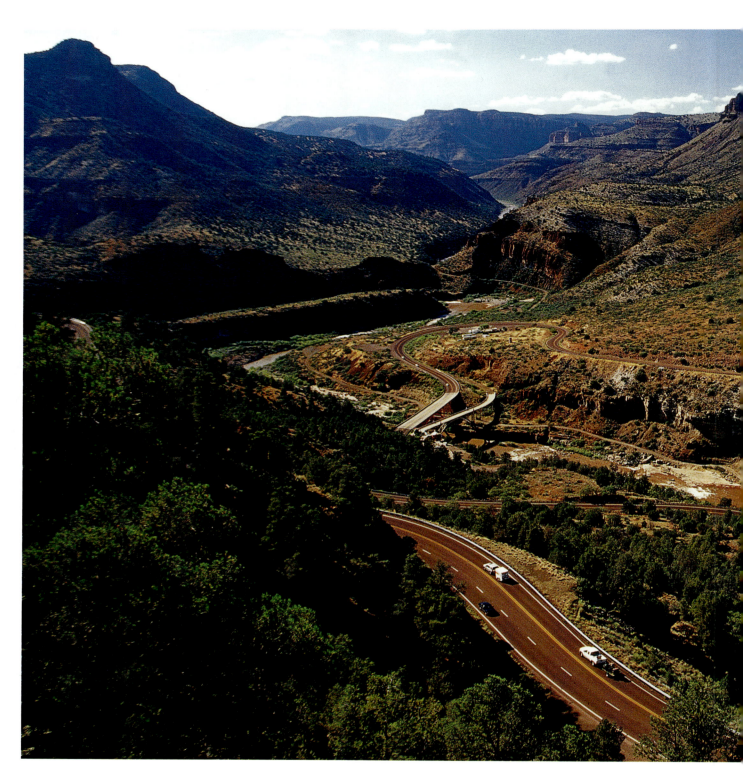

The rugged beauty of the Salt River Canyon presses in on both sides of U.S. 60.

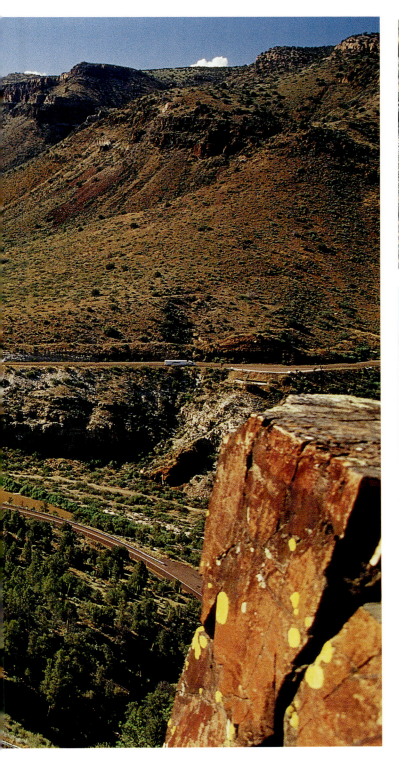

The gardens at Boyce Thompson Arboretum capture the beauty that is unique to Arizona's vast deserts.

From San Carlos, U.S. 70 begins a climb into more-rugged mountain scenery. Nestled among the crags and rocks are three dusty frontier towns that remind visitors of a time when mining was king: Globe, Miami, and Superior.

Framed by the Pinal and Apache mountains, the small community of Globe, with its century-old buildings of brick and stone, is both picturesque and historic. After more than two decades of existence, and in spite of increasing mining revenues, the community remained one of the most isolated in the Arizona Territory. Supplies were hauled in from as far away as Silver City, New Mexico, more than 150 miles to the west. By the turn of the twentieth century, many of the richest ore bodies in Globe had been exhausted, and in 1909, richer deposits of copper ore were located about seven miles to the west. In typical frontier fashion, a new community, Miami, was established at the new site, and merchants from Globe left for greener pastures.

Unlike Globe, with its twisted main street, the community of Miami has a valley floor for most of its business district, and the older residences are on the slopes of the surrounding hills. In time, open-pit mining operations swallowed portions of the community, including some of the original mining offices and historic residences.

Signage along this portion of U.S. Highway 60 between Globe-Miami and Superior designates the route as the Gila Pinal Scenic Road for good reason. Frequent overlooks of Queen Creek Canyon and a scenic tunnel carved from the stone are but a few of the highlights along this portion of the route.

Like Globe and Miami, Superior began as a mining town, the result of rich silver lodes and, later, copper deposits. Aside from mine tailings, the dominant landscape feature in Superior today is a towering cliff that appears like the ruins of a castle streaked in various shades of red. A tragic legend surrounds this precipice, known as Apache Leap. The story is that troops from nearby Camp Pinal pursued a band of Apache to the edge of the precipice. Rather than submit to the humiliation of surrender, they chose to leap to their deaths on the rocks below.

A fitting end for this drive is near Superior, in the looming shadows of Picket Post Mountain: the Boyce Thompson Arboretum. Established by

A NOT-So-SUCCESSFUL GETAWAY

In downtown Clarkdale, where the First Interstate Bank stands today, the Bank of Arizona stood in 1928. On the morning of June 21, Earl Nelson and Willard Forester, wanted outlaws from Oklahoma, strode into the bank and stole $40,000.

As the two men left the bank, the town constable, seventy-year-old Jim Roberts, turned the corner. One of the gangsters fired a wild shot in his direction. Roberts, however, was not easily intimidated. He was a survivor of the bloody Pleasant Valley War and he had been a peace officer in some of the woolliest towns in the Arizona Territory—Jerome, Congress, and Douglas.

The outlaws' getaway car had just begun picking up speed when Roberts stepped into the street and fired one shot to the head of Forester, the driver. Before the vehicle had come to a complete stop, Nelson stepped out with arms raised and surrendered.

William Boyce Thompson in 1924 as a living laboratory for the study of plants from the world's arid regions, the arboretum has grown to include a number of scenic hiking trails, which range from moderate to strenuous.

RED ROCK COUNTRY AND GHOST TOWNS
FLAGSTAFF TO JEROME

The initial miles of Arizona Highway 89A south of Flagstaff offer no hint of the beauty or adventure that lie just ahead. The road simply meanders among the towering ponderosa pines after breaking with Interstate 17, and then, with little warning, it begins a steep descent through a series of switchbacks along a beautiful mountain stream. This is Oak Creek Canyon.

During early fall, this fifteen-mile drive becomes an exercise in sensory overload. Changing leaves on oak and sycamore trees provide color, the wind in the trees and the babbling brook provide sound, and the hint of a frosty breeze from the head of the canyon stimulates the appetite.

Built in 1929, winding, twisting Arizona Highway 89A through Oak Creek Canyon into Sedona is, with the exception of the Grand Canyon, the most photographed drive in the entire state. *USA Weekend* singled out this area as "The Most Beautiful Place in America" in May 2003. The two-lane road is narrow and steep with sharp curves, and it attracts a large number of tourists. Use the numerous pullouts to enjoy the scenery rather than trying to take it in while driving, especially in heavy traffic areas, as in Sedona.

At the entrance to the canyon, truly breathtaking red-rock buttes and mesas appear as the ruins of an ancient civilization and as towering cathedrals; they serve as the backdrop for legendary Sedona. Discovered by international celebrities in recent years, this once-quaint Arizona community has become a faux-western resort filled with art galleries and new-age gurus. This is not saying the modern Sedona is without charm. The awe-inspiring scenery in which the town is nestled seems to enhance all manmade intrusion, as evidenced by the beautiful Chapel of the Holy Cross, built into a butte two hundred feet above the valley floor.

Then there is the magic of Tlaquepaque (pronounced *t-laca-pocky*) Arts and Crafts Village, designed to resemble an actual village in Guadalajara, Mexico. A variety of shops are connected by a series of small pathways that pass under graceful archways, through courtyards with fountains, and under towering sycamore trees. Vendors in the courtyards sell seasonal fruits, vegetables, flowers, and even baked goods. Each September, the Fiesta del Tlaquepaque brings added flair, with strolling mariachis and piñatas; in December, there is the beautiful Festival of Lights.

South of Sedona, near Cottonwood, is Dead Horse Ranch State Park along the Verde River. This beautiful little park features an abundance of wildlife, a well-stocked lake for fishing, and a variety of hiking trails through the riparian area.

ROUTE 16

From Flagstaff, drive south on Interstate 17 to exit 337, the Fort Tuthill exit. Then turn south on Arizona Highway 89A. Sedona is 27 miles south of this junction and Jerome is 27 miles south of Sedona. For the first detour to Montezuma Castle National Monument, take Highway 179 east from Sedona to Interstate 17. The second detour begins at the towering ruins of the Daisy Hotel near the Jerome State Historic Park, off Perkinsville Road (County Road 72).

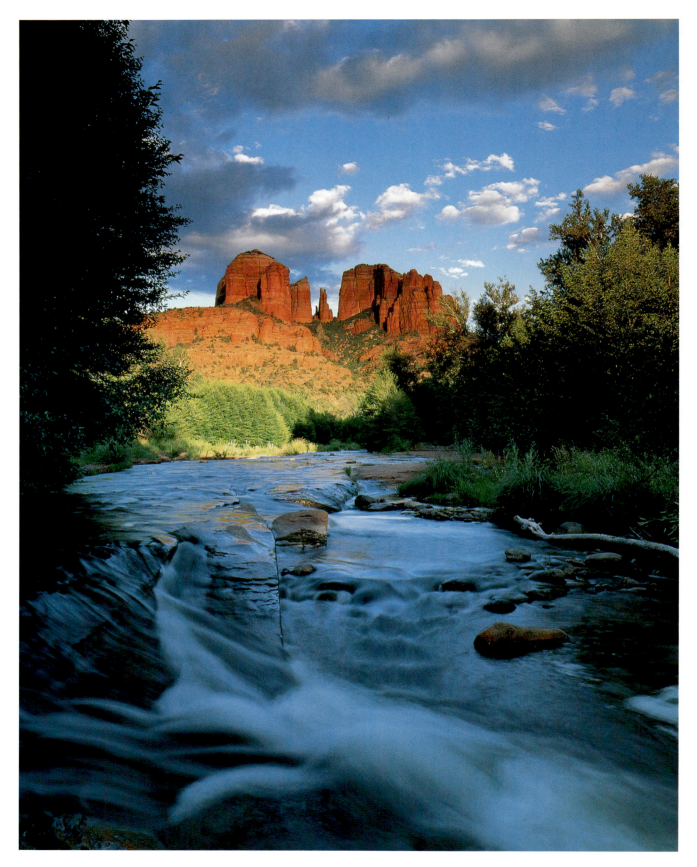

Like the ruins of an ancient castle, Cathedral Rocks tower above Oak Creek at Red Rock Crossing State Park near Sedona.

Fall leaves add a sprinkle of color to a rivulet in West Clear Creek Canyon near Sedona.

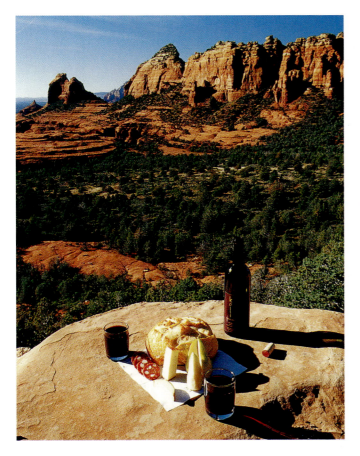

Schnebly Hill Road and countless other locations in the red rock country near Sedona are wonderful places for a picnic.

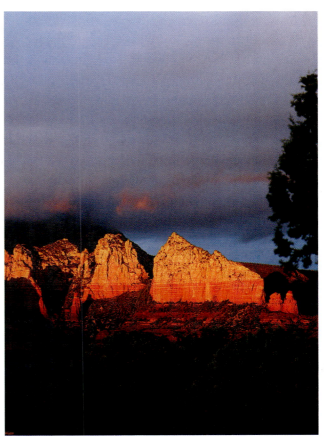

The view from the Sky Ranch Lodge in Sedona, especially after a summer storm, is truly extraordinary.

The city of Jerome is in itself an engineering marvel that seems to defy gravity as it perches precariously on the slopes of Cleopatra Hill.
Author's collection

Another point of interest found between Clarkdale and Cottonwood is Tuzigoot National Monument. Situated scenically on a hilltop above the Verde River, the remains of this pueblo, built by the Sinagua Indians about five hundred years ago, provide numerous opportunities for the shutterbug. The informative visitor center is an excellent place to stretch your legs and experience another forgotten chapter in Arizona history. Both of these parks can be accessed from Arizona Highway 89A.

With the current surge in population growth in the Verde River valley, both Cottonwood and Clarkdale are quickly losing their rural feel, but here and there are vestiges from when these communities played important roles in the dynamic mining industry. Clarkdale in recent years has developed one survivor of that era into an excellent attraction: the Verde River Canyon Railroad.

The railroad, constructed in 1911 for the transport of copper ore and mining supplies, originally ran forty miles to the town of Drake. By the late 1950s, mining in the area had effectively ended and there was no longer a need for the railroad. In 1990, a group of investors purchased the old line in the hope that providing access to the unique scenic beauty of the Verde River would be profitable. Utilizing refurbished New York Metro Line coaches and open gondola cars, the Verde Canyon Railroad provides easy access to the wilderness areas along the Verde River, a rare riparian area where bald eagles nest and the views are breathtaking.

From Clarkdale, Arizona Highway 89A begins a steep ascent from the Verde River valley up over Cleopatra Hill toward Mingus Mountain. Perched precariously on the slopes is "the largest ghost town in Arizona": Jerome.

Mining here has a long history. In 1583, Antonio de Espejo discovered a variety of rich mineral deposits in the hills above the Verde River valley. In the years that followed, other explorers passed through the area and, on occasion, even tried to profit from the ore bodies of copper and silver. However, it wasn't until 1876 that serious mining of the rich deposits of gold, silver, and copper on Cleopatra Hill began in earnest. In 1882, the railroad arrived at Ash Fork, north of the area, solving one of the most pressing deterrents: profitable shipping of ore.

The principal financier for mining operations here was Eugene Jerome of New York, a cousin of Jennie Jerome, the mother of Sir Winston Churchill. Interestingly enough, Jerome never visited the community bearing his name.

Eventually, the town population soared to fifteen thousand, making it the third-largest community in the state. Building a town on the steep slopes presented unique engineering challenges that resulted in some fascinating construction, such as buildings with fronts that open onto the street, and rears that are three stories above the street below. The upper rears of some of these structures have been creatively converted into restaurant decks with million-dollar views. Throughout the old town, most every turn presents breathtaking vistas of the Verde River valley and the red cliffs that serve as a buttress for the far horizon. From such heights, the views are truly awe-inspiring.

One of the more unfortunate results of building on slopes and then undermining the slopes with tunnels has been the dislocation of several buildings. Perhaps the most famous dislocated building in Jerome is the traveling jail, which has slid 225 feet since being dislodged from its foundation in the mid-1920s.

Mining ended in 1953, and Jerome began another kind of slide—into oblivion. The trickle of traffic over Mingus Mountain into Prescott was but enough to keep a few businesses going. In the late 1960s, the renaissance began, as an eclectic group of jewelers, artists, and sculptors discovered the quiet little community with one-of-a-kind views. Today, Jerome is a wonderful mix of unique restaurants, fascinating shops, art galleries, and ruins. Lodging is as unique as the town itself, and it includes a bed-and-breakfast in an old speakeasy and one in a hospital perched high above town. For museums with a view, I know of none that can surpass the huge adobe Douglas Mansion in Jerome State Historic Park. The 8,700-square-foot mansion, constructed in 1916, houses extensive displays of the area's rich history and the evolution of mining.

Arizona Highway 89A from the Verde River valley through Jerome and over Mingus Mountain is steep and narrow, and many portions have seen

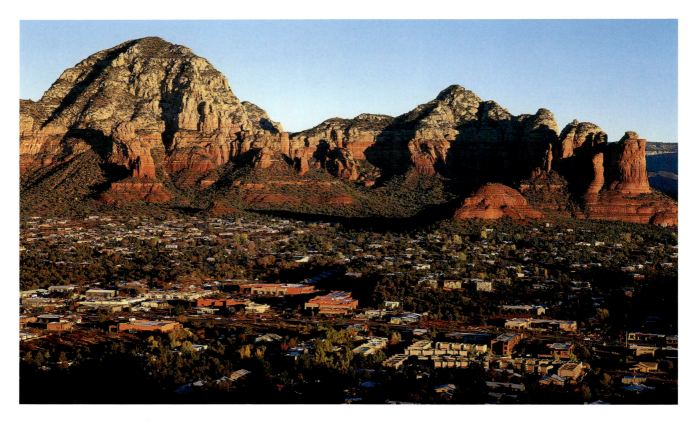

This panoramic view of Sedona is from Airport Mesa at Sky Ranch Lodge.

Slide Rock State Park on Oak Creek near Sedona is a playground for summer visitors.

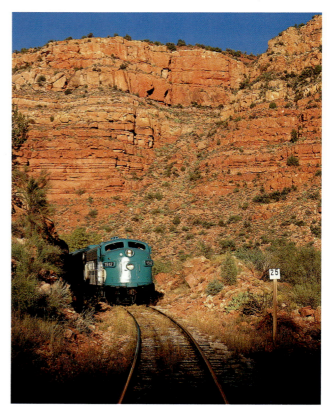

The Verde Canyon Railroad provides access to the wilderness of the Upper Verde Canyon.

ABOVE:
Cleopatra Hill looms high above historic Jerome, a community billed as "the largest ghost town in Arizona."

CENTER:
In Jerome, many historic buildings have been given a new lease on life as fine art galleries.

BELOW:
Jerome's traveling jail has slid 225 feet down the hillside since a 1920s mining explosion dislodged it from its foundation.

little improvement since its construction in 1930. Added enhancement to this drive is found along two detours. The first detour, Arizona Highway 179 from Sedona to Interstate 17, is a scenic drive that provides access to Montezuma Castle National Monument, a well-preserved cliff dwelling dating to A.D. 1150, located at the end of a shaded, paved quarter-mile trail.

The second detour begins at the towering ruins of the Daisy Hotel, near Jerome State Historic Park. Inquire in Jerome about the conditions of Perkinsville Road (County Road 72), as it can be quite rough in some places. This old road climbs high into the mountains north of Jerome, crosses the upper Verde River on a vintage one-lane bridge, winds through a beautiful pine forest and past several small lakes, and ends in the scenic, historic mountain community of Williams.

UNDER THE MOGOLLON RIM
CAMP VERDE TO EAGAR

ROUTE 17

Begin at Fort Verde State Park, two blocks north of Arizona Highway 260 in Camp Verde. Then follow Highway 260 east 240 miles to Eagar.

The drive from Camp Verde to Eagar isn't overwhelming during the long summer days, as travelers can enjoy cool, pine-scented breezes as they cruise these Arizona backroads. There are, however, more treasures found along this route than just deep forests set against the towering escarpment of the Mogollon Rim and the rare opportunity to beat the heat.

The route begins at Fort Verde State Park, a re-created time capsule from when this area was the frontier and Arizona was a territory, more than forty years before it gained statehood. The park's exacting attention to detail makes it possible to overlook the modern community that is pressing in on all sides. This fort, established in January 1864 as Camp Lincoln, was a pivotal supply base for patrols against the Apache during the campaigns of General George Crook in 1872 and 1873. The security offered by the fort and the abundance of water available in the area from five streams that flowed all year—the Verde River, Clear Creek, Beaver Creek, Oak Creek, and Cherry Creek—encouraged civilian settlement around Camp Verde. As a result, the Verde River valley became one of the richest agricultural areas in the territory before 1890.

From Camp Verde, the drive follows the contours of the rolling hills along the river and then breaks to the north as Arizona Highway 260 climbs to higher elevations dominated by deep pine forest. Small streams are scattered throughout this area, as well as quiet brooks that flow though rocky arroyos and across grassy valleys. On occasion, the small valleys or clearings in the forest gently shelter quiet villages that seem forever locked in an earlier time.

One of these villages is the quiet little community of Strawberry, named for the profusion of strawberries found in this valley by pioneers who settled here in 1886. A rough-hewn gem is the old log school, built in 1887 and last used for its original purpose in 1907.

Found a few miles down the road near Pine is a treasure of another kind. The centerpiece of Tonto Bridge State Park is a beautiful limestone arch, believed to be the largest of its kind in the world. A steep hiking trail from

the visitor center (located in a resort) opened in 1887, past an orchard planted in 1882 and now gone wild. This trail is the only option for accessing the underside of the stone bridge.

From Tonto Bridge, the highway dips under one of the dominate features in Arizona geography—the Mogollon Rim (pronounced *muggy-own*). Named for Juan Ignacio Flores Mogollon, governor of the Spanish colony of New Mexico from 1712 to 1715, this towering stone escarpment is often referred to as the "spine of Arizona" and is most prominent near Payson.

Nestled among the pines, the community of Payson was one of the most remote communities in the Arizona Territory. Even statehood in 1912 did little to change things; mail was delivered by horseback for another two years. As Payson is only ninety miles from the desert metropolis of Phoenix, in recent years it has become a haven for those wishing to escape the blistering heat. The result is a community that is modern and urban with a small-town veneer and rich frontier heritage that manifests each August with the world's oldest continuous rodeo.

After leaving Payson, Arizona Highway 260 passes through an area full of opportunities for hiking, camping, or merely relaxing alongside the many brooks and streams or in small, quaint mountain communities such as Heber and Overgard. If there was to be a complaint, it would be that during the summer months, traffic and congestion can spoil the serenity of the drive under the Mogollon Rim and through the Apache-Sitgreaves National Forests.

For those who first discovered Arizona through the prose of prolific western writer Zane Grey, many of the landmarks, mountains, and canyon names along this portion of the drive will be quite familiar. Until a few years ago, when a forest fire swept through the area, his cabin stood in the shadow of the Mogollon Rim that so inspired him.

An excellent way to experience the raw beauty of this area is by hiking the relatively easy one-mile Mogollon Rim Overlook Trail. The reward is sweeping views of unimaginable proportions.

As with Payson, urban sprawl in the desert valleys has spawned a transformation in the cool, pine-shaded towns of Show Low (named for a card game to establish the town site's ownership in 1875), Pinetop, and Lakeside. The upside of this sprawl is modern resorts replete with golf courses, unique dining opportunities, and, in winter months, skiing at Sunrise Peak Resort.

The White Mountain Apache Reservation, which this drive skirts along its northern edge, is a veritable cornucopia of recreational opportunities. There are miles of hiking trails, fishing streams, lakes, golf courses, and even a casino at Hon-Dah (the Apache word for "welcome").

A few miles to the west of Eagar, the highway breaks from the forest and crosses a landscape of volcanic cinder, tall grass, sharp knolls, and rolling hills—the White Mountains Grassland Wildlife Area. Isolated ranch houses seem natural in this timeless landscape.

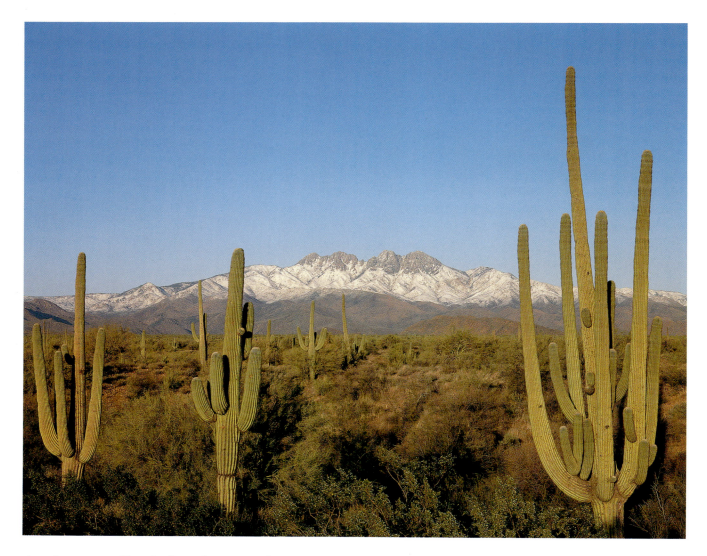

A spring snow on Four Peaks in the Mazatzal Mountains and towering saguaros under clear blue skies make for a stunning scene of contrast.

ABOVE:
Towering pines stretch to the southern horizon below the Mogollon Rim.

LEFT:
On the Perkinsville Road, a vintage bridge spans the Verde River near Jerome.

ROUTE 18

From Ash Fork to Wickenburg,
follow Arizona Highway 89
south about 112 miles.

The place where the three forks of Ash Creek join has served as a stage for a parade of history that has spanned centuries. Evidence of occupation dating to A.D. 1000 has been found here. This location was used as a rest area on the trade route that connected the pueblos of the Zuni and the land of the Hopi with the California coast before the arrival of Anglo explorers.

Spanish explorers passed through the area in the late 1500s. American trappers and traders, including Bill Williams and Kit Carson, stopped here en route to the Mexican village of Los Angeles. Lieutenant Amiel Whipple and Captain Lorenzo Sitgreaves of the U.S. Army Corps of Topographical Engineers surveyed a route nearby for a proposed transcontinental railroad. Lieutenant Edward Beale watered his camels here on his way to California, during an experiment in using the animals as military transport in the desert.

The railroad arrived in 1882. With pressure from freight companies that served the mining camp of Jerome and the territorial capital of Prescott, the railroad established a side route that shortened the haul to Prescott by eighteen miles. Cattle and the railroad served as the lifeblood of this area for decades. In 1914, with the establishment of the National Old Trails Highway (which was replaced by Route 66 in 1926), a new industry came to town—tourism by automobile.

Throughout the small community of Ash Fork, located on gentle, juniper-studded slopes about fifteen miles west of Williams, relics from many eras are found. The flagstone construction that gives many of the buildings in town a colorful, solid look exemplifies why Ash Fork is the "flagstone capital of the world."

The drive south on Arizona Highway 89 is through rolling hills, across grassy plains, and over deep canyons, roughly following the route of the Peavine railroad that linked Prescott with the main line of the Arizona and Pacific Railroad in 1893. Two years later, the completion of an extension to Phoenix was an event that many historians believe marks the end of the frontier period in Arizona.

An earlier effort to link Prescott to the outside world via rail, attempted in 1886, was an adventure worthy of Charlie Chaplin and the Keystone Cops. It began with Tom Bullock, a fast-talking promoter who acquired $300,000 from Prescott residents to build a spur line that would connect with the main rail line at Seligman, twenty-four miles west of Ash Fork. The agreement included a stipulation that the spur be completed by midnight on December 31, or a $1,000-a-mile penalty would be imposed. Mobile saloons followed each mile of construction, and cattleman resented the intrusion on their grazing lands and often stampeded their herds through the construction camps. Ever-increasing bets for or against completion resulted in vandalism, which included setting fire to trestles and derailing the work train.

With odds nearing twenty-to-one against timely completion, some residents put on work clothes and joined the track gangs as volunteers. The railroad was completed with five minutes to spare. But the Prescott and Central Arizona Railroad represented the ultimate in inefficient operation, including frequent beer stops at Del Rio Springs and a temporary suspension of service for hunting in Chino Valley.

Before 1950, one of the highlights, or trials, of a drive between Ash Fork and Prescott was the descent into and crossing of Hell Canyon. With the exception of those who stop at the rest area to the south of the canyon, few motorists today even notice this scenic chasm.

With abrupt suddenness, the rolling hills of juniper yield to a vast grassy plain where antelope still roam, even though the Chino Valley is rapidly becoming an urban bedroom community for nearby Prescott. The community of Chino Valley began as Jerome Junction, a side route for the railroad built by William Clark. The railroad to Jerome Junction was through such steep terrain that one thirteen-mile portion had 168 curves. The engines and cars used on this line had to be specially constructed as a result.

Rolling plains give way to the whimsical stone formations of Granite Dells just outside Prescott. The boulders and rocks form natural avenues and alleyways that hide a variety of old and new businesses, secluded homes, and even a small lake.

Prescott has become a small metropolis, but malls and fast-food parlors have not replaced a long, colorful history that is treasured and preserved. The downtown area with its courthouse square exemplifies this history. Unlike many communities in America, downtown Prescott never succumbed to urban decay or abandonment. As a result, there are hotels that have been providing quality lodging for most of a century; authentic western saloons; and all manner of stores, shops, banks, restaurants, offices,

A TREASURE TUCKED AWAY

Nestled high in the Bradshaw Mountains south of Prescott is a dusty gem of almost unimaginable beauty—the old mining town of Crown King. A saloon and restaurant that dates to the 1870s; a general store and post office that has been in operation since 1883; and a historic chapel are but three of the treasures found here, among the pines. Modern amenities include a quaint lodge, an ATV rental store, and a one-pump gas station.

There are two roads to Crown King. From Mayer, southeast of Prescott, County Road 59 is a steep, one-lane, graded-gravel road that follows the old rail bed through a series of twists and turns that present breathtaking vistas. The drive is just less than thirty miles, but requires at least one hour.

For the more adventuresome with a sturdy truck, preferably four-wheel-drive, there is the incredible Senator Highway, a thirty-five-mile drive from Prescott to Crown King that requires at least three to four hours. Steep grades, numerous small stream crossings, sharp curves, and many rocks are among the hazards. But among the many rewards are the opportunities to experience a frontier highway little changed over a century, deep forests, beautiful views, and the Palace Station, an authentic stagecoach station built in 1875 that's now a private residence.

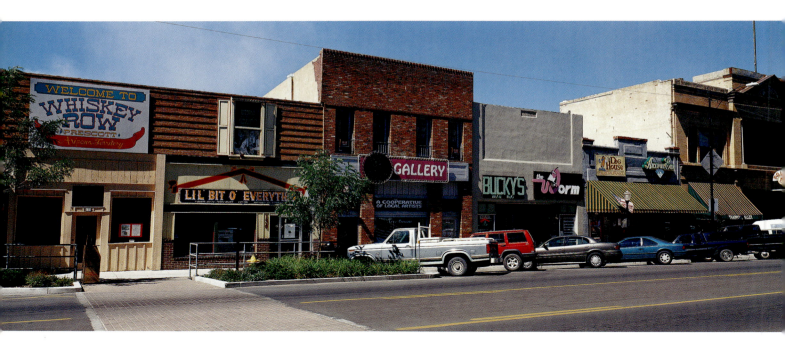

Galleries and shops now are the attractions at the historic Whiskey Row in Prescott.

The brightly adorned courthouse illustrates why Prescott is billed as "Arizona's Christmas City."

The Corn Mother sculpture adorns a garden in the Sharlott Hall complex at Prescott.

A vintage hot dog marquee on Yarnell's Main Street predates the modern era of generic fast food.

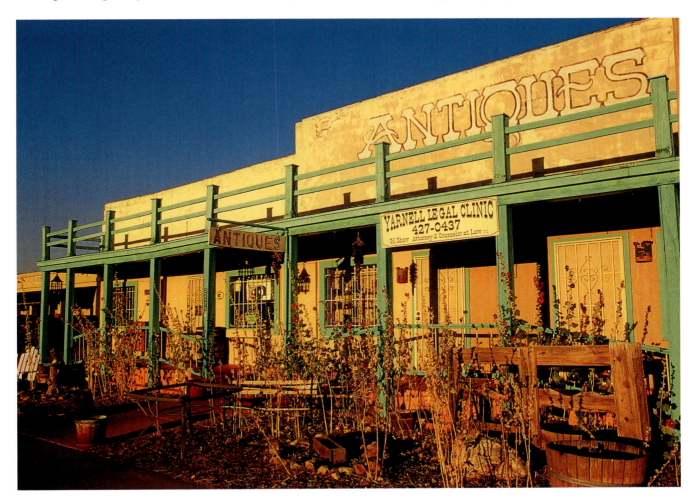

In Yarnell, colorfully trimmed Southwestern-styled antique stores line Main Street.

The Escalante Hotel in Ash Fork, as seen on this vintage linen postcard, hints that Ash Fork was once more than just a dusty, sleepy little town for Route 66 enthusiasts to pass through. Author's collection

and even a brewery. With the exception of the modern vehicles crowding the wide streets and filling the parking lots, the downtown district seems locked in the years before small-town U.S.A. gave way to malls and suburbia.

This bustling community, nestled among the pines in the shadow of the Bradshaw Mountains, has roots that date to 1863, the year President Abraham Lincoln proclaimed Arizona a territory. Most everyone who knew the territory at the time assumed the capital would be Tucson, as there were no other communities of significant size. However, Tucson was a hotbed of secessionist activity (the California Volunteers had driven the Confederates from the pueblo of Tucson the previous year). That fact, plus the discovery of rich gold placers along the Hassayampa River and Granite Creek, prompted the selection of a more-central location for the capital—the site of modern Prescott.

Much of the territorial history—including the community's first substantial building (a log store dubbed Fort Misery) and the territorial governor's log home—is preserved in a beautiful museum and park complex called the Sharlot Hall Museum. In addition to colorful flower gardens and shaded paths, there are other historic buildings that have been relocated to the grounds, which also house interpretive displays pertaining to early mining and ranching in the area.

The drive south from Prescott on Arizona Highway 89 is, with the exception of the traffic, a pleasant ride through a forest of towering pines. Communities that have held onto their small-town charm against overwhelming odds—Kirkland, Peeples Valley, and Yarnell—offer ample opportunity for a cup of joe, a piece of pie with the locals, and an escape from the trappings of the modern age.

Until quite recently, those who made their living behind the wheel knew the road down Yarnell Hill—from the pine forest to a desert of saguaro, scorched stone, and dry arroyos—as the most treacherous drive in Arizona. In late 1914, the drivers participating in the last Los Angeles-to-Phoenix Cactus Derby race made the run down the precipitous slope

during a torrential rainstorm. Barney Oldfield and Louis Chevrolet later commented that Yarnell Hill was one of the most challenging drives they had ever made. Even with recent straightening and widening, the long, steep grade and the sharp curves make for a bit of a thrill ride. However, the vistas and views easily offset any trepidation or concern.

The desert that stretches to the horizon at the bottom of the hill is dotted with colorful reminders of the area's frontier history. Today, little remains of Congress Junction or nearby Stanton, Octave, or Weaver, but in 1900, this area was one of the most promising mining districts in the state. Attesting to its importance was a lengthy whistle stop made by President William McKinley that same year.

A few miles of scenic desert driving from Congress Junction sits the intriguing community of Wickenburg. At first glance, the town appears to be an older western town with an overlay of vintage tourism—motels, neon, western-themed restaurants. However, there is more here—much more.

This little community on the banks of the Hassayampa River, recognized as the dude-ranch capital of the world, supplies the needs of working cattle ranches scattered throughout the surrounding desert plains and rocky hills. In Wickenburg, authentic cowboys still outnumber the Rexall Rangers (drugstore cowboys), and the blending of those who come to play cowboy with those who truly earn their keep with a rope—as well as with those who have come to retire and enjoy the excellent golf courses—gives Wickenburg a unique feel.

While tourism and retirement activities are the economic lifeblood of this charming desert town today, gold led men to settle in this rugged desert wilderness, and stories of gold and the men who pulled it from the rocks fuel the area's legends. About 1860, in spite of warnings about venturing into Apache territory, Joe Walker and a party of adventurers followed Mojave Chief Irataba to the Hassayampa River headwaters, near present-day Prescott in the Weaver Mountains. Stories of the rich gold discovered at numerous locations along the way encouraged others to soon follow.

A few miles north of present-day Wickenburg, members of the Abraham Peeples expedition discovered a hilltop sprinkled with gold nuggets. Legend has it that the men picked up $100,000 in gold in a few weeks, which was the largest placer find ever discovered in the state of Arizona. However, the greatest chapter was yet to be written.

Henry Wickenburg, born Heinrich Heintzel, joined the rush that resulted, and in 1863, he discovered a rich ore body about twelve miles west of the river. The resultant Vulture Mine further fueled the gold rush in the area and spawned numerous industries, most notably forty arrastras (mule-driven ore crushers) at the river near the current site of Wickenburg. By 1870, the town was the largest in the territory, with a population of more than five hundred full-time residents. A few miles to the south, a small farming community named Phoenix, along the Salt River, exploded as the demand for livestock feed and food for miners skyrocketed.

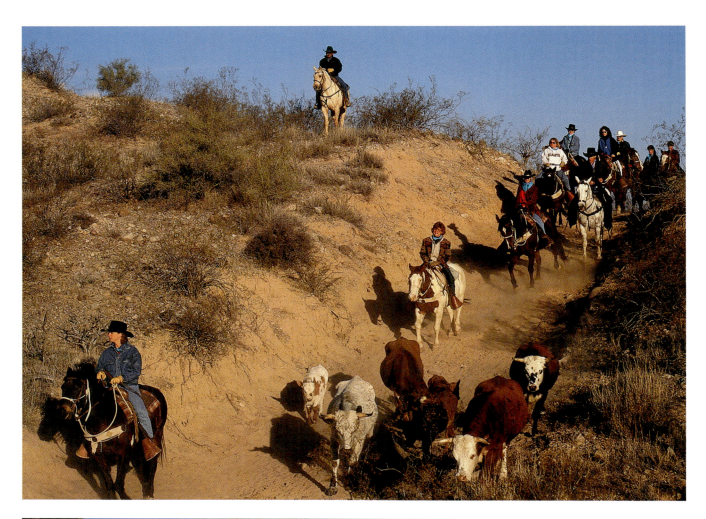

ABOVE:
Roundup on a dude ranch near Wickenburg gives the tenderfoot an opportunity to eat trail dust and experience the romanticism of the Wild West.

LEFT:
Wooden Indians and cowboys greet visitors to historic Wickenburg.

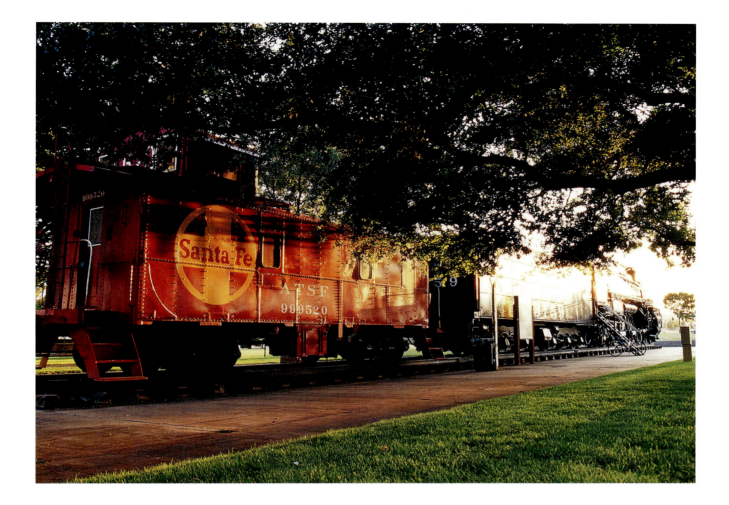

ABOVE:
Locomotive Park in Kingman preserves icons of the railroad that gave rise to the town.

RIGHT:
On the historic railroad depot in Kingman, a refurbished Santa Fe logo stands as testimony to a time when the railroad was America's main passageway across the country.

Today, Wickenburg is a modern community, proud of its heritage and its small-town atmosphere. You can easily spend several days here, exploring the community, discovering its many hidden treasures, and sampling its unique atmosphere.

THE ROAD NORTH
WICKENBURG TO KINGMAN

ROUTE 19

This entire route runs northwest from Wickenburg to Kingman on U.S. Highway 93. About 15 miles east of Kingman, Highway 93 merges with Interstate 40 West.

The drive north from Wickenburg on U.S. Highway 93 is initially through a landscape that has been immortalized in countless postcards, with an odd blend of towering cacti and of rich green pastures where well-fed, well-groomed horses graze. It's not long, however, before open desert vistas, sun-scorched outcroppings of rock, and deep canyons replace any semblance of modern civilization.

Splendid desert scenery today lures adventurers to this scenic corner of Arizona. During the frontier era, there was a different draw—gold. During the late frontier period, this area was known as the Martinez Mining District. Dominated by the legendary Congress Mine, which produced nearly $8 million dollars for its owners and stockholders between 1889 and 1910, this district was briefly one of the richest in the nation.

As with so much of the desert of Arizona, looks can be deceiving. The landscape appears merely to be one of rugged, harsh beauty, but hidden among the rocks and canyons are flowing waters, many of which played an important role in the state's history that has now been largely forgotten.

Date Creek, north of Wickenburg, once offered a pleasant and even lifesaving respite from desert extremes. In 1866, the California Volunteers established an outpost, Camp McPherson (later renamed Camp Date Creek), a few miles from the present-day highway. In July 1867, the encampment became crucial to protecting the road between Prescott and Ehrenberg.

Undoubtedly, the Santa Maria River was crucial to the native people who traversed this harsh land before the Anglos arrived. Historical knowledge of this vital desert resource dates to the expeditions of Juan de Onate in 1604. Shortly after Lieutenant Amiel Whipple and his troops arrived in this area in 1854, it became a cornerstone for the infant mining industry that was developing in the area.

Since U.S. Highway 93 is crucial to international trade between Canada and Mexico, in recent years, modern bridges and four-lanes have replaced many of the twists and turns that had made much of this route a two-lane, white-knuckle adventure. However, the awe-inspiring scenery that embraces the highway remains as timeless as ever. (As the process of updating the highway to accommodate the needs of modern traffic is a lengthy project scheduled to take several years, delays and small detours are common. Inquire in Kingman, Wickenburg, or with

the Arizona Department of Public Safety to help plan travel and avoid undue frustration.) The press of traffic can make it difficult to enjoy, appreciate, or savor the beauty here. But salted along the route are overlooks and pullouts that allow for photo opportunities.

Premier among these photo opportunities is Burro Creek. The original highway bridge here is an engineering marvel that frames the beautiful canyon and the sparkling creek below in an intricate tapestry of steel. Along the older stretch of the highway that follows the creek through the canyon is a wonderfully scenic campground, and for the adventuresome who enjoy a hike, there is a secluded hot springs nearby.

To the north of Burro Creek, at the top of a long grade, is the proverbial "wide spot in the road"—a small store, a dirt parking lot, and a service station. Welcome to Nothing, Arizona.

Just north of Nothing, the highway is listed as the Joshua Tree Parkway. The quirky twisted "trees" add an almost surreal aspect to the raw desert that seems to flow toward the looming mountains.

During most months of the year, the Big Sandy River lives up to its name, and travelers will seldom give it a second glance as they pass over the bridge. Nevertheless, much of the valley through which the river runs is an agrarian and ranching anomaly within the harsh desert. The small town of Wikieup is this desert's heart.

Wikieup is the name for the brush-covered, dome-shaped dwelling of many nomadic desert people throughout the region, including the Apache, the Hualapai, and the Yavapai. An early party of explorers inaccurately noted a large settlement of Pah-Ute with brush shelter wikieups in this valley.

Access to water coupled with an abundance of grass make the valley ideal for ranching as well as farming. Mining camps such as Signal and Greenwood, with its ten-stamp mill in the nearby mountains, provided a ready market. Surprisingly, it would be long after the mines had played out and the communities that surrounded them had returned to dust before an actual town, as locals know it, sprang here. The post office in Wikieup dates to 1922.

The desert begins a rather rapid transition after leaving Wikieup, because of a change in elevation. Within a few dozen miles, the saguaros and other cacti give way to cedar, pinion pine, and oak, while the desert sands have morphed into grassy knolls.

U.S. 93 joins with Interstate 40 as it continues around the towering Hualapai Mountains. Shortly after the highway clears a crest, the wide Hualapai Valley and the community of Kingman, nestled against the Cerbat Mountains, springs into view. A skyline of picturesque mesas and buttes—which if seen at sunset with a hint of clouds is truly breathtaking—dominates the far horizon.

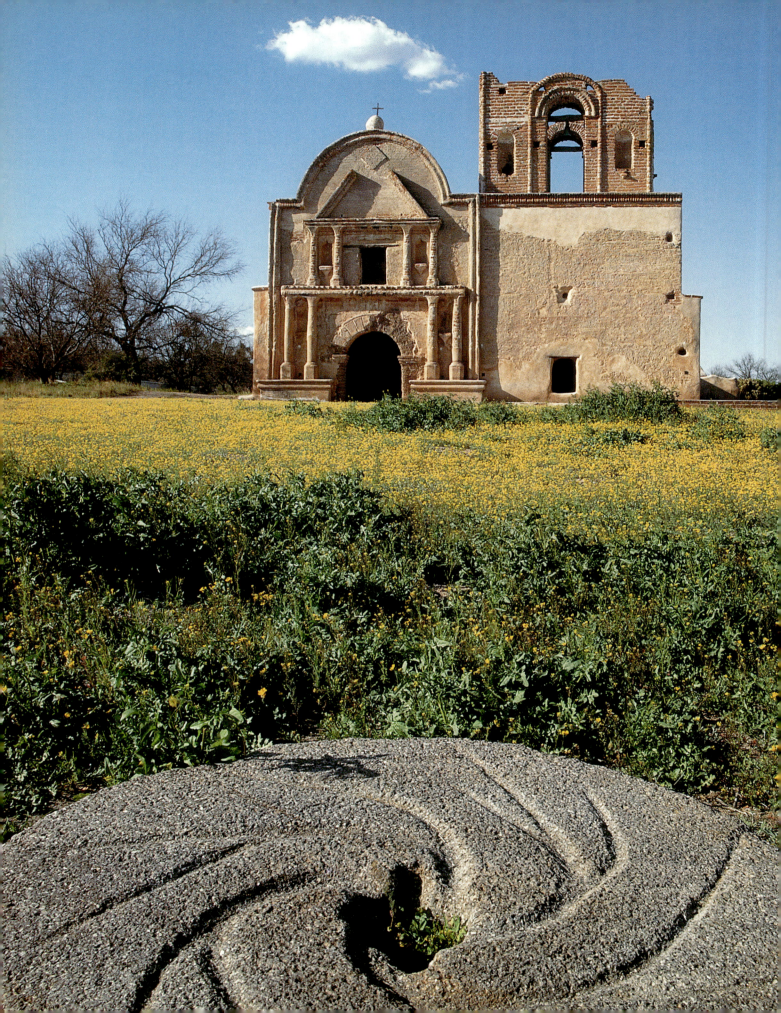

SOUTHERN ARIZONA

FACING PAGE:
A sea of spring flowers flows around the ruins of Tumacacori Mission in Tumacacori National Historic Park. There are ruins of three missions on the site, with two (Tumacacori and Los Santos Angeles de Guevavi) being the oldest in the state.

ABOVE:
In historic Tombstone, a team and coach still stir the dust in the streets.

If the modern incarnation of Arizona were to have a birthplace, it would be southern Arizona. Tubac, Tumacacori, and the glorious "White Dove of the Desert," the mission church San Xavier del Bac, hearken to the earliest days of the Spanish colonial period. The mining communities of Bisbee and Douglas are foundation stones in the mining industry that launched Arizona from territory to statehood.

The entire state is a tapestry of diversity, but here in southern Arizona this diversity seems concentrated. In a single day, you can retrace the steps of Doc Holliday and Wyatt Earp in the dusty streets of Tombstone; be awestruck by the natural cathedral of Kartchner Caverns; and enjoy fine wines at wineries that predate the formation of the state.

Here you can wander the trails of Geronimo, Cochise, and the Butterfield Stage, or enjoy the quiet of a wildlife sanctuary that preserves Arizona as it was more than a century ago. At the end of the day, taking a step back in time is as easy as checking in to the Copper Queen in Bisbee or at the Gadsen Hotel in Douglas, with its forty-two-foot Tiffany stained-glass mural.

Nestled among the scenery is one of America's most unique metropolitan areas: the city of Tucson. Surrounded by national parks that preserve the towering saguaro, Tucson has the southernmost ski resort in the United States in its backyard, and a vibrant blend of cultures that is manifest in one-of-a-kind dining experiences.

A short visit to southern Arizona will leave you forever changed. An extended vacation in southern Arizona may leave you thinking about moving here.

LAND OF LEGEND
BENSON TO DOUGLAS

ROUTE 20

Follow Arizona Highway 80 south 73 miles from Benson to Douglas, just north of the Mexican border.

We begin this drive in the sleepy little village of Benson. If time allows, chances are you will still be here two days later, as this community hides a number of surprises. The most notable is the recently refurbished San Pedro and Southwestern Railway, with a well-informed narrator who weaves fascinating tales about Cochise County and some of its famous former inhabitants, including Doc Holliday and Wyatt Earp. The railroad runs between the ghost town of Fairbanks and the town of Benson, providing a wonderful opportunity to experience the pristine beauty of the San Pedro Riparian National Conservation Area.

Bibliophiles will be thrilled with another Benson gem, Singing Wind Ranch, where a vintage Southwestern ranch house shelters an incredible collection of books—all jumbled together in no apparent order. Seeking a particular title here is akin to a treasure hunt.

For visitors more fascinated by food than books, there's the Horseshoe Café, an area landmark for decades. In addition to serving excellent burgers, authentic Mexican food, and mouthwatering cinnamon rolls, the café

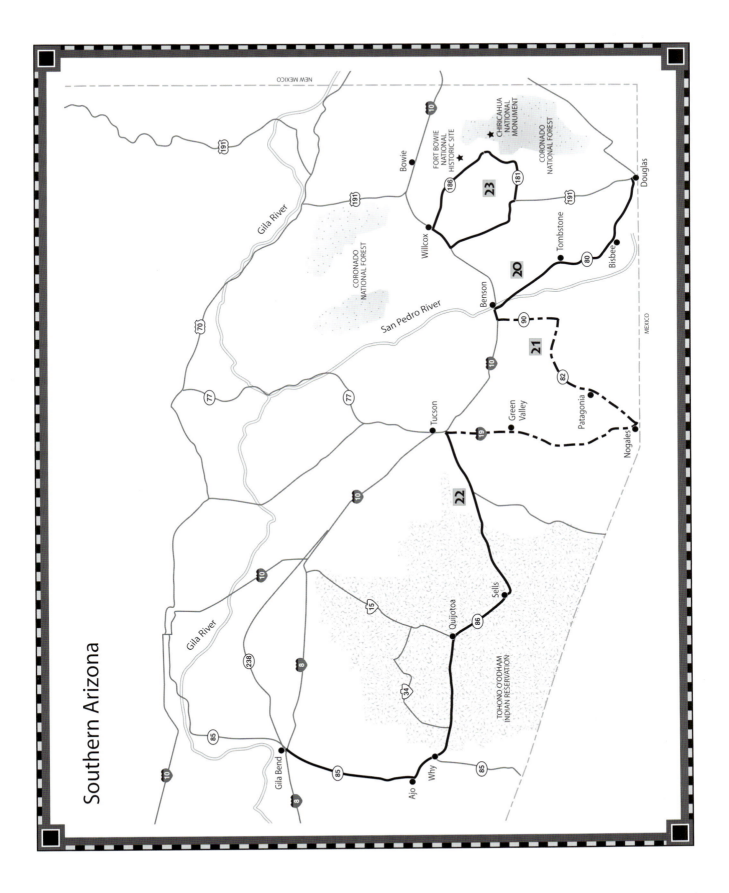

Southern Arizona

NEW MEXICO

MEXICO

CHIRICAHUA NATIONAL MONUMENT

CORONADO NATIONAL FOREST

Douglas

Bowie

FORT BOWIE NATIONAL HISTORIC SITE

186 23 181

Willcox

Tombstone

191

80 Bisbee

191

191

Gila River

CORONADO NATIONAL FOREST

San Pedro River

Benson 20

90

21

82

Patagonia

70

77 77

Tucson

Green Valley

19 Nogales

10

10

22

10

Sells

15

Quijotoa 86

34

TOHONO O'ODHAM INDIAN RESERVATION

10

Gila River

238 8

85

Gila Bend 85 Why 85

Ajo

8

LEFT:
The town's claim to fame is enshrined in a welcome sign at Tombstone.

BELOW:
In Tombstone, stepping back in time is as easy as boarding the next stagecoach.

OPPOSITE PAGE, TOP:
Built in 1881, the Birdcage Theatre in Tombstone was a burlesque theater, dance hall, saloon, and brothel in one adobe package.

OPPOSITE PAGE, BOTTOM LEFT:
The old courthouse in Tombstone, now a state park, looms above the gallows yard.

OPPOSITE PAGE, BOTTOM RIGHT:
In Tombstone's historic Boot Hill, the stones and markers serve as time capsules from when this town was truly the Wild West.

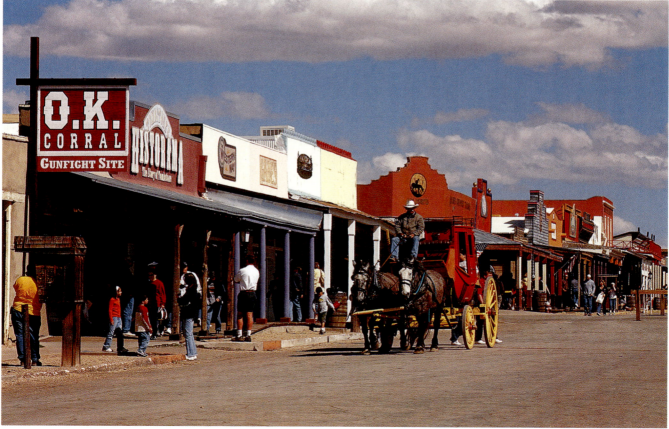

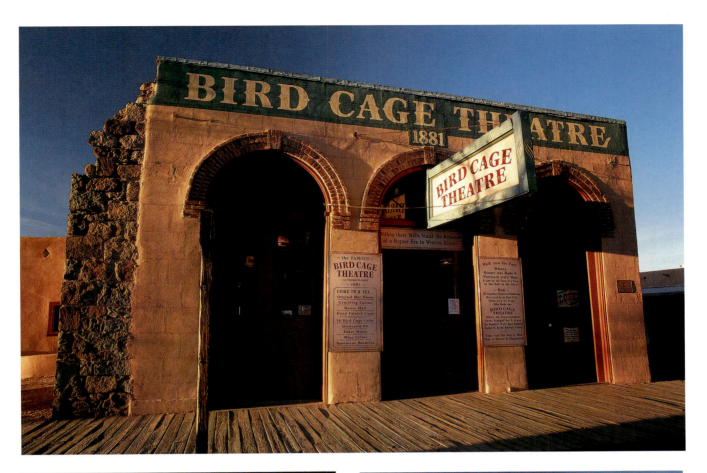

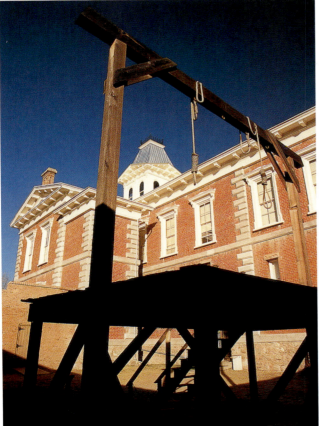

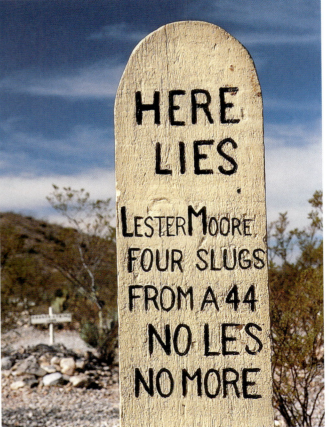

sits near train tracks, so patrons can watch a parade of trains pass by the windows as they enjoy their meals.

The leisurely four-hour, forty-mile trip on Arizona Highway 80 that begins in Benson showcases a delightful blend of Arizona scenery, wildlife (two-thirds of North America's inland bird species have been spotted here), and history. Heading south, the road gently twists and turns through desert riparian areas and into the quaint community of St. David.

Big silver strikes once spawned boomtowns such as Tombstone and St. David—communities past their heyday, but which nevertheless shelter many hidden treasures today. To the south of St. David, you'll find the Holy Trinity Monastery, with a gift shop, a museum, and a library.

The greenery of the riparian area around St. David is soon replaced by desert landscapes and horizons dominated by looming, deeply shadowed towers of stone that seem to reach to the clouds. The desert abruptly gives way to one of the most famous frontier-era communities in the state—Tombstone.

Legend has it that this "town too tough to die" received its name from its founder, Ed Schieffelin. When he and his brother set out to prospect the Mule Mountains, he was told that the only thing he would find in that part of the territory would be his tombstone. At its height during the mid-1880s, the population in Tombstone skyrocketed to nearly ten thousand people, and area mines were open around the clock. An estimated $37 million in ore was produced before flooding and the depth of further deposits made continuation cost-prohibitive.

Tourism built on the legend of a single gunfight has replaced mining as an economic force in Tombstone, and, as a result, the town today is more movie set than actual town. My father-in-law was born in this community, and his grandfather was a sheriff here. On a visit some years ago, he was amused to find wooden boardwalks had replaced the concrete sidewalks he had known as a child.

Nonetheless, there is fun to be found in the reborn frontier atmosphere, which comes complete with shootouts, stagecoach rides, the legendary OK Corral, and Boot Hill, the frontier-era cemetery. Moreover, here and there are some rather unique treats—the old courthouse is now a state park and has been refurbished as a fine museum, and the Rose Tree Museum, formerly the Rose Tree Inn, is home to the world's largest rose tree, which was planted in 1885.

The drive south is an excellent opportunity to experience the raw beauty of the Sonoran Desert, with its unique flora and fauna. Within a few miles of Tombstone, the highway crosses a wide desert valley and begins a steep ascent into the Mule Mountains through an ever-narrowing canyon dotted with cedar and juniper trees. Dependable, year-round springs and seeps made this canyon a haven for the Apache, and, in later years, for Mexican prospectors, who named the head of the canyon *Puerto de las Mulas*—Mule Pass.

Highway 80 is an all-weather, paved highway. During winter months, however, the summit above Bisbee can be snowy and slick, so exercise caution.

A tunnel that is more than a mere engineering marvel dominates the summit today; it is a portal from the present to the past. The canyon that squeezes the Bisbee historic district into a series of narrow, twisting streets is a treasure box overflowing with trinkets and surprises. During winter months, the occasional dusting of snow furthers the illusion that this is truly a magic kingdom, untouched by the modern age. Every shade-dappled path and alley seems to be hiding a special treat. From its well-preserved business district, which dates to the closing years of the nineteenth century, to the vintage homes that cling to its steep slopes (one home is known as "the house of a thousand steps"), Bisbee is best explored on foot.

The Bisbee Mining and Historical Museum is located in the 1897 Copper Queen Consolidated Mining Offices on Main Street. Other Bisbee highlights include antique stores and art galleries; restaurants that have been operated by the same family for more than a half century; and a gourmet steakhouse in the old stock exchange, where the 1914 exchange board is still displayed.

When a day of hiking the steep streets in the cool, clean mountain air leaves you with the desire for a soft bed and a quiet night, Bisbee features some truly one-of-a-kind lodging opportunities. There is the incredible Copper Queen Hotel on Howell Avenue, seemingly unchanged from when President Theodore Roosevelt stayed there, and the School House Inn, which, as its name implies, was once a schoolhouse. Perhaps the most distinctive lodging opportunity is at the Shady Dell Vintage Trailer and RV Park, a cluster of restored vintage Airstream trailers, complete with pink flamingos and a fully refurbished operating diner.

From Bisbee, Highway 80 continues in a gentle series of twists and turns to the desert of Sulfur Springs Valley and the Mexican border at Douglas. Near this border crossing, the old highway becomes a bustling modern four-lane road, underscoring its importance.

THE LONE LYNCHING IN TOMBSTONE

In light of Tombstone's larger-than-life reputation, it may come as a surprise to learn there was but one lynching in all of the community's history. Shortly before Christmas in 1883, five men held up the Goldwater-Castaneda Store in Bisbee, and a shootout ensued. When the smoke cleared, five innocent citizens, including a pregnant woman, lay dead or mortally wounded on the street.

The five bandits made a clean getaway down Tombstone Canyon, but were captured after a relentless manhunt and sentenced to hang. Later, a sixth man, John Heath, a Bisbee businessman, was implicated as the man who planned the robbery, and he was arrested.

The jury found him guilty of the robbery, but not the murders, and sentenced him to the Yuma Territorial Prison. Some residents of Bisbee were so outraged that they stormed the Cochise County Jail in Tombstone, dragged Heath out onto Tough Nut Street, and hanged him from a telegraph pole.

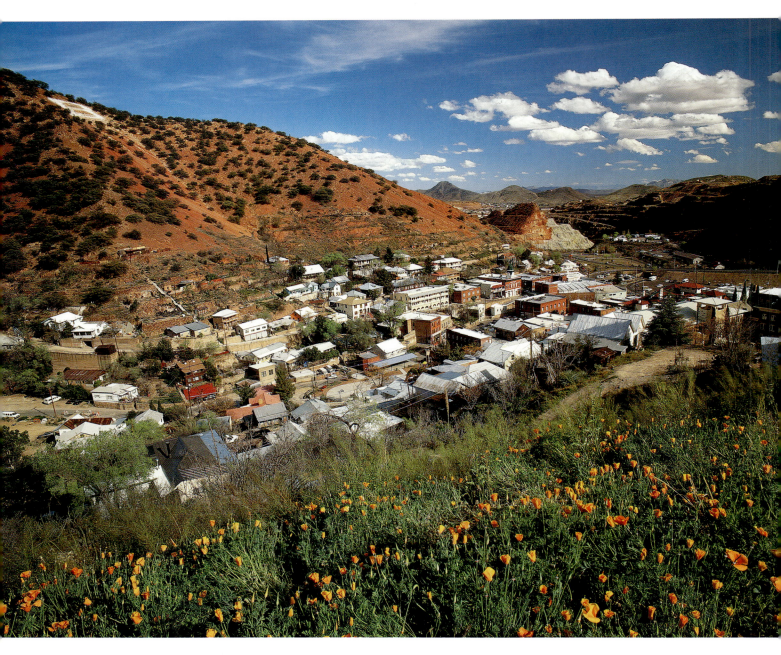

Fields of poppies crown the ridges that squeeze the historic mining town of Bisbee into a narrow canyon.

LEFT:
A cluster of restored vintage RV trailers, pink flamingos, and a restored diner make the Shady Dell in Bisbee a truly unique lodging experience.

BOTTOM:
Near Benson, a roadside stand offers all manner of locally grown produce.

Nestled in Douglas among the clutter of the modern generic architecture are a number of interesting attractions and sites. The Gadsen Hotel, built in 1907, is on the National Register of Historic Places. It features a lobby dominated by a wide staircase of Italian marble and four massive columns decorated in gold leaf. To step into the lobby is to step into the opulence of the era that produced the Titanic. Another point of interest can be found on East E Avenue, where four churches stand on four corners of the same block—the only place in the world with such a claim.

The drive from Benson to Douglas is less than seventy-five miles, but the number of natural and historic attractions along the way can consume an entire weekend or more. As an added bonus, the variances in elevation make it possible to enjoy several seasons in one short drive.

LAND OF THE CONQUISTADOR
BENSON TO TUCSON

ROUTE 21

From Benson, drive south 19 miles on Arizona Highway 90. At the junction with Arizona Highway 82, turn west and drive 50 miles to Nogales. Then, at Nogales, turn north onto Interstate 19 and drive north 60 miles to Tucson.

Arizona Highway 90 south from Benson goes through scenic rolling desert hills, bordered to the west by towering mountains and the Coronado National Forest. There is little to indicate that hidden here is one of the most beautiful natural treasures on the planet.

Kartchner Caverns State Park is a series of caves considered by authorities to be some of the most beautiful and pristine living (still actively forming) caves found in the United States. Within the breathtaking chambers are incredible crystalline formations; the longest soda-straw formation in America (twenty-one feet and two inches in height); columns nearing sixty feet in height; and delicate formations found nowhere else.

The drive southwest to Nogales on Arizona Highway 82 is a pleasant one, across grasslands, through valleys bordered by gentle rolling hills dotted with cedar, through communities almost too small to be considered a village, and through some of the most storied historic sites in the state. This area also is the heart of Arizona's wine country.

Much of the grass-carpeted rangeland to the east of Sonoita is part of the once-sprawling San Ignacio del Babocomari land grant—one of the largest ranching operations in the territory before the area was ceded to the United States via the Gadsen Purchase of 1854. Even before the arrival of the Spanish, these well-watered valleys were a center for agricultural enterprises. In 1697, Father Eusebio Kino discovered a Pima village named Huachuca on the banks of Babocomari Creek.

Grapes and wine to a large degree have begun to replace cattle in and around Sonoita. Even though the wines, wineries, and vineyards here are not yet as famous as those of the Napa Valley of California, the industry is rapidly growing, with a current approximate annual production of twenty thousand cases. Another indication that Arizona wines are gaining notoriety is that they have complemented meals at the White House since 1989. When you consider that wineries and the planting of vineyards in this area

dates to the late seventeenth century, it is rather surprising this national recognition has taken so long.

The Sonoita Creek area—with its rolling, grass-carpeted hills studded with groves of live oak and a stream shaded by towering stands of ash, sycamore, cottonwood, and walnut—may be familiar to film buffs. It was here in the 1950s that Rodgers and Hammerstein filmed their cinematic classic *Oklahoma*. A special-projects team generated the cornfields and the apple orchards; the apples were wax and melted with the Arizona heat, prompting a near constant need for replacements.

Patagonia, with its shaded streets, numerous art galleries, antique shops, and unique restaurants, makes a pleasant place to while away a summer's day. Strolling along the quiet streets filled with refurbished remnants from the town's rich history leaves no doubt that the folks who call this town home take pride in it.

Located nearby is the Patagonia-Sonoita Creek Preserve, a snapshot of southern Arizona before the arrival of the Spanish conquistadors and padres. Cottonwoods and willows, some more than a century old and towering to nearly one hundred feet, dominate the view, but as this is a complete desert riparian ecology, there are many other natural treasures to be found here. More than 260 species of birds and white-tailed deer, javelina, and coyote call this unique preserve home.

South of the preserve, Highway 82 breaks from the grasslands and rolling hills to drop once again into the Sonoran Desert. It is here you come to a city with a truly split personality—Nogales.

North of the Mexican-American border lies a bustling, crowded, somewhat dirty community that, especially at the lower end of Grand Avenue, seems to be more Mexican than American. Crowded sidewalks, lots of street traffic, and open-front stores selling all manner of merchandise often threaten to overwhelm the senses.

The crossing into Mexico itself is a busy one. Most residents on the American side have friends, family, and business partners on the Mexican side, and they routinely pass back and forth. Seventy-five percent of the imported winter fruit and vegetables consumed in the United States pass through this crossing, further adding to the cacophony of sights and sounds. American visitors may travel to Nogales, Sonora, without a visa or vehicle permit, but you must have photo identification and proof of citizenship. Due to increasing border security, a passport may also be required so please check on the most up-to date requirements before you leave home.

To state the obvious, Nogales is another country, and much of what we Americans take for granted, such as handicap-accessible businesses, is rare. In addition, there has been an increasing trend in violence toward Americans recently, but commonsense precautions—such as traveling with others, staying on well-traveled streets, and being careful not to flash money—will go a long way toward avoiding problems. (For more information, call U.S. Immigration and Naturalization Services at 520-670-4624.)

In the Barrio Historico District of Tucson, colorful adobe houses and murals add to the neighborhood's charm.

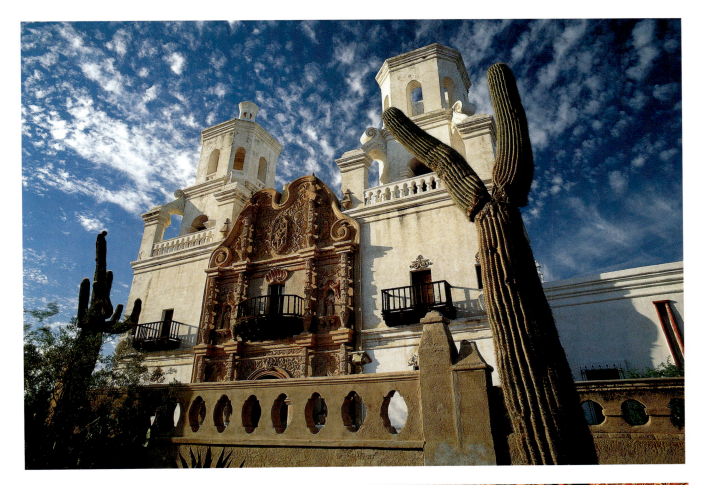

ABOVE:
The Mission San Xavier Del Bac near Tucson is known throughout the world as "the white dove of the desert."

BELOW AND RIGHT:
Finely detailed carvings, beautiful statuary, and awe-inspiring murals have earned the mission of San Xavier Del Bac comparisons with the Sistine Chapel.

The San Xavier del Bac mission hearkens to the Spanish colonial period in Arizona's history. It was established in 1700 and still serves parishioners today.
Library of Congress

Tucson is only sixty-five scenic miles north from Nogales, but the overwhelming number of historic sights between the cities makes it almost impossible to accomplish this drive in a single day. The original residents in this region, the Tohono O'odham, called this area *Arizonac*, "place of little springs."

"A photographer's paradise" is an understatement in describing Tumacacori National Historic Park. Framed by the crisp beauty of the Santa Cruz Valley, the ghostly ruins of this adobe mission, built in the early nineteenth century by Franciscan friars and native residents, seems to rise from the grassy plain. The original mission here dates to 1691, making it one of the oldest in Arizona.

A few minutes' drive north is Tubac, the oldest Anglo community in the state. Established in 1752, the quaint little town is on the fast track to becoming Arizona's answer to Santa Fe. Tubac Presidio State Historic Park is located on the east side of town. The main attractions are the crumbling adobe walls of the original fort, a schoolhouse built in 1885, and an excellent museum chronicling the Spanish history in the area. Nearby is historic St. Ann's Church. Built by a Bavarian carpenter, much of the woodwork has a European flair that seems almost out of place.

Not all of the history here is ancient. North of the modern retirement community of Green Valley is the Titan Missile Museum, the only publicly accessible missile complex in the world. The nuclear warhead has been removed, but the silo is otherwise as it was when it was an integral part of America's defense system.

The crown jewel in this string of gems is Mission San Xavier del Bac, the "White Dove of the Desert." When seen against a background of desert scenery, little changed since the first stones were laid, and with the modern skyline of Tucson looming on the far horizon below the Santa Catalina Mountains, the mission gives the illusion that you are looking from the distant past to the modern era.

Established in 1700, the venerable mission has survived abandonment, attack, and the harsh desert climate. Construction of the current mission church began in 1783, and the many colorful murals that adorn its walls have earned it the nickname "Sistine Chapel of North America." Self-guided tours of the chapel are allowed, except during services or weddings, as this is still an active parish church. The museum and gift shop add depth to visitors' understanding of the mission's importance and significance in the settlement of the Arizona Territory.

Across the courtyard from the church is an open-air shopping plaza that hearkens to earlier times. Here Native American artisans make and sell their wares, and vendors offer fry bread and other traditional fare.

THE FORGOTTEN LAND
TUCSON TO GILA BEND

I prefer open spaces, with little to mask the sound of whispering winds twisting through the chaparral or the view of a summer storm rolling in from the

mountains across the desert. However, if I were to trade my open space for a metropolis, if I were to have to leave the uncluttered vistas of the desert behind, then there is nowhere I can imagine living than Tucson. Though it is now a major city, Tucson feels like an overgrown small town, a setting for a series of Norman Rockwell prints, with a hint of Spanish influence.

The lush, fertile Santa Cruz River valley was a haven for generations before the arrival of the Spaniards. In 1954, a construction project uncovered ruins and potsherds that dated to A.D. 800. Since then, artifacts have been unearthed that push the time of settlement in this valley to before Christ, making it one of the oldest continuously inhabited sites in the United States.

The European roots of the community date to fall 1694 and the establishment of a mission by Father Eusebio Francisco Kino at a Pima village on the banks of the river. But then, for almost a century, the community languished as an outlying rancheria, suffering assaults by the warring Apache.

Toward the closing weeks of 1775, Spanish authorities in Mexico made the decision to blunt Apache raids by relocating the presidio in Tubac farther north to a site on the riverbank across from the Mission San Augustin del Tucson. As an odd footnote to this story, the military commander charged with implementing a plan to establish an arc of presidios from San Diego to San Antonio, including the relocation of the Tubac presidio, was not a Spaniard: he was a redheaded Irish mercenary named Colonel Hugo O'Conor.

Since the time the flag of Spain flew over the presidio, there have been three other flags flown in Tucson—Mexican, Confederate, and American. In recent years, large influxes of immigrants from Mexico, Asia, and Europe have added to the mix of ethnicities found there. Add unprecedented scenery, such as that found in the Santa Catalina Mountains; Saguaro National Park, which borders the community on two sides, and Tucson Mountain Park; and the southernmost ski resort in the United States at Mount Lemmon, and you have a city without equal.

From Tucson, this route will continue on to Sells. A short distance from the town of Sells, Arizona Highway 386 offers an opportunity for a small detour with a great reward. Through a series of twists and sharp curves, the road rises above the desert and delivers you to the top of 6,900-foot Kitt Peak, home to a world-famous observatory. The breathtaking views of the surrounding Sonoran Desert and the Baboquivari Mountains equal or surpass those of the heavens seen from the observatory.

From the junction of Highway 386 to the town of Why, Highway 86 crosses the Tohono O'odham reservation. As with all reservations, respect is the key word. Before taking photographs of houses or individuals, ask. Before intruding on ceremonies, ask. Before setting out to explore, seek permission.

The scenery bordering the highway here is the pure, romanticized, stereotypical Arizona desert that the uninitiated often associate with the state. As such, it is spellbinding in its raw, rugged beauty and splendor.

ROUTE 22

From Tucson, take Interstate 19 south to Arizona Highway 86, exit 99 (the Tucson-Ajo Highway). Take Highway 86 west 114 miles to Ajo, and then follow Arizona Highway 85 an additional 43 miles to Gila Bend. To reach Kitt Peak, turn south on Arizona State Highway 286. This junction is 36 miles west of Tucson. To reach Organ Pipe Cactus National Monument, take Arizona Highway 85 south from Why. After visiting the monument, return to Highway 86 and continue following it north to Gila Bend.

LEFT:
On Ajo Mountain Road in Organ Pipe Cactus National Monument, a towering saguaro seems to offer friendly greetings to visitors.

BELOW:
Near Tucson, high in the Quinlan Mountains, the Kitt Peak Observatory complex features the world's largest solar telescope.

OPPOSITE PAGE, TOP:
In Picacho Peak State Park during the months of spring, hedge hog cacti blossom in a stunning display of color.

OPPOSITE PAGE, BOTTOM:
In Organ Pipe Cactus National Monument, a Gila monster basks on a bed of warm stones.

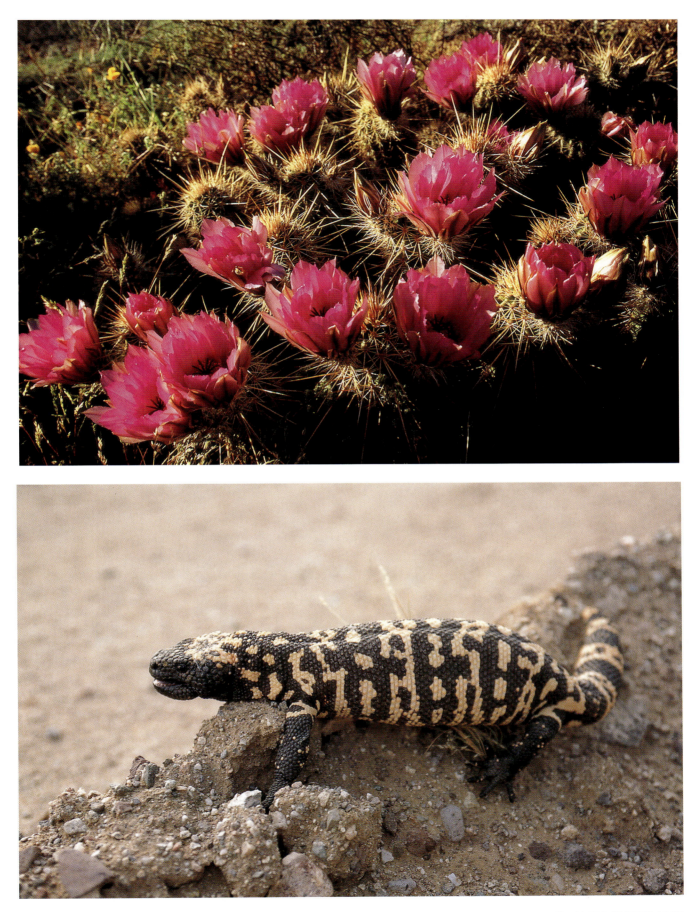

SOUTHERN ARIZONA / 147

The use of *town* or *village* to describe Why seems a gross exaggeration. Located at a Y junction—where one road leads to Ajo, one to Lukeville (along the Mexican border at the southern end of Organ Pipe Cactus National Monument), and one to Tucson—Why is merely a quick stop for supplies needed to get to anywhere else.

Organ Pipe Cactus National Monument lies to the south via Highway 85. Sprawled across a little more than five hundred square miles of the most formidable landscape found in the state, this fascinating treasure will enamor first-time desert visitors, or terrify them with its desolation and solitude. The infamous El Camino del Diablo ("the Devil's Highway") crosses through here on its way to Yuma. During the years of the California Gold Rush, more than four hundred people are estimated to have perished along this portion of the road. For those with true grit and a sturdy four-wheel-drive vehicle, some portions of El Camino del Diablo are still passable.

For less adventuresome folk who want to experience the raw beauty of the park, there is Ajo Mountain Drive, a twenty-one-mile loop on a graded gravel road that winds through the Diablo Mountains to Mount Ajo and back to the visitor center. Depending on the rainfall, an unimaginable array of color provided by wildflowers and cacti blossoms will surprise visitors making this drive in late spring.

Continuing north on Highway 86 to Ajo, the landscape is best described as barren. In the very heart of this wilderness is the intriguing community of Ajo, named either for a Tohono O'odham word for paint derived from a pigment made from an ore gathered near here, or for the Spanish word for garlic, which is found in its wild form in the nearby mountains. Mining and the dreams of riches are about the only things that could lure anyone to such a remote, desolate landscape, let alone encourage the creation of a town. The mines at Ajo are among the oldest in the state; they operated from 1855 up until the mid-1980s.

PICACHO PASS

Picacho Pass, north of Tucson, is today the route for Interstate 10. To pioneers traversing the formidable deserts on the Gila Trail, the dominating volcanic peak in the pass acted as a beacon, just as Independence Rock did for travelers along the Oregon Trail. The volcanic peak also served as an important milepost for the location of water, as there were several dependable springs there.

Anglos new to the area rushed to name landmarks or geographical locations, often mixing native or Spanish names with something in English. The result can be somewhat comical, as in the case with Picacho Peak. *Picacho* is a Spanish word for peak, making the translated name Peak Peak.

With the exception of die-hard Civil War buffs, few are aware of the role this pass played during that conflict. The westernmost battle of the Civil War was fought here in spring 1862, when two Union military units clashed with a small band of Confederate soldiers. A monument commemorating the battle is located on the south side of the interstate at Picacho State Park.

Today, the community is an odd blend of snowbird haven for those trying to escape winter snow, a fledgling retirement community, and a bedroom community for eclectic artists and an eccentric few who make a two-hour commute to Tucson or to Phoenix. The heart of Ajo is a traditional town square created in a Spanish Colonial style and shaded by palm trees. Surrounding the plaza and lining the connecting side streets are a plethora of well-preserved or restored historic buildings. Among the most notable is the Curley School, which dates to 1919; the New Cornelia Hotel, built in 1916; and the wonderful train depot, opened in 1915.

The drive north on Highway 86 continues through wild desert landscapes that will leave you in awe of those who traversed it without the benefit of air conditioning. This is especially true during the blistering temperatures of summer months.

Before being diverted for irrigation purposes, the Gila River made a wide bend where the town of Gila Bend stands today. Most drivers just fuel and go without ever realizing this dusty old town has something to offer.

Outside the immediate town of Gila Bend, you'll find Painted Rocks. Surprisingly, its petroglyph-covered rocks, small lake, picnic area, and scenic adobe ruins of the Agua Caliente Hotel and Hot Springs are not well known. In Gila Bend proper, you'll find a few oddities and historical footnotes in concrete, including the old Stout Hotel, a poured-concrete structure that opened in 1929. Incredibly for the time, this hotel featured steam heat and air conditioning as a byproduct of the ice plant in the basement. Among the many illustrious individuals who signed the register here were Clark Gable and Carol Lombard.

Then there are the remains of Harvey Brown's store, constructed entirely of old railroad ties. Known as Jungle Jim by locals, for the fact that he chose a pith helmet over the more-traditional wide-brimmed Stetson, Brown opened the store at the height of the Great Depression. He sold all manner of goods, from apples and sandwiches to used shoes and luggage. His targeted clientele were vagrants, like him.

LAND OF APACHE LEGENDS
WILLCOX LOOP

The Sulfur Springs Valley is an island of agriculture in a sea of desert. Here, all manner of produce is grown, from pecans to apples to chilies. A small detour onto I-10 is needed to find the premier location for sampling the valley's bounty, including some wonderful ice cream: at Stout's Cider Mill, off exit 340.

At the heart of this high-desert valley is the charming community of Willcox, home to the legendary cowboy crooner and narrator for numerous 1950s Disney-produced nature films: Rex Allen. Homage to the community's favorite son is given every October with Rex Allen Days, which include a rodeo, a parade, and other events.

ROUTE 23

From Willcox, follow Arizona Highway 186 southeast to the Chiricahua National Monument. The road to Fort Bowie National Historic Site north of the park is well marked as Apache Pass Road. From Chiricahua National Monument, continue south on Arizona Highway 181 until you loop west and can eventually turn north onto U.S. Highway 191. From that point, drive 18 miles to Interstate 10. Turn east and drive 8 miles to Willcox.

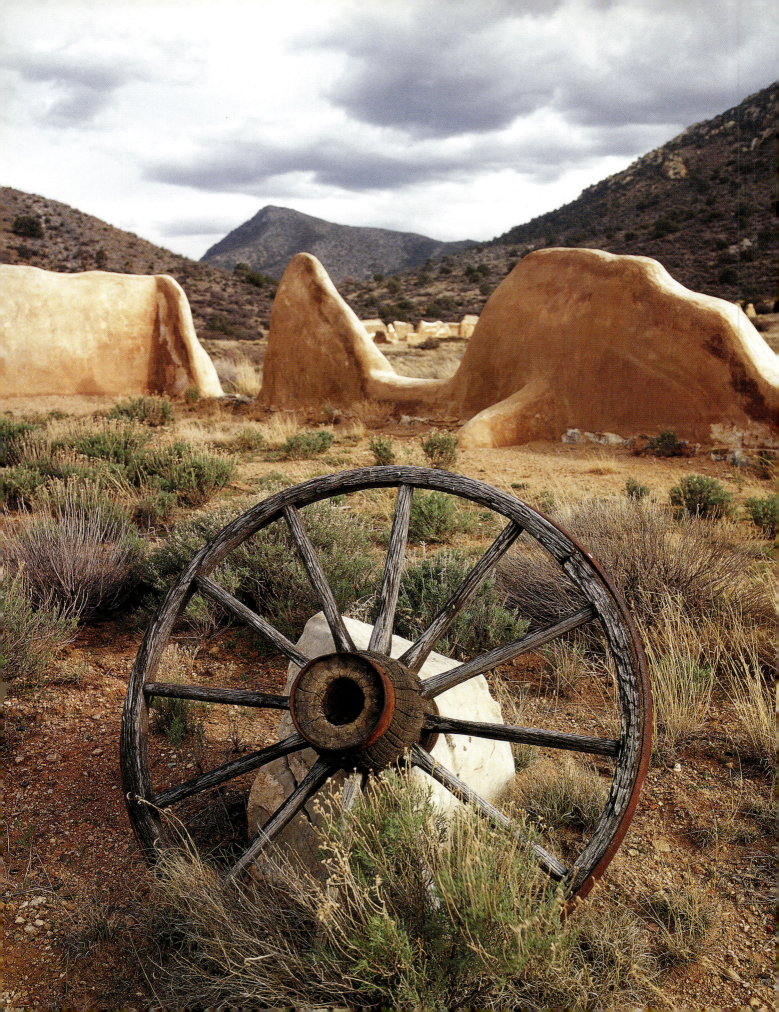

OPPOSITE PAGE:
The ruins of Fort Bowie in Fort Bowie National Historic Site seem to be melting into the desert.

ABOVE:
Headstones and memorials stand in mute testimony to those who served at Fort Bowie National Historic Site.

RIGHT:
In the Dragoon Mountains, an oasis along the Cochise Trail offers cool respite from the desert heat.

As with most American communities, Willcox has succumbed to the generic plague of fast-food palaces and generic shops that crowd the exits along the interstate. For the adventuresome who choose exploration over convenience, it will become apparent that cattle and farming are still more important to the fabric of this community than amenities for the fuel-and-go traveler. The extensive displays at the Chiricahua Regional Museum, for example, chronicle the rich, colorful, and fascinating history of the area. As a result, this stop makes for an excellent introduction for the rest of your drive.

The pleasant drive south from Willcox on Arizona Highway 186 is at first agricultural, but soon gives way to high-desert plains that roll toward a bulwark of imposing mountains. On one ridge are two distinctive knolls—Dos Cabezas, or "two heads"—that denote the range of mountains by the same name. A dependable, year-round spring and enough gold and silver to sustain mining operations led to the establishment of a small community that also carried this name. Little remains of this community other than a house or two and a few building shells, but in 1881, it was noted that the Dos Cabezas business district consisted of a hotel, three saloons, a blacksmith shop, a post office, and a stamp mill.

After Dos Cabezas, it is but a short drive on the somewhat rough Apache Pass Road through a picturesque desert landscape to Fort Bowie National Historic Park. Established in 1862, Fort Bowie played a pivotal role in the initial attempts by the United States to subdue the Apache. In addition to denying them use of Apache Pass—a primary route between Dos Cabezas and the Chiricahua Mountains that was later used by the storied Butterfield stage line—nearby Bowie Peak served as a primary heliograph station for military communications, which resulted in faster, more-coordinated troop movements.

Today, all that remains of the fort are crumbling adobe walls, but a museum on the grounds provides an illustrated history. A relatively easy, scenic, 1.5-mile hike from the parking lot to the fort winds past the ruins of a Butterfield stage station and a lonely cemetery, where legend has it the son of Apache leader Geronimo is buried.

From the Fort Bowie detour, the landscape along Arizona Highway 186 begins a rapid transition from high desert to a land of twisted stone spires intermingled with forests of pine and juniper. An easterly turn at the junction with Arizona Highway 181 provides access to the Chiricahua National Monument, which preserves the best of this unique ecosystem. Bonita Canyon Drive provides access to some of the monument's premier sites, including Massai Point, with its sweeping views of the Chiricahua Mountains.

Skirting the Chiricahua Wilderness, Arizona Highway 181 resumes the southerly trek through a high-desert plain of rolling hills little changed from when this was the land of the Apache. Scattered here and there are a few ghost towns, which provide tantalizing glimpses into the Arizona frontier.

One of the most fascinating of these ghost towns has to be Pearce—located north of the junction with U.S. 191, the route for the return to Willcox—which seems held in a suspended state of decay. Standing in the dusty main street, looking toward the false-fronted Soto Brothers and Renaud General Merchandise Store, complete with hitching post and circa-1920 visible-register gas pump, it's easy to imagine you have stepped into an earlier time.

The return drive north to Willcox on U.S. 191 is along the foothills of the historic Dragoon Mountains. Few places in the state have witnessed as much pivotal history as these rocky mountain slopes.

Dragoon Pass served as a primary route through this formidable landscape, as well as a dependable source of water. In 1856, a railroad survey crew, with military accompaniment led by Lieutenant John Parker, recommended this as an ideal crossing through the mountains because of its gradual grade on either side. In 1857 and 1858, dragoons of the United States Army garrisoned here in initial attempts at containing the Apache. Built shortly thereafter was a stone station/fortress for the Butterfield stage line, and in fall 1872, a peace treaty was ratified with Cochise near Dragoon Springs. Almost due west of Pearce is Cochise Stronghold, where the legendary leader made his final stand and died in 1874. His body was secretly buried among the deep canyons, and even today, the location remains unknown.

The rugged nature of the terrain in the Dragoon Mountains and the steep changes in elevation have resulted in a landscape barely changed since the Apache used these mountains as a stronghold. Interspersed throughout the range are well-marked hiking trails, picnic areas, and campsites.

Surprises are a large part of what makes driving in Arizona such an adventure. As you drive north on U.S. 191 toward Willcox from the Dragoon Mountains, the cresting of each hill provides a better view of what appears to be a large deepwater lake. In actuality, this is a mirage, as the Willcox Playa Wildlife Area is a huge shallow lake that almost completely dries up during the summer months. There are a number of stories about the effect this mirage has had on travelers. The most interesting story pertains to a navy flying-boat pilot during World War II. After developing engine troubles, he saw the lake as an answer to his prayer. The landing, however, was not what he envisioned.

For the bird-watcher, January is the best time to visit this unique desert treasure. From late October to mid-February, thousands of sandhill cranes flock to the area for nesting, and in January, the community of Willcox hosts "Wings over Willcox" to celebrate the arrival of these birds.

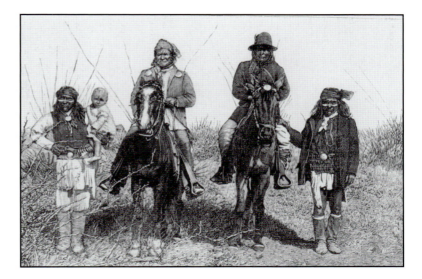

Geronimo and Natchez, both leaders in the Apache tribe, led warriors in their hostile resistance to frontier settlements and the military men serving at Fort Bowie in southeastern Arizona. Eventually, their efforts proved futile. Library of Congress

Advertising simplicity made manifest at the Cochise Country Store in old Cochise.

ABOVE AND OPPOSITE PAGE: *Simple, historic homes still serve as residences in old Cochise, including one at right that is considered the oldest Anglo residence in southeastern Arizona.*

INDEX

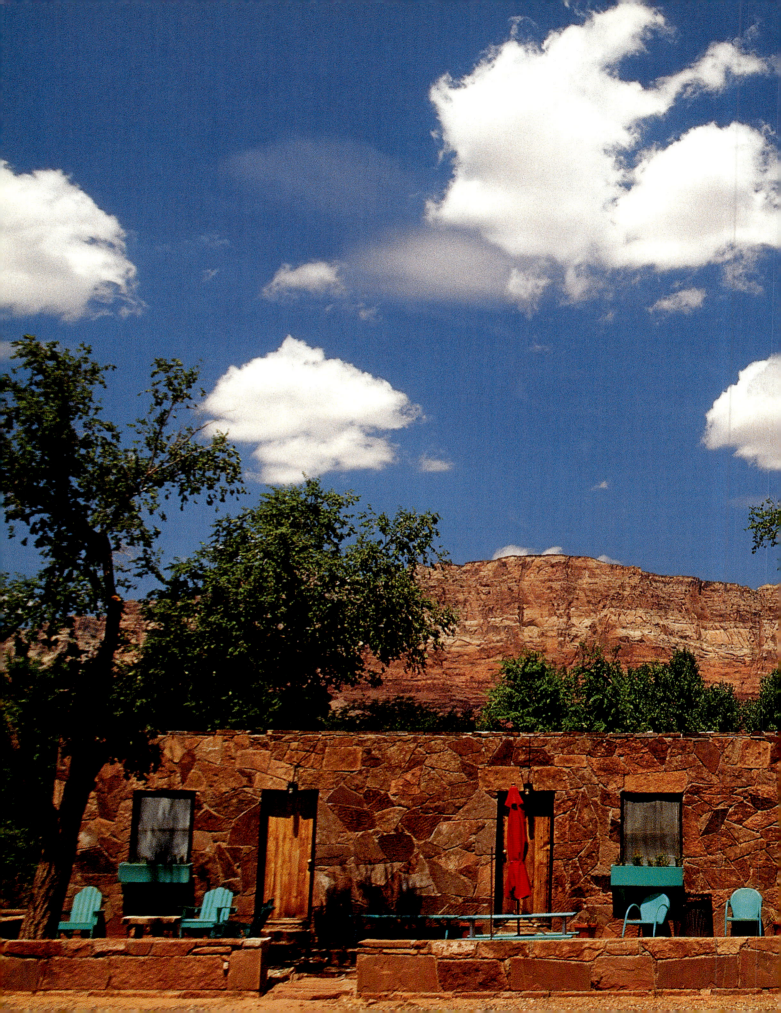

SUGGESTED READING

Arizona Good Roads Association Illustrated Road Maps and Tour Book. Prescott, Arizona: Arizona Good Roads Association, 1913.

Harris, Richard. *Hidden Highways Arizona*. Berkley, California: Ulysses Press, 2001.

Kosik, Fran. *Native Roads*. Flagstaff, Arizona: Creative Solutions Publishing, 1996.

Miner, Carrie, and Jill Florio. *Off the Beaten Path Arizona*. Guilford, Connecticut: The Globe Pequot Press, 2005.

Trimble, Marshall. *Roadside History of Arizona*. Missoula, Montana: Mountain Press Publishing Company, 1986.

The historic Lee's Ferry Lodge seems to be carved out from the Vermillion Cliffs that tower above.

ABOUT THE AUTHOR

Jim Hinckley moved to Arizona as a young boy in the summer of 1966. While his first impression of the state was that it reminded him too much of "a place warned about in Sunday school," he eventually fell in love with Arizona's colorful, rugged landscape.

After spending time as a cowboy, miner, and truck driver, Jim became a regular contributor to the *Kingman Daily Miner*, writing columns about his two main passions: automobiles and travel. His work has also appeared in a wide variety of magazines, including *Route 66*, *American Road*, *Old Cars Weekly*, and *Classic Auto Restorer*. Jim is also the author of *Checker: An Illustrated History* and MBI Publishing Company's *The Big Book of Car Culture*.

He lives in Kingman, Arizona, with his wife and son, David, copilot for the adventures in this book.

ABOUT THE PHOTOGRAPHER

Kerrick James has been a professional photographer for more than twenty years. He moved to Arizona in 1990, and since that time he has specialized in travel imagery. He is a regular contributor to Getty Images; *Arizona Highways*, *Sunset*, and *National Geographic Adventure* magazines; and the magazine for *Alaska Airlines*.

Kerrick lives in Mesa, Arizona, with his wife, Theresa, and their three sons.